In the words of my dear friend Andrew Loog Oldham
(the Rolling Stones legendary first manager and producer):

REMEMBER THAT WHILE ONLY THE GOOD DIE YOUNG,
THE BEST REMAIN FOREVER YOUNG…

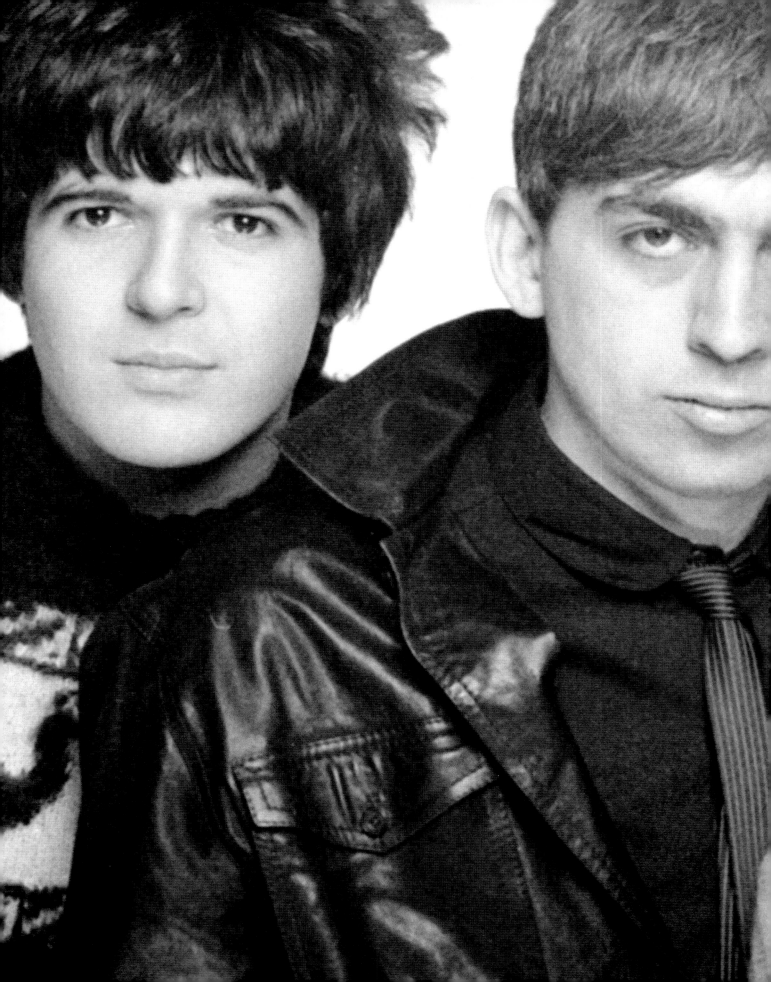

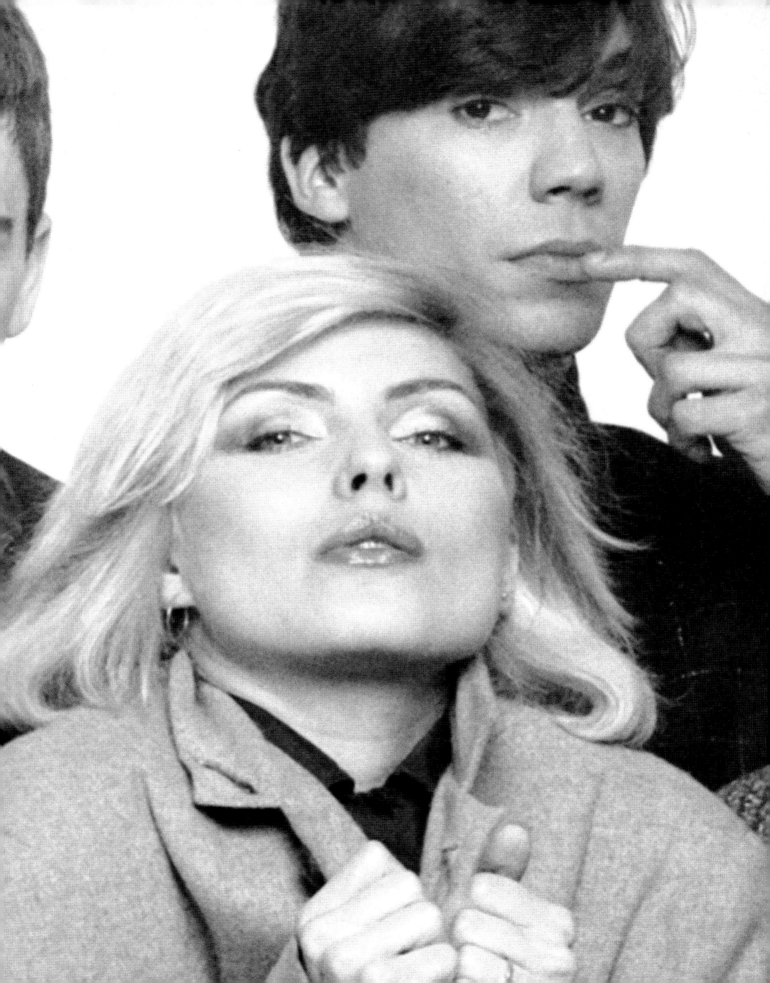

This is for my pretty Pati, who knows a thing or two about the blonde life…

This edition first published in Great Britain in 2010 by

PALAZZO EDITIONS LTD
2 Wood Street
Bath, BA1 2JQ
United Kingdom

www.palazzoeditions.com

Art Director: Adrian Cross

All photos mastered by Lucky Singh of Lucky Digital Inc, NYC
www.luckydigital.us

A CIP catalogue record for this book is available from the British Library.

ISBN 9780956494207

Printed and bound in Singapore by Imago.

PALAZZO

DEBBIE HARRY AND BLONDIE
PICTURE THIS
MICK ROCK
FOREWORD BY DEBBIE HARRY

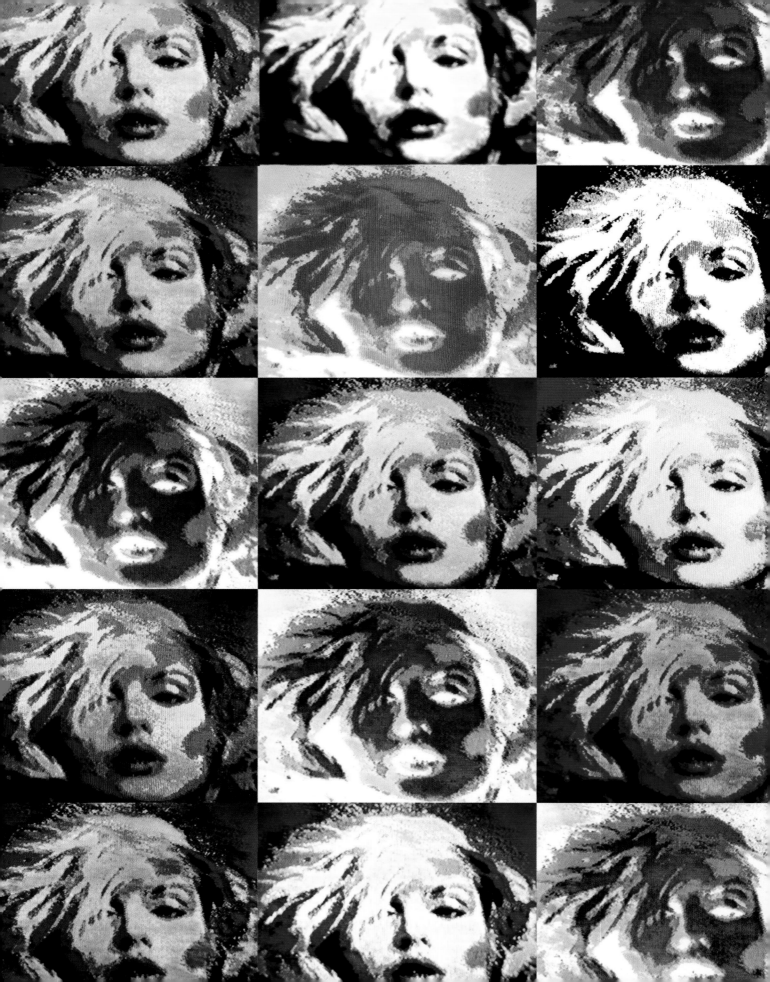

Foreword

OK. So Mick's gonna do this book of his shots of me and the boys. We have done some great ones together. He's very energetic – driven, in fact, even without the blow. Practically on overkill he shouts his enthusiasm as he clicks and flashes away, shooting roll after roll of film…

I never really liked the way I looked in pics as I was growing up. But then after I started shooting with Chris (Stein), our close relationship made it easy for me to relax in front of the all-seeing eye, the camera. I also think that developing the Blonde persona gave me sort of a 'wizard's screen' to stand behind as I vamped out in front, the Blonde in Blondie.

There were so many movie stars that influenced me, especially the gorgeous blondes. For me that glowing irresistible attraction gave me little choice. I had to hit the bottle. I had to be a blonde. As well as this mad attractiveness that the blondes possessed for me, they also seemed so innocent: the vulnerability of little children, the child inside us all.

Over the years Mick Rock has made history with all the musicians and rock stars that he has immortalized. A good photo session is sometimes as good as sex. You leave feeling well massaged, satisfied and a little bit outside yourself. I guess it's different for everyone, but a good shoot leaves you excited and satisfied and wanting some more. And then a day or so later you get together and look over the proofs. I've learned what to look for but usually I go along with the photographer's choices. He most often chooses the best shots.

Mick Rock is big: over six feet tall with lots of personality. At first I thought he was a put-on, but that's just the way he is. That's the way he shoots and that's the way he lives. Even now after chasing down the reaper, his approach to life is big. He is a busy man, productive in his art and business and he also has a family.

I've been photographed by a lot of different people since I started Blondie but Mick is unforgettable. Most of my sessions are for magazines. Some are for album art, some for fashion and some for portraiture. Mick specializes in rock musicians. He's made history with his shots of Iggy, Bowie, Lou Reed, Freddie Mercury and many more. And as Mick says, the last time he was elbow to elbow in the pit, I blew him a kiss. All right, love, happy I was there for you. Even happier you were there for me.

Debbie Harry

Introduction

I love to shoot. I love the whole process: gathering the elements, stirring the juices, finding the focus, building the energy, exploring all the possibilities within the limitations of each circumstance. Something happens inside of me – a kind of transformation. I become the other, the image maker, and everything is possible. It's very therapeutic. This is what I love to do above all…

The best way to build a reputation as a people photographer is to produce an indelible image or two. How well circulated that image becomes often depends also on how well-known the subject is. People see your credit and a little bit of the fame rubs off on you. Of course, better than fame is notoriety, with the added edge of titillation; that is even more seductive and a lot more fun. It must be said I have frozen more than a few characters in my time who have freely dabbled in the ancient and delicious art of notoriety…

Like a hit record to a rock 'n' roller, the downside is that a great image, besides defining the subject, can limit what others call on the photographer to do. I wouldn't mind shooting the occasional politician or actor (or even a gangster or two!), but that's not how art directors or magazines view me. I am considered above all a 'Rock' photographer, which certainly has not been without its benefits. I've had enormous personal freedom and opportunity to explore many facets of my personality: sensual, creative, illicit and spiritual. But I also have a treasure trove of cat and erotic imagery so maybe one day I'll get to do a rock 'n' roll pussy book… Anyway, that's life. You take what you are supposed to get and make the most of it. And I have…

To create a book built around a specific subject, a photographer first has to have enough images to fill it. To get it published, the subject has to have enough appeal that a publisher believes he can make money off it. That's only fair. The image-maker may be willing to put out because he's enamored of his collection, but publishing is first and foremost a business. For the author/photographer (and while the photos are paramount, the words are also important – it is after all a book, not a gallery exhibit) it takes a lot of time, patience and energy to put the whole project together and you have to put a little of your soul into it. So having enough pictures and finding a publisher are only the first steps. It's not like shooting where the snap of the shutter and the alchemy of the moment provide instant gratification. A book is a long process of editing, writing and tinkering. The subject has to stir some serious respect and excitement in you.

Which brings me to Blondie…

In the annals of rock 'n' roll, these guys are unique. Not only did they coin a whole new brand of popular music, 'Power Pop', their output has proven to be timeless, durable and a source of endless pleasure to millions (myself included). And they are fronted by the most photogenic and charming chanteuse to ever come down the bawdy pike of Pop. In their heyday I had the privilege of lensing a slew of classic imagery of them. What a buzz…

Of course, the primary focus of this tome is the divine Ms Deborah. The rest of the fabulous four long ago learned that she was their ticket to ride. But, let's be clear, as Debbie would be the first to insist, they were also her ticket. Musically/creatively the quartet who have ridden this magic bus since their debut, Debbie, Chris, Jimmy and Clem, have been equal partners in crime. While every-one is fascinated by the Blonde, they love her most in the context of Blondie, notwithstanding all her other achievements. As their reformation and resurgence of recent years has clearly underscored, Blondie are a band for the ages, and even their '70s recordings sound modern and relevant. And the bonus of their ability to come again is that as well as new record sales, they now garner the critical acclaim and respect which was denied to them first time around.

Time has proven Debbie Harry to be arguably the most potent visual female icon in the annals of 'rock'. Certainly no others can match the seduction of her image, that sexy blend of New York downtown punk princess and Marilyn. Part of her appeal lays in the undiluted naturalness of her attitude. She never seemed to be trying to be 'hot'. Unlike most of the moderns, she comes across as totally self-styled. She presents herself as she wants to be presented. She is not the product of over-solicitous image-makers and stylists. She's essentially a product of her own dreams; nobody else's.

So feast your beady eyes at length here on the greatest Blonde that ever rocked, but also on the cute cohorts who formed (and still form) her creative posse. Let's hear it for a delightfully adorable and soulful rock 'n' roll lady and a truly great rock 'n' roll band. Keep on rocking on and on and on, Blondie. You only live twice…

Mick Rock

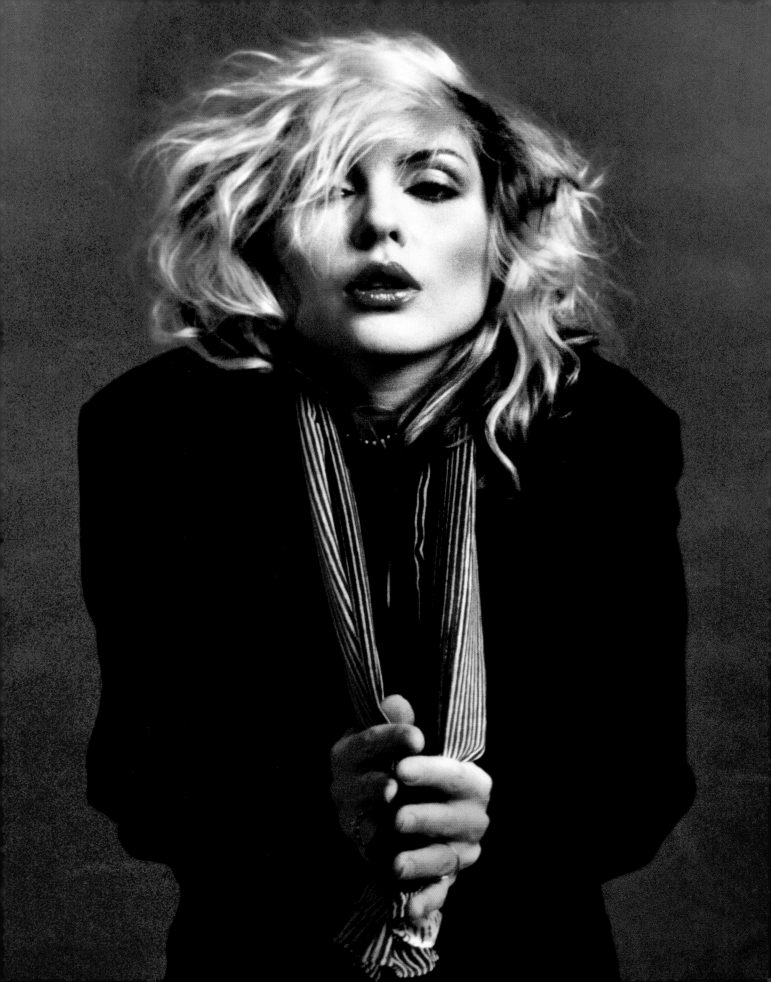

Of course there was *Blondie* the cartoon strip, long before there was Blondie the band. The only time the toon figures registered strongly in my imagination was when a friend at school showed me underground porno pastiches of popular cartoons; one featuring Blondie and Dagwood romping away in a particularly joyful and salacious manner.

Later in my college days I had a pretty blonde girlfriend who was wolf-whistled by good, solid, street-working males who assailed her with jaunty appreciative cries of 'give us a kiss, blondie!' They got to whistle, I got the kisses...

This same young lady was my very first photo subject.

SO, IN THE BEGINNING, THERE WAS THE BLONDE...

Something magical happens when a photographic light hits a blonde female mane. It bounces off the hair and creates a subliminal and sexual aura. Brunettes absorb light; blondes reflect it. The reflective power of the dyed blonde is more potent than the natural. Think 'blonde bombshell' or 'platinum blonde' or maybe 'blonde ambition'...nothing natural about the blondes that these monikers were attached to.

THE REFLECTIVE
POWER OF THE
DYED BLONDE
IS MORE POTENT
THAN THE NATURAL

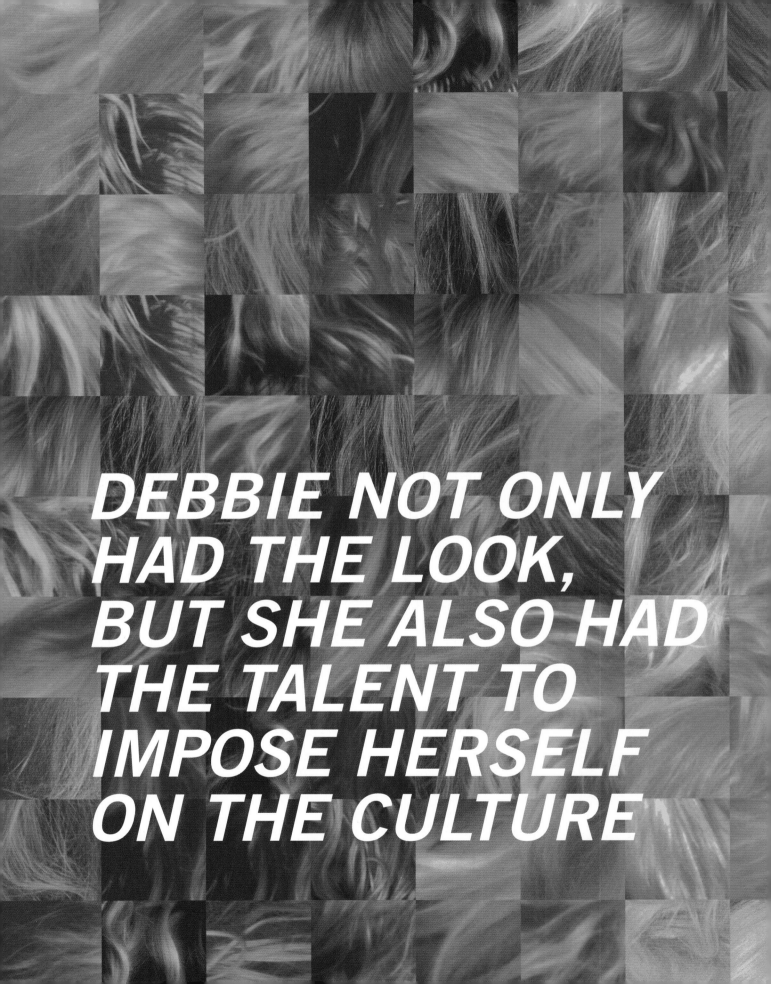

DEBBIE NOT ONLY HAD THE LOOK, BUT SHE ALSO HAD THE TALENT TO IMPOSE HERSELF ON THE CULTURE

BLONDE AS A FETISH HAS LONG BEEN A STAPLE OF THE MOVIE AND PHOTOGRAPHIC LANDSCAPE. FIRST THERE WAS JEAN HARLOW – FREQUENTLY FRAMED BY ONE OF MY PHOTOGRAPHER HEROES, GEORGE HURRELL – THE ORIGINAL 'BLONDE OF ALL BLONDES'. AND ALMOST SIMULTANEOUSLY THE NAUGHTIEST BLONDE OF THEM ALL, MAE WEST.

I met George Hurrell in the early eighties, when he was just being rediscovered and appreciated and was gearing up for his last run at photo glory.

I interviewed him for a French photo magazine – something along the lines of glam-rock shutterbug meets classic Hollywood glamour lensman.

We exchanged tales of shooting stars. I was especially intrigued about Jean Harlow. 'She was one of my favorite subjects. She was certainly ambitious but she was also fun loving, with no pretense whatsoever and had a humorous attitude about the whole star system. She was a white-hot blonde and the chemistry of the light as it blended with her blondness was magic on film...'

IT SOUNDED LIKE A DESCRIPTION OF MY OWN FAVE STAR BLONDE...

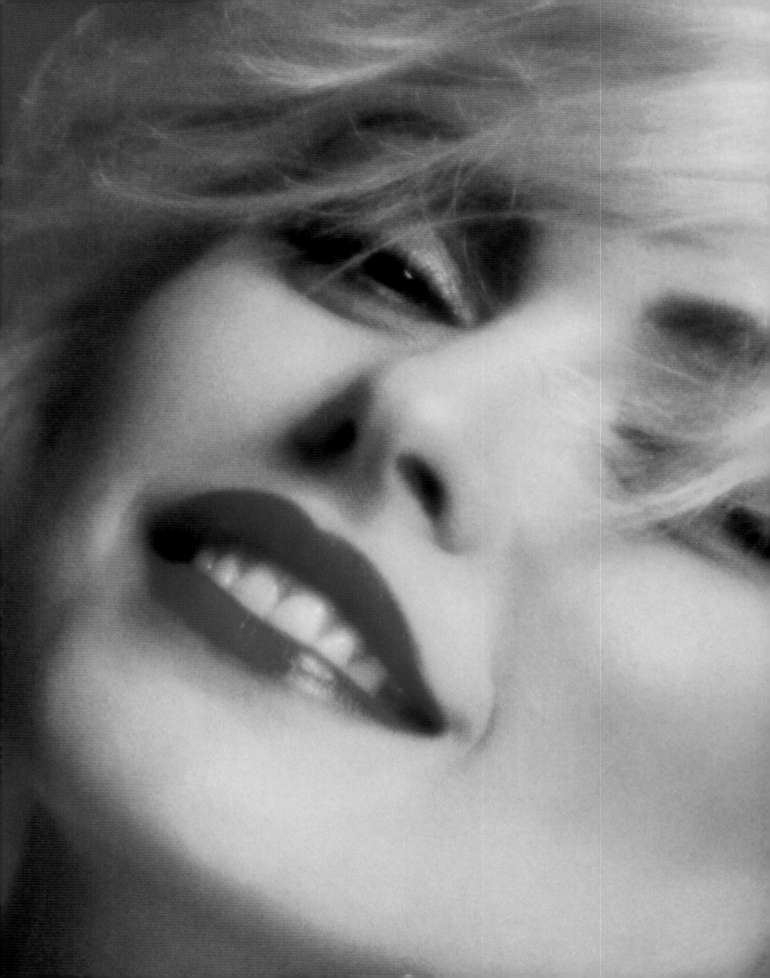

"*Beauty is the wonder of wonders, it is only the shallow people who do not judge by appearances.*"

OSCAR WILDE

Then there were the blonde femmes fatales of the film noir genre of the '40s and early '50s. Lana Turner in *The Postman Always Rings Twice*, a very blonde Barbara Stanwyck in *Double Indemnity*, Rita Hayworth totally blonded up by her then husband Orson Welles for *The Lady From Shanghai*, Claire Trevor – a blond convert for *Murder My Sweet* (a Raymond Chandler adaptation), and the less feted Gaby Rogers in her only role of note *Kiss Me Deadly* – more potent than all in her blondness, in that in the end she blows up the world!!! Her short blonde crop presaged Jean Seberg in Jean Luc Godard's *A Bout De Souffle*... Then there was that sweet gal pal peek-a-boo blonde Veronica Lake, Alan Ladd's counterpoint in *This Gun For Hire* and *The Glass Key*. It can't just be coincidence that all the films named here rank among my fave celluloid distractions. Blondes may or may not have been more beautiful, but they certainly seemed to have more fun (and to get into more trouble).

Of course a number of them also ended up very dead...

Just in case anyone doubted the erotic power of the blonde female persona, the '50s spawned the all time über-blonde, the blonde to leave 'em frothing in the aisles (and in the bedrooms).

THE VERY DELECTABLE AND VERY DOOMED
MARILYN MONROE.

THIS BLONDE EMBODIED THE ESSENCE OF FEMALE MAGNETIC BLONDNESS FOR ALL TIME. SHE SET THE STANDARD. SHE WAS TO BLONDES WHAT JIMI HENDRIX WAS TO GUITARISTS: THE YARDSTICK TO WHICH ALL SERIOUS BLONDE FEMALE ENTERTAINERS HAVE BEEN COMPARED TO FOR THE LAST FIFTY YEARS.

There were many challengers to her breathy supremacy in her day – most notably Jayne Mansfield and Mamie Van Doren. Although they may have been more ample in the breast department, Marilyn had the face to die for. She was the all-time keeper. No movie actress has been able to scale the Marilyn pinnacle in the years since her demise. Who has ever acquired the quality of sexual scalps to match hers: Frank Sinatra, Joe DiMaggio, Arthur Miller, JFK and RFK for starters?

While it's true that the modern popular music world is littered with dynamic and nubile chanteuses blondes – Britney Spears, Gwen Stefani, Mariah Carey, Jessica Simpson and Ms. Blonde Ambition herself, Madonna, et al - before the advent of the divine Ms Deborah Harry in the mid-'70s there were none of note. Well, there was the early Marianne Faithfull with her demure sub-Françoise Hardy folkie aura, but she didn't start to rock 'til after Debbie laid down the gauntlet.

BEFORE DEBBIE THERE WERE NO OUT AND OUT
DROP DEAD FEMALE ROCKERS. JANIS JOPLIN,
GRACE SLICK, LULU, DUSTY SPRINGFIELD???
NOT QUITE...

IT WOULD NOT BE AN OVERSTATEMENT TO SAY
THAT MS HARRY CHANGED THE FACE OF POPULAR
MUSIC FOREVER.

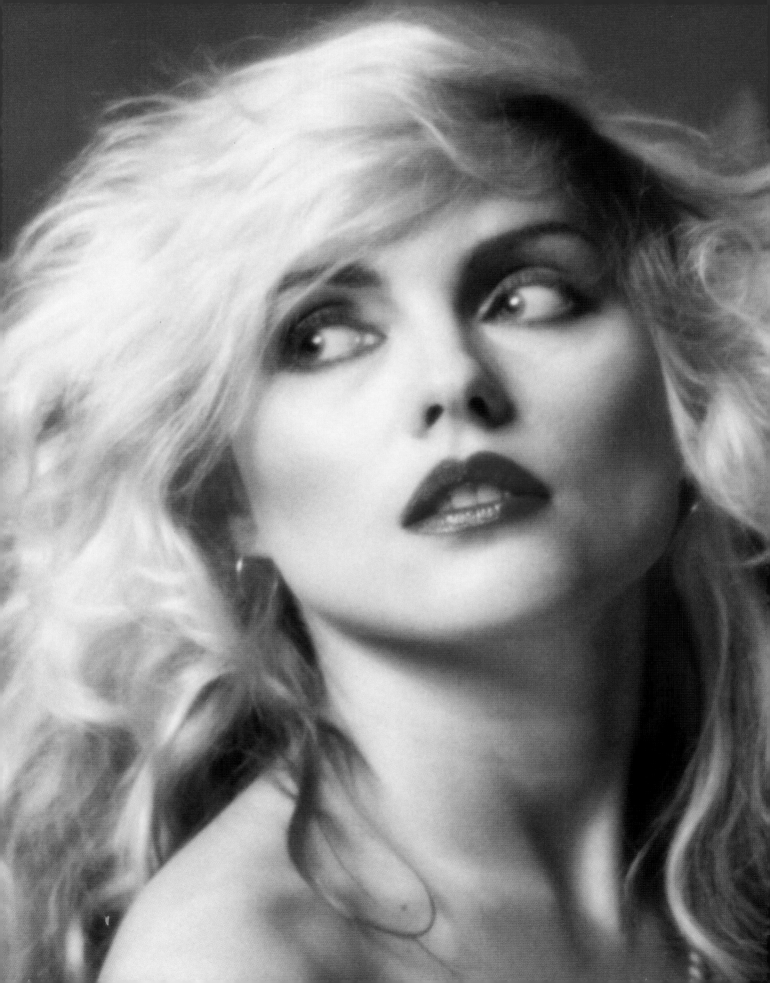

Now in the '60s, Andy Warhol had his own sexy rocket blonde superstar in Edie Sedgwick, whose influence is apparent on the early glam-rock icons who graced my lens: Angie Bowie and Cyrinda Foxe (another Warhol protégé). Check out Cyrinda in my classic Bowie video for Jean Genie. 'Talkin' 'bout Monroe and walking on Snow White...'

But like Edie, Angie and Cyrinda were limited in talent (although they all certainly looked the part) and were essentially peripheral operators. Debbie not only had the look, but she also had the talent to impose herself on the culture.

Cyrinda Foxe and Angie Bowie
Plaza Hotel. September 1972

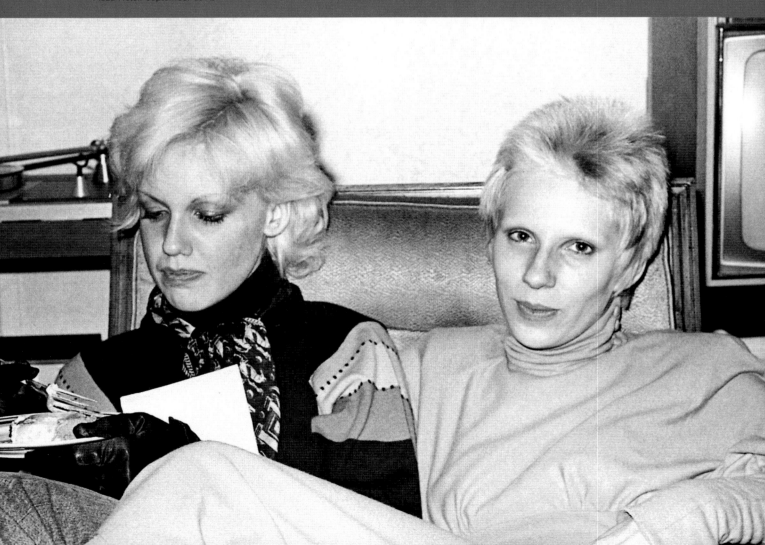

TOO SMALL TO BE A MODEL, TOO INDEPENDENT TO
BE A FULL-TIME ACTRESS, HER INNATE BOHEMIAN
SPIRIT BLOSSOMED INTO ONE OF THE GREAT POP
ENERGIES OF ALL TIME. IT'S NO ACCIDENT THAT SHE
WAS ALSO ANDY WARHOL'S FAVE DOWNTOWN GIRL.
THIS GIRL COULD NOT ONLY POSE AND POUT AND
DELIVER SUPERB LENS, SHE COULD SING AND WRITE
MEMORABLE SONGS TOO. OF THE MODERNS, ONLY
THE SUPERSMART MS STEFANI CAN ROCK OUT LIKE
OUR DEBBIE.

MS HARRY REMAINS HOWEVER, INDISPUTABLY THE
GREATEST BLONDE THAT EVER ROCKED...

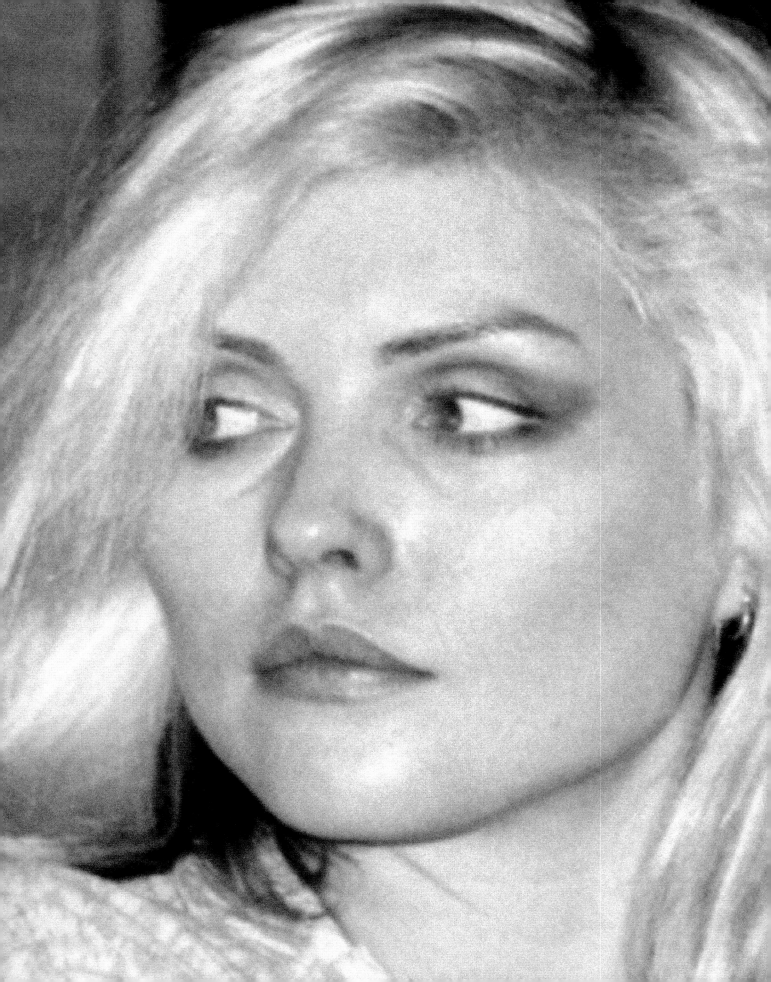

Which brings me (enfin!) to CBGB's in the summer of 1974. I was in New York in August fo[r]
a couple of weeks, part working – part holiday. In those days, to pep up my modest income, I woul[d]
do interview pieces illustrated with my photos for music and men's magazines. The art director o[f]
Club International, Steve Ridgeway, who did great graphics on a number of album covers I photo-
graphed and art directed, most notably Lou Reed's *Coney Island Baby* (one of my three Gramm[y]
nominations in the '70s) and *Rock and Roll Heart*, would often pull gigs for me at the magazine.

IN FACT THE FIRST PIECE I EVER WROTE/PHOTO-GRAPHED FOR THE MAGAZINE WAS ON A PRE-STAR TIME DAVID BOWIE/ZIGGY STARDUST IN THE SPRING OF 1972.

David Bowie
Beckenham. March 1972

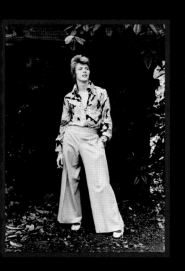
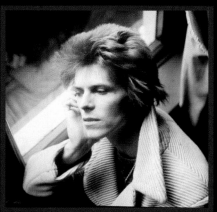
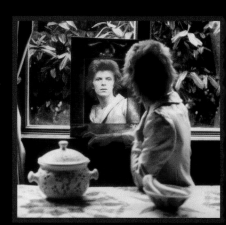

I also published sex-orientated illustrations and interviews (it was and is after all, a men's magazine). There was a Puerto Rican stripper Steve admired called Margie Villa. She lived in the Bronx with her two small children and stripped in one of the traditional seedy men's clubs in a then pimp-and-dope sodden Times Square.

Intriguing fare for a young, would-be hip Englishman in the Big A.

The interview and photos she graciously acceded to paid for my trip to New York.

Through *Circus Magazine*, one of the primary rock publications of the period, I had made the acquaintance of a young journalist called Michael Gross (he was a staff writer). He soon moved on to bigger and better paid gigs, and after a couple of minor mystery novels he finally banged a major gong in the early '90s when he published a lurid, but well written and highly entertaining exposé of the sordid underbelly of the New York modelling world called Model. His father was a legendary New York sports columnist called Milton Gross, who died while Michael was still young. He was very driven compared to most of the hip music writers of the time, driven at least partly by the need to live up to the glowing reputation of his prematurely-deceased father.

In more recent years he has become a significant contributor/columnist for several significant New York publications.

ONE STICKY AFTERNOON, TYPICAL OF NEW YORK IN IT'S FULL SUMMER SWEAT, MICHAEL INVITED ME TO ACCOMPANY HIM TO THIS GRUBBY, DIMLY-LIT DIVE ON THE URINE AND BOOZE SOAKED BOWERY, TO CHECK OUT SOME 'INTERESTING' NEW BANDS.

I KNEW THAT MICHAEL LIKE MYSELF WAS ALWAYS
LOOKING FOR AN EDGE SO I HAPPILY TRUNDLED
ALONG IN HIS WAKE. THERE WERE AT MOST 20
PEOPLE IN THE AUDIENCE BUT ONE OF THEM
THAT MICHAEL INTRODUCED ME TO WAS WILLIAM
BURROUGHS.

Like Michael he lived in the neighborhood. Like many would-be hip young men of my
Burroughs held a fascination for me. He formed along with Jack Kerouac and Alle
the unholy trinity of the Beat Generation writers. His junked-out deadpan raspy voic
mesmerized me when I heard him intone passages from *The Naked Lunch* on a spok
inch album called *Burroughs Speaks* (I can still hear Breakthrough In Grey Room... a
thirty five years since I last heard the record), which my friend Pete Carr (heir to the
biscuit empire) played to me coming down off an acid trip while we were ostensibly st
degree in Modern Languages at Cambridge University.

I was charged to be breathing the same musty air as Mr B and somewhat put out
mislaid my camera (I had one 35mm SLR in those days) at a friend's and wouldn't
retrieve it 'til he returned home from work that evening. Burroughs had met my f
Bowie the previous year when they did a joint interview for *Rolling Stone* magazine ar
curiosity seemed to concern David's sexual and chemical habits.

That afternoon there were three bands on the bill.

The most seriously musical were the ostensible headliners, Television fronted by a very youthful and awkward-looking Richard Hell. They were sort of experimental and the twin guitarists were certainly trying to make some kind of statement. Though what it was I wasn't sure. Bear in mind that this was 1974.

The middle act certainly struck me as being very short on rock 'n' roll sexual allure, which I considered a distinct drawback. In fact, they struck me as the least attractive act I had witnessed to that point. I didn't quite know how to assimilate the ridiculously short barrages they served up. Like the rest of the world I wasn't quite ready for the Ramones but within a couple of years I was an avid convert.

The Ramones
New York City. 1979

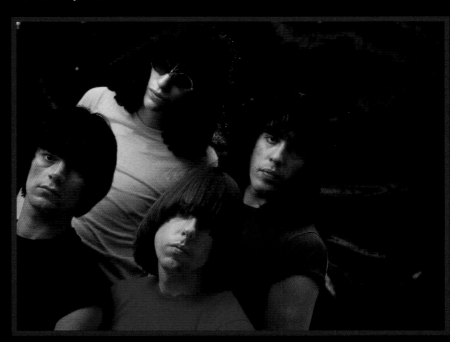

LIKE THE THIRD ACT WHICH AS I RECALL WERE
ACTUALLY THE FIRST TO PLAY, THEY SEEMED LIKE
SOME TRASHY PARODY. THIS COMBO POPPED OUT
LYRICS, WHICH SEEMED LIKE '50S TEEN ANGST,
B-MOVIE PASTICHES. MUSICALLY THEY WERE VERY
UNDISCIPLINED AND UNREMARKABLE. THE ONE
ELEMENT WHICH KEPT ME FROM COMPLETELY DIS-
MISSING THEM WAS THEIR TRASHY BUT ADORABLE
LEAD SINGER, WHOSE VOICE AND STAGE PERSONA
WERE LESS THAN DYNAMIC. FOR ALL HER INADEQ-
UACY, THERE WAS SOMETHING MEMORABLE ABOUT
HER. BUT OVERALL IT WAS PRETTY LIGHTWEIGHT
FARE. LITTLE DID ANY OF US IN THE MINIMAL AND
TEPIDLY ENTHUSIASTIC AUDIENCE DREAM OF HOW
THIS WOULD ALL EVOLVE...

THIS WAS MY FIRST EXPOSURE TO A BAND AND
PERSONA WHO WOULD INSPIRE GREAT ADMIRATION
IN ME WITHIN A FEW SHORT YEARS, THE FABULOUS
DEBBIE HARRY AND BLONDIE...

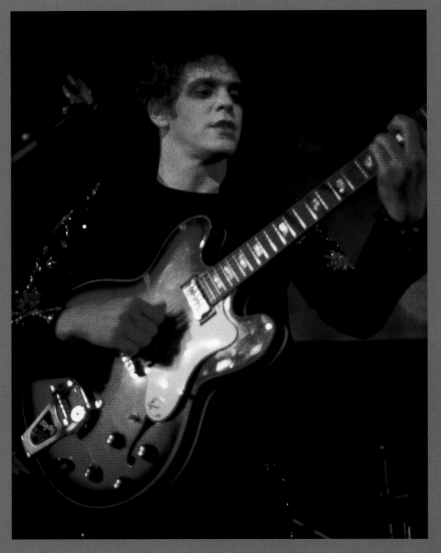

Lou Reed
King's Cross Theatre
London. July 1972

My next visit to New York came in the late summer of 1976 when Lou Reed, to whom I had been close since I shot the cover to his *Transformer* album in the summer of 1973. He flew me over to produce an album cover and collaborate with him on the TV backdrop stage design for his new album *Rock and Roll Heart*.

That was one of the more interesting autumns of my life…Lou never seemed to sleep. He obviously had much better things to do. We would work the craziest hours, pulling together esoteric, experimental, abstract imagery to festoon the myriad of TV sets that would be meaningfully arranged to augment his upcoming performances. For most of the tour he let me manipulate the moving plethora of feedback art in a checkerboard mosaic across the screens. Every gig we would blow out a set or two. We started the tour with 60 sets. There were 24 sets left standing at the end. In spite of the chaos of that experiment, it was in retrospect absolutely groundbreaking.

The very first time any TV or video backdrop was used in a live rock 'n' roll setting.

IN THE LATE SIXTIES AND SEVENTIES LOU WAS ALWAYS WELL AHEAD OF THE FIELD CREATIVELY. ONE OF MY MOST VIVID MEMORIES OF THAT PERIOD WITH LOU CAME AT THE END OF THE TOUR AFTER WE'D RETURNED TO NEW YORK. LOU DECIDED WE NEEDED TO HAVE 'A LITTLE PHILOSOPHICAL CHAT'. IT WAS MID-DECEMBER, THE STREETS OF MANHATTAN WERE THICK WITH SNOW AND WE WALKED 80 BLOCKS AT BREAKNECK SPEED. I CAN'T REMEMBER WHAT WE TALKED ABOUT, BUT THE STIMULANTS WERE FIRST CLASS…

A day or two later, I was again invited to CBGB's to check out a band whom my friend Ian Hunter had recently introduced me to called Tuff Darts.

They were providing support for Blondie.

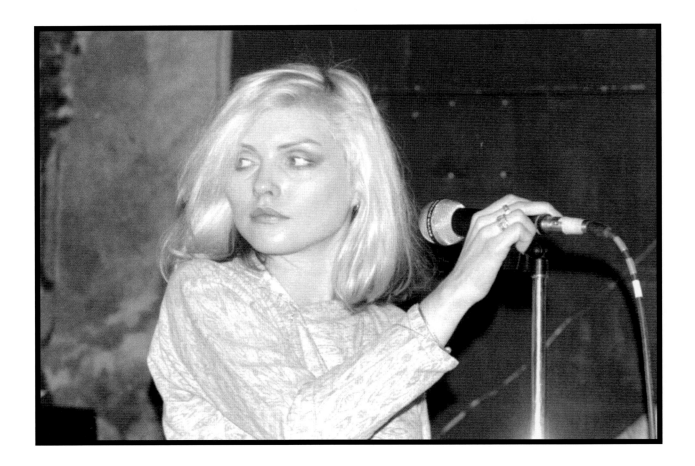

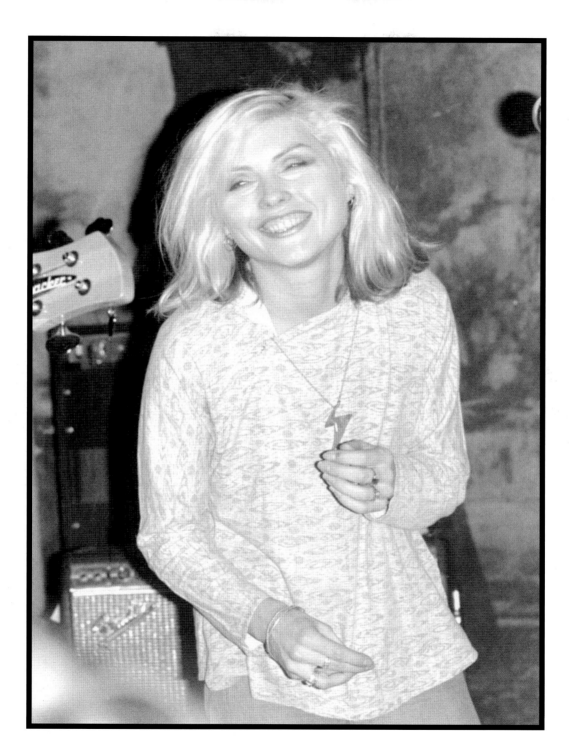

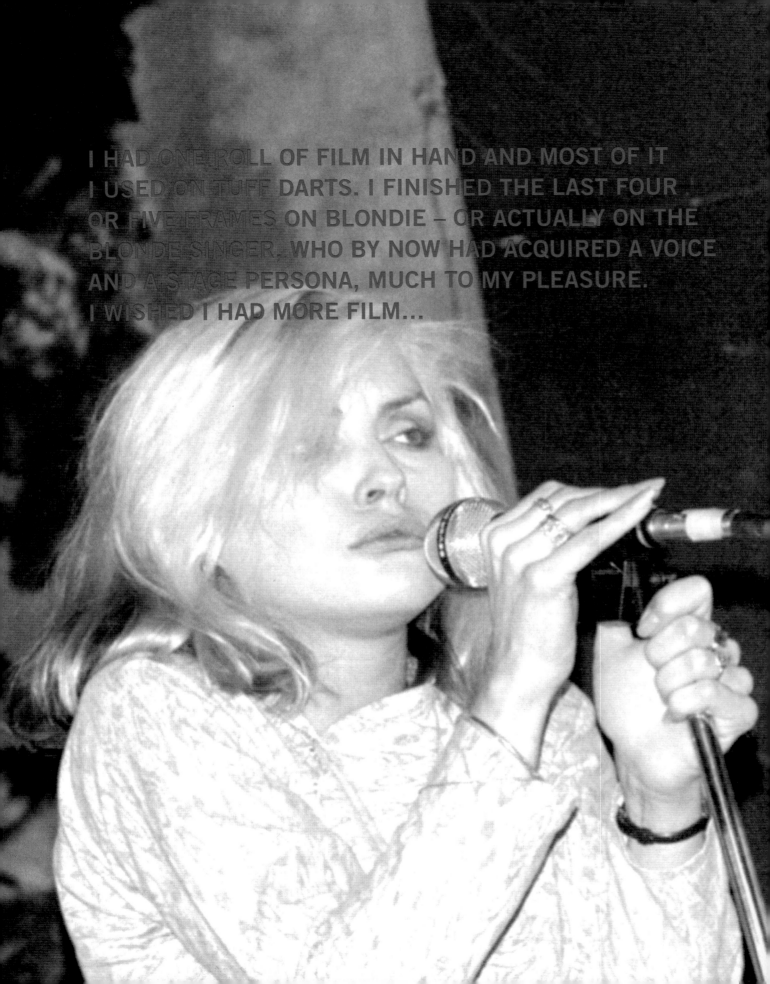

I HAD ONE ROLL OF FILM IN HAND AND MOST OF IT
I USED ON TUFF DARTS. I FINISHED THE LAST FOUR
OR FIVE FRAMES ON BLONDIE – OR ACTUALLY ON THE
BLONDE SINGER, WHO BY NOW HAD ACQUIRED A VOICE
AND A STAGE PERSONA, MUCH TO MY PLEASURE.
I WISHED I HAD MORE FILM...

MALCOLM MCLAREN HAD ALREADY ENLISTED MY EYE
TO TAKE THE FIRST PHOTOS OF THE SEX PISTOLS IN
THEIR FIRST EVER PERFORMANCE AT THE CHELSEA
ART COLLEGE CHRISTMAS PARTY IN DECEMBER 1975.

Sex Pistols Live
London. December 1975

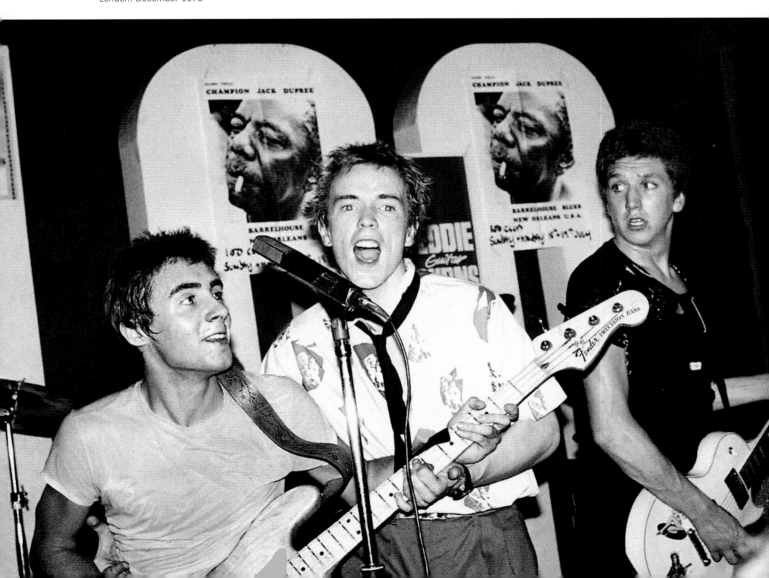

I REMEMBER HE PAID ME WITH A FEW PAIRS OF RACY UNDERWEAR FROM HIS NEWLY NAMED SHOP, SEX, IN LONDON'S WORLD END!!!

On my return to London in the winter of 1976/77, I shot Johnny Rotten, Paul Cook and Steve Jones (on the day Glen Matlock left the band) for the German magazine *Stern*. Outside of England no one really knew what the Pistols looked like, so we were able to substitute a side view of one of the bank roadies to pretend there was a complete band...and *Stern* published the photos in February 1977. Later that year a solo image of Johnny became the October cover of *High Times* magazine, the Pistols first US magazine cover.

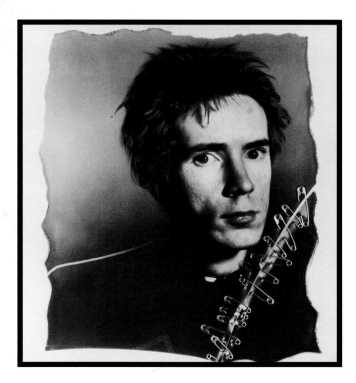

Johnny Rotten
High Times magazine cover. 1977

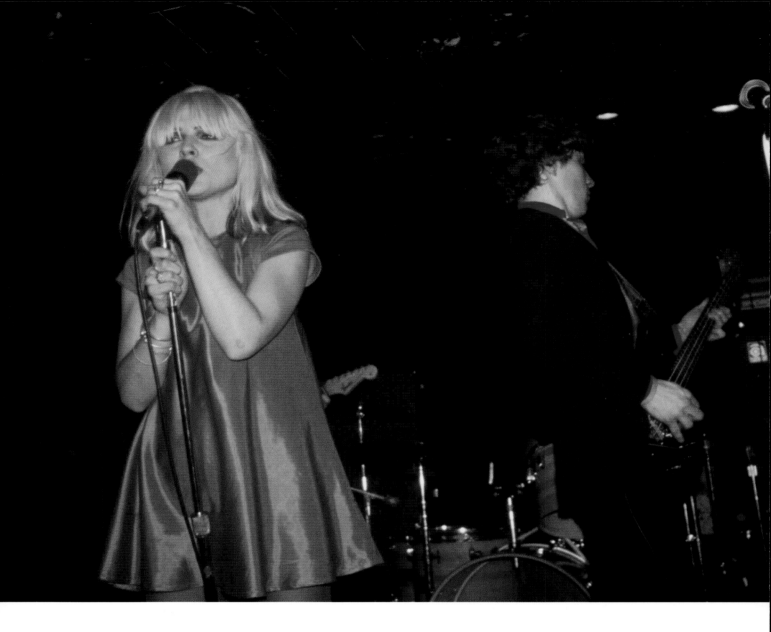

MY NEXT ENCOUNTER WITH BLONDIE OCCURRED
IN MARCH 1977 AT MAX'S KANSAS CITY.

A FRIEND INVITED ME TO MEET ANDREW LOOG OLDHAM – THE ORIGINAL 'BOY WONDER' MANAGER/PRODUCER OF THE EARLY ROLLING STONES, WHO HAD RECENTLY TAKEN A BAND FROM TEXAS CALLED THE WEREWOLVES UNDER HIS WING AND WANTED TO TALK TO ME ABOUT WORKING WITH THEM. HE HAD LIKED THE RECENTLY RELEASED FIRST BLONDIE ALBUM, PRODUCED BY HIS FRIEND RICHARD GOTTHERER. ANDREW THOUGHT THE BAND STILL HAD A 'WAY TO GO', LIKED DEBBIE'S BABY-DOLL DRESS ATTIRE, BUT WAS IRRITATED BY THEIR BASS PLAYER, GARY VALENTINE.

Andrew called him a 'stage hog' and accused him of trying to upstage Debbie. 'He's only the bloody bass player. He needs to play better and be seen less. Bill Wyman could teach him a thing or two in those departments.' Of course, Gary would depart the band in July 1977, so maybe Andrew's point was well made... It should be noted however that before he left Gary did contribute one memorable and durable song to the Blondie repertoire, (I'm Always Touched) By Your Presence Dear... Blondie's very first single.

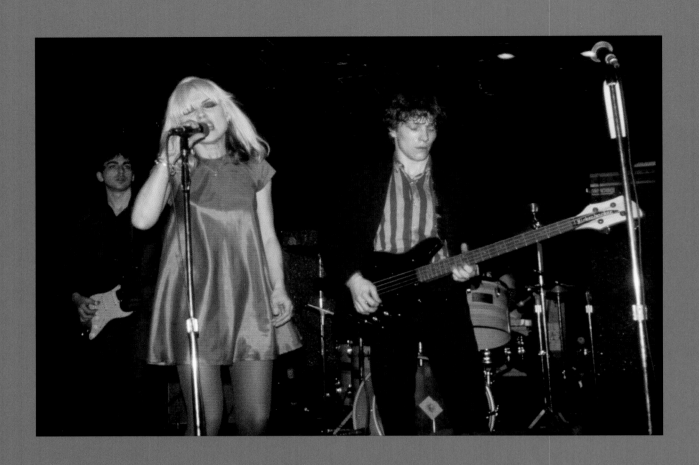

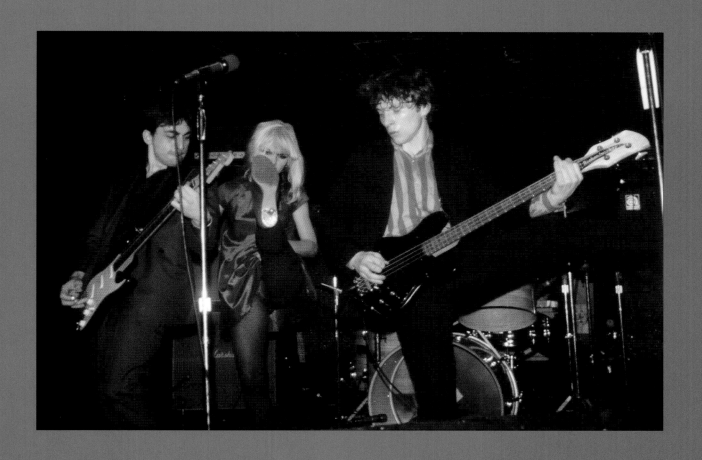

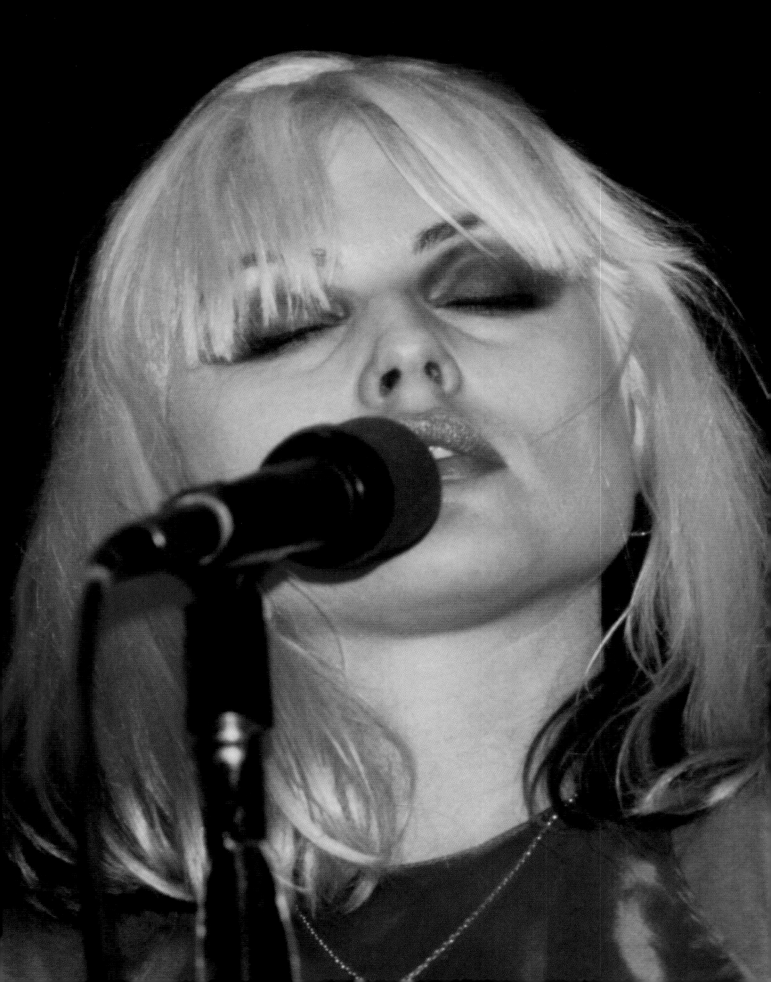

AGAIN, I DON'T REMEMBER MUCH ABOUT THE
MUSIC BUT I RESPONDED STRONGLY TO DEBBIE'S
LIBIDINAL PULL.

I KNEW THAT THIS WAS SOMEONE I COULD DO
SOME MAGIC WITH PHOTOGRAPHICALLY.

THIS MOMENT WAS STILL OVER A YEAR AWAY
HOWEVER...

In the meantime, Blondie released their second album *Plastic Letters*, which had minor impact in the US, but provided them with their first UK hit Denis, and over the next year they became stars in my home country.

THEY BEGAN THE PROCESS OF ESCAPING THE CONFINES OF THEIR DOWNTOWN NEW YORK 'PUNK' IMAGE, WHICH WAS NO GREAT LOSS TO THEM SINCE THEY HAD BEEN AFFORDED LITTLE RESPECT OR CREDIBILITY ON THEIR HOME TURF. WHAT THEIR DEVELOPING AUDIENCE RESPONDED TO HAD NOTHING TO DO WITH 'PUNK' AND EVERYTHING TO DO WITH DEBBIE'S SEXUAL ALLURE. IN MANY WAYS THEY HAD BEEN REGARDED AS THE LEAST LIKELY TO SUCCEED OF ALL THE DOWNTOWN ACTS.

Patti Smith, Television, Talking Heads and the Ramones: these were all the acts that garnered all the critical acclaim.

Blondie were regarded as strictly lightweight on their home turf.

Everything changed the following year with the release of *Parallel Lines*, the perfect album at the perfect moment. It smashed all the labels wide open and put a new phrase 'power pop' on the critics' typewriters. After that they owned the world. *Parallel Lines* was released in September 1978 and it was the promotional push for the album that finally connected the divine Ms Deborah with my Hasselblad.

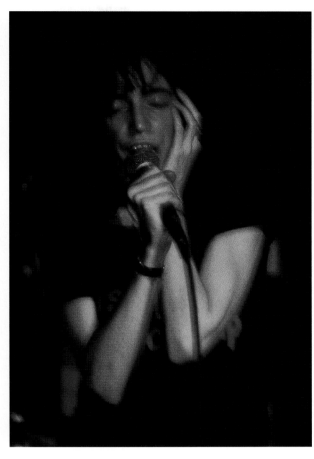

Patti Smith
New York City. 1976

I had been spending increasing amounts of time in New York, although I still maintained my house and studio in London (and would do so until my first wife divorced me in 1982). The allure of New York was beginning to overwhelm me. London was exciting, but New York at this period was something that will never be repeated.

Because of my associations – especially with Lou Reed, Bowie and Iggy – all imaginable temptations were open to me and I leapt in with all the unbridled fervor of a wide-eyed reprobate.

Remember, this was a pre-AIDS era and chemicals and sexual experimentation were regarded as de rigueur for young men who naively regarded themselves as cultural outlaws. Illicit and depraved was good; everything else was boring.

THE LUST FOR THE 'ALTERED STATE' WAS OVERWHELMING.

I stretched the limits of my nervous system by mixing large doses of yoga, sleep and food deprivation, sex and certain chemicals.

And I had fun.

Lots of it.

I found that lower Manhattan was the perfect playground.

It was all here – and I forgot about London, my house, and my wife and strode headlong into the blissful abyss.

So I was in a prime creative nervous state in that autumn of 1978.

In my early New York peregrinations I had come across a brilliant art director called Rowan Johnson. He was in a constant state of intoxication, as were almost all of my acquaintances in that period. But it certainly didn't impair his creative faculties. He was very energized, lots of fun. I remember one dawn after all-night partying: he opened up completely to me and related how his father had committed suicide by shooting himself in the head right in front of his eyes when Rowan was a teenager. He tossed it off almost casually with a laugh as he stated, 'I never liked him anyway'. This revelation struck me profoundly. Just the idea of it...surely it would shock anyone. This is probably why in spite of many later attempts at rehab, he eventually ruined his liver and died of a heart attack in the early '90s. I remember he spoke of how his father's brains and blood splattered his clothes and how he had to clear the mess up and let his mother know. He had always struck me as so carefree, but after this I viewed him with a sense of empathy and sadness.

Rowan worked on a fashion magazine called Viva, which was owned by Bob Guccione. Guccione's main publication *Penthouse* generated a lot of money at this period. Viva was without doubt a publication ahead of its time thanks in no small part to Rowan's great visual flair. Helmut Newton shot fashion for them on occasion. Helmut was friendly with Jerry Hall. Jerry set up a meeting for Rowan and Helmut to present Mick Jagger and Charlie Watts with some ideas for the upcoming Stones album *Some Girls*. Helmut, with his startling injection of the erotic into high fashion was the hottest photographer in the world in the late '70s. Rowan related how he and Helmut went to Mick's suite at the Plaza and how he (Rowan) had hit the room with a hands-on-hips strutting parody rendition of the first few lines of Sympathy for the Devil. Mick, apparently was not amused...Helmut laid out his idea for the cover: 'I will shoot a close-up of your groin area, in very tight leather trousers, with a lady's hand coming up between your legs and gripping your balls very, very firmly. This is the only thing I want to shoot.'

This take it or leave it attitude did not endear him to Mick and wasn't helped by Rowan's piss-take entry. 'We never heard from him or Charlie again,' laughed Rowan.

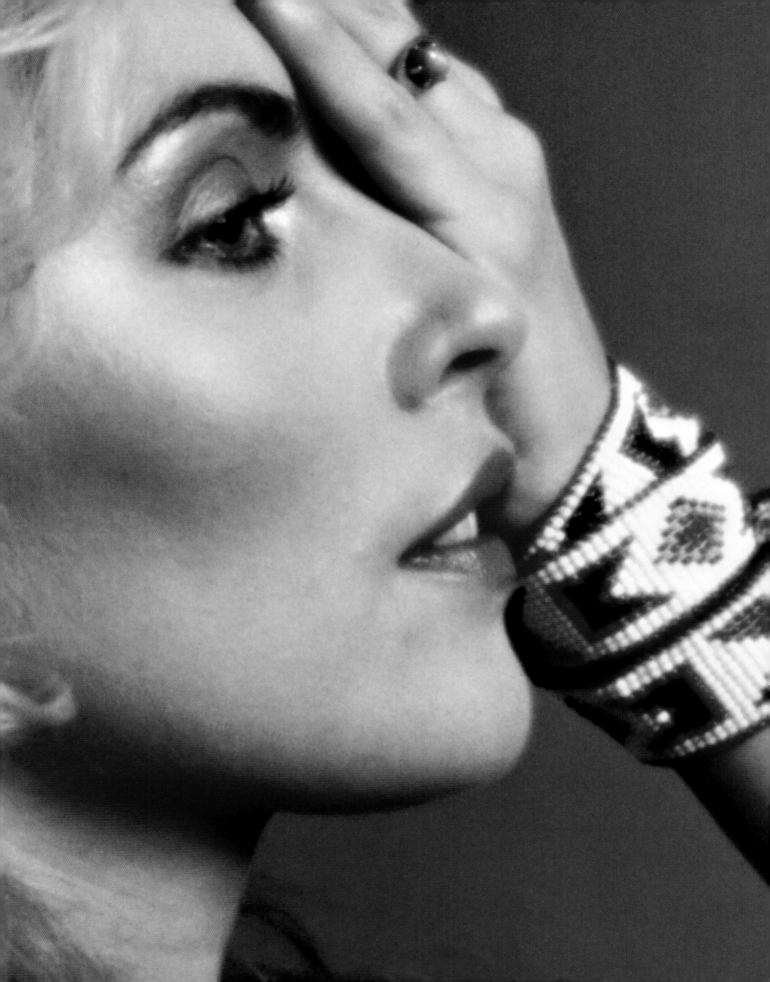

Viva had bought an interview with Debbie and needed photos to illustrate it. Rowan rightly decided that she and I would be the perfect match. Blondie had already toured England as the support act to Iggy Pop on the release of his album *The Idiot*. David Bowie had produced the album and played keyboards as back up musician on the tour.

DEBBIE AND CHRIS STEIN KNEW MY WORK AND WERE APPARENTLY INTRIGUED BY THE PROSPECT OF THE SESSION. DEBBIE'S ONLY STIPULATION WAS THAT SHE BE ALLOWED TO WEAR WHAT SHE LIKED.

Her favorite designer was the very young (and then still obscure) Stephen Sprouse, who designed and styled her especially for this session. Rowan's only brief was that I set some of the photos to the left or right of frame to allow him to run text on the photo itself. He had no interest in being at the session. He decided that he would be a distraction, which was probably true. Anna Wintour (now the editor-in-chief of *American Vogue*) was the magazine's fashion editor. Her only contribution (but an important one) was to supply me with a make-up artist. 'She'll be perfect for Debbie', she told me of Sharon Slattery. And she was right. Sharon would work with me on a number of sessions over the next few years with subjects as diverse as Carly Simon and the Ramones. She also became a hangout pal during this first phase of my crazy love affair with New York. I worked a lot in those years, which in spite of (or because of!) my attachment to an extreme lifestyle was by any standards very successful. Sharon also shared the same taste for inebriation, and was also successful, until like many of my compadres from that period she also flamed out in the '80s.

But that came later...

This was 1978 and we were all still flying high and wild, married to the overcharged trifecta of 'sex, drugs and rock 'n' roll'.

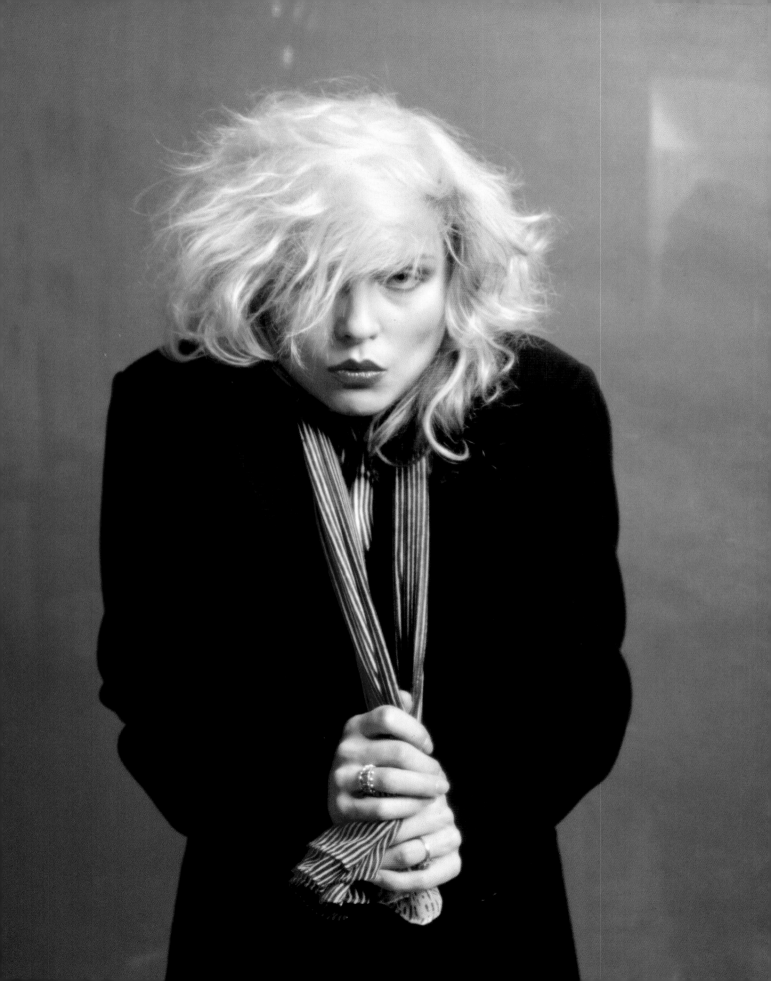

WE WERE ALL
MARRIED TO THE
OVERCHARGED
TRIFECTA OF
'SEX, DRUGS AND
ROCK 'N' ROLL'

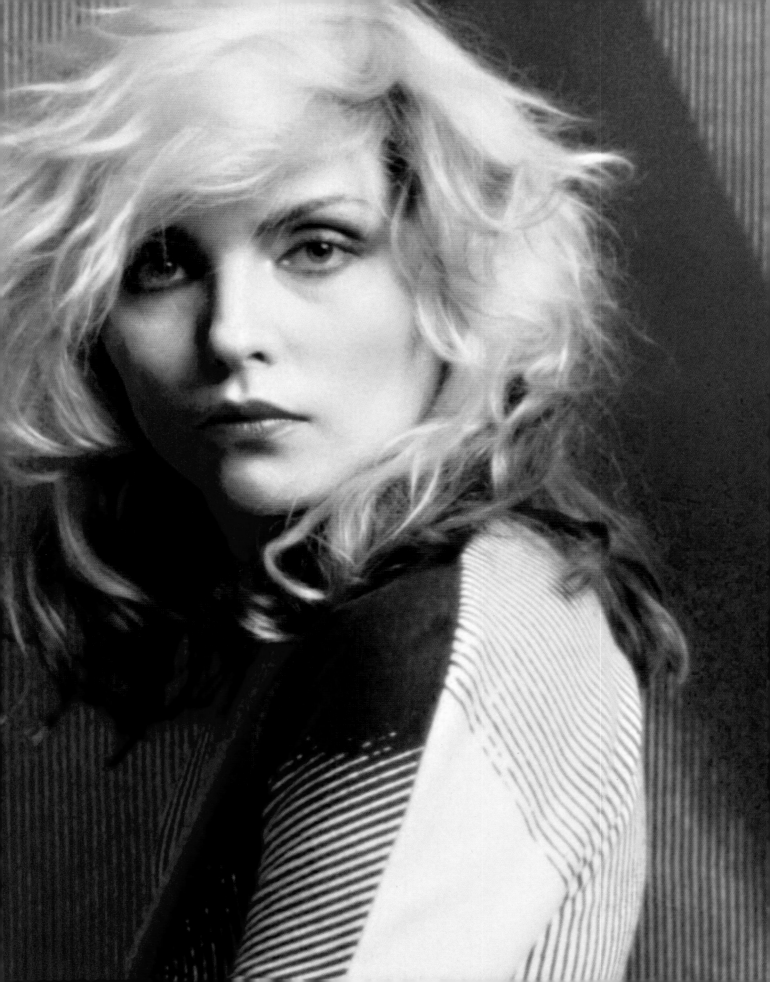

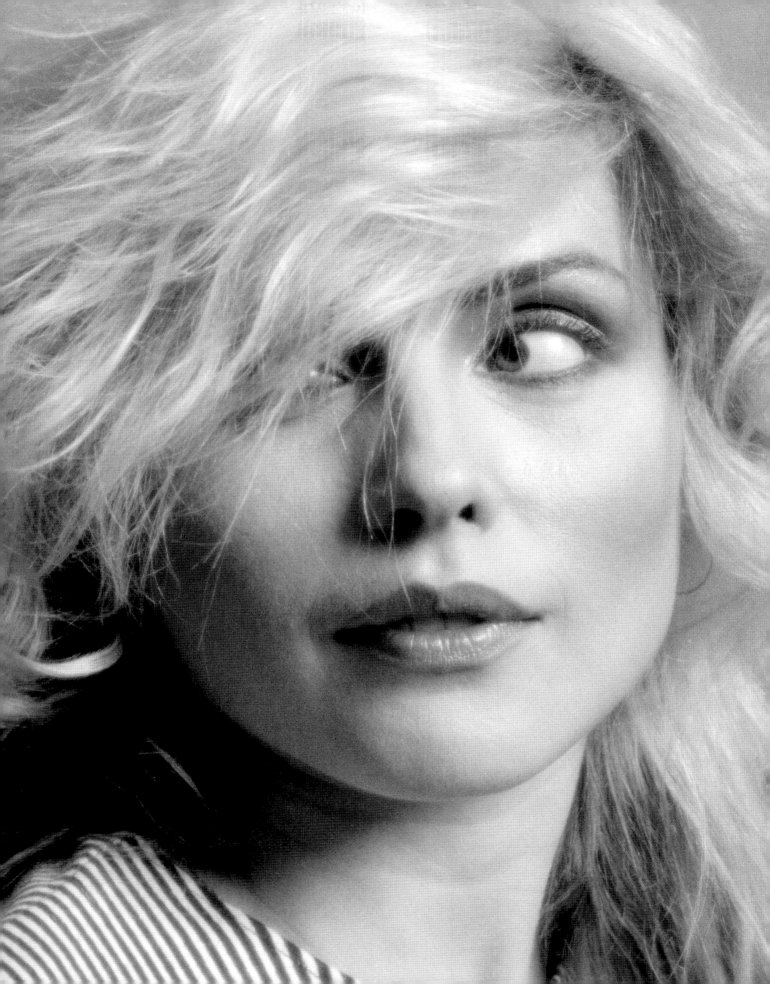

I had recently moved into a small loft on 21st Street between Park Avenue and Broadway, which served as both a living space and studio. It had an elevated sleeping space with a large, enclosed storage cupboard underneath. The back of the loft was a living/dining area. The front, as you came in through the door, I used as a shooting space. It had two huge mirrors, which made that part of the loft seem larger than it actually was.

It had previously belonged to a fashionable hairstylist, who had run a successful private salon in this front part, until his own chemical habits had devoured his income and attention and forced him to give up the premises. The writing was, as it were, in the walls, but I was too blinded by the delights of New York and the wild side, to heed any of the signs.

THIS WAS THE DAY OF STUDIO 54 AND THE MUDD CLUB AND ROCK 'N' ROLL HEDONISM RUN BERSERK.

THE ONLY PEOPLE I MADE SERIOUS CONTACT WITH WERE IN THE CREATIVE COMMUNITY AND THEY ALL SUBSCRIBED TO THE SAME HABITS OF SENSUAL EXCESS.

While I was not organically part of the local hip downtown scene, I was readily embraced by its' denizens because I came with all the right credentials. I had, after all, provided the images for the album covers of two of New York's fave rock 'n' roll personae, Iggy & The Stooges *Raw Power* and Lou Reed's *Transformer* (plus *Coney Island Baby* and *Rock and Roll Heart*), and shot the first photos of the Sex Pistols. By the winter of 1978 I had also taken the photos for Talking Heads first album.

Later I would shoot covers for the Ramones and Dead Boys.

I had been primed by London's glam and early punk scenes and had an instinct for the cutting edge which I would follow wherever it led me...

Dead Boys
Miami. January 1978

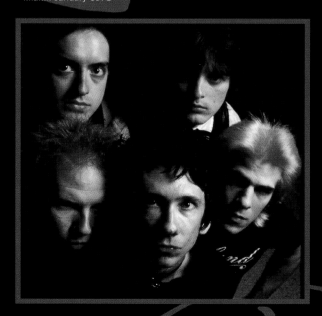

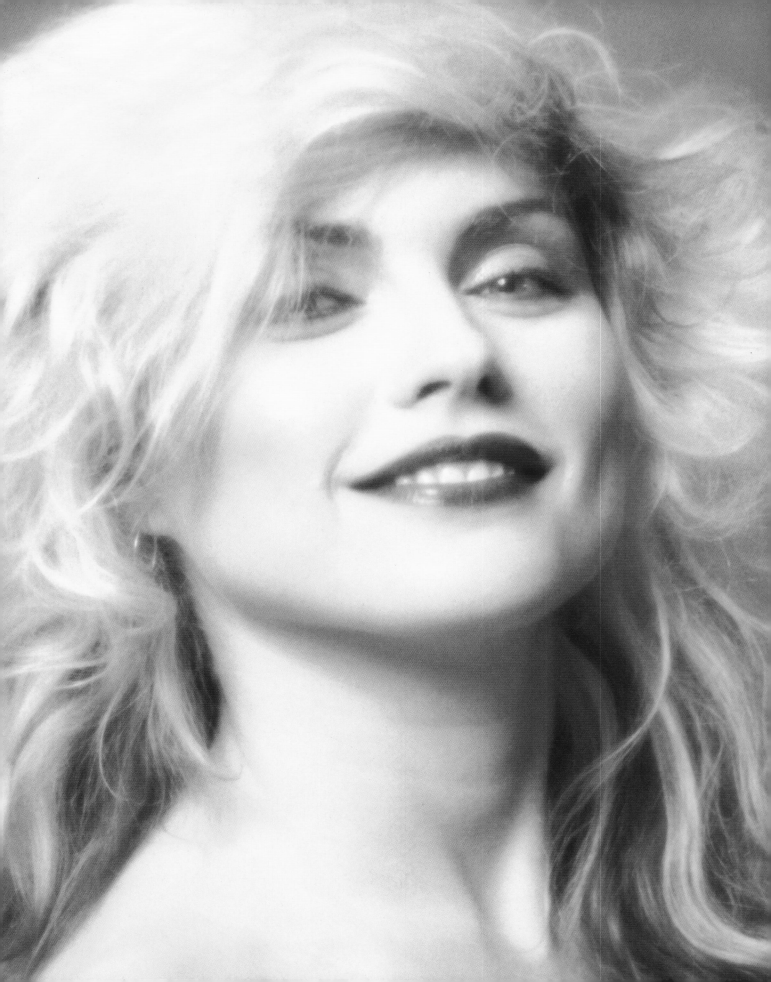

Chris Stein accompanied Debbie and Stephen Sprouse. He was after all her boyfriend and was curious (he said) to watch me at work. He was, I was well aware, something of a lensman himself. He had worked for *Rock Scene* magazine and had shot the best early punk images of Debbie. The rumors were that he had some kind of 'svengali' grip on Debbie, so I was unsure of how much he might try to impose his opinion on the session. In fact, he was very low-key and offered only quiet encouragement. Stephen Sprouse hung out for a while and helped Debbie with her first outfit, but departed soon after. Sharon Slattery delivered a hot mixing of reds and gold laced with a little blue around the eyes, and helped Debbie backcomb her hair into a very full mane. The result pumped me. Although 'punk Marilyn' was a phrase that attached itself to her image, I saw very little punk and lots of Marilyn when I viewed her through the lens of my Hasselblad, although if I was channeling anyone it was more probably George Hurrell lensing Jean Harlow.

DEBBIE WAS MORE GLAM THAN PUNK, AS THE PHOTOS TESTIFY.

Certainly I was absolutely consumed for the next three hours with the delectable apparition that flowed onto the film. It wasn't so much about her sexuality (although she was and remains to this day, eternally sexy), it's just that this neat little lady with a head just a touch too large for her body, exuded a delirious sweetness and vulnerability which was so absolutely stunning. It was only when I viewed the first few test Polaroid's that I fully appreciated what a visual gem she was, what an absolute gift to photographics.

The thousands of images produced by so many photographers over the years provide ample evidence that it's impossible to take a 'bad' photo of her. In person she was certainly very attractive, but filtered through a lens she transforms into a completely magical, almost mythical creature – and notwithstanding all the other great pix of her, the passage of time has proven this particular shoot to have been something very special. She never registered more 'Marilyn' than she did this special afternoon in November 1978. This was and remains a session for the ages, I humbly submit...

ALTHOUGH 'PUNK MARILYN' WAS A PHRASE THAT ATTACHED ITSELF TO HER IMAGE, I SAW VERY LITTLE PUNK AND LOTS OF MARILYN

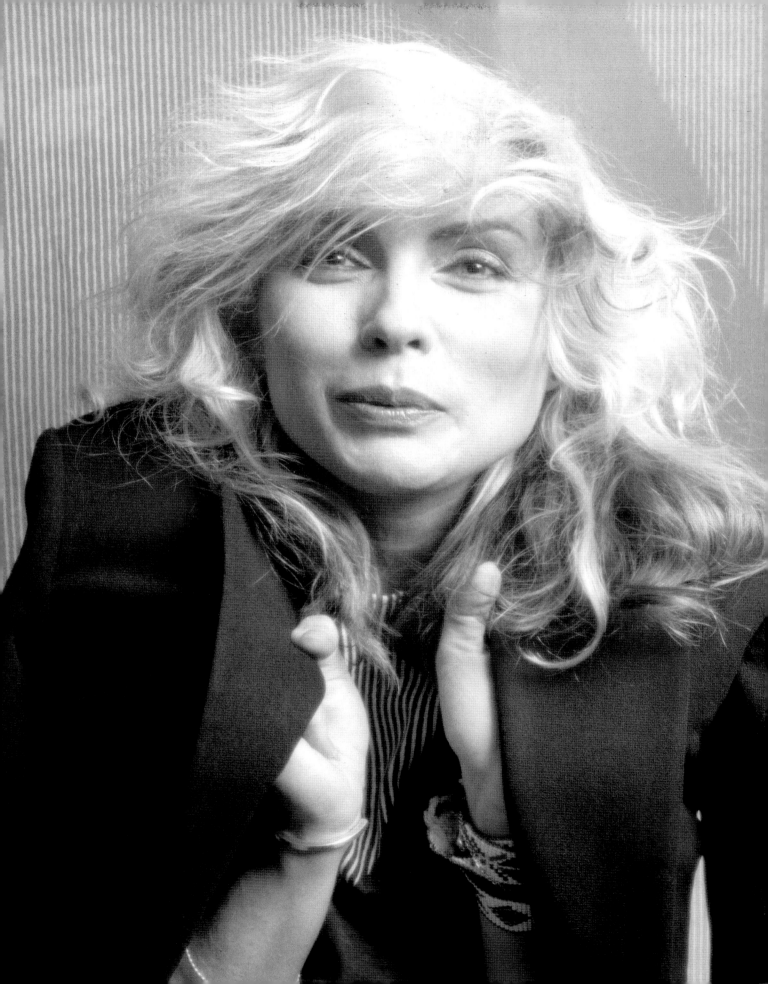

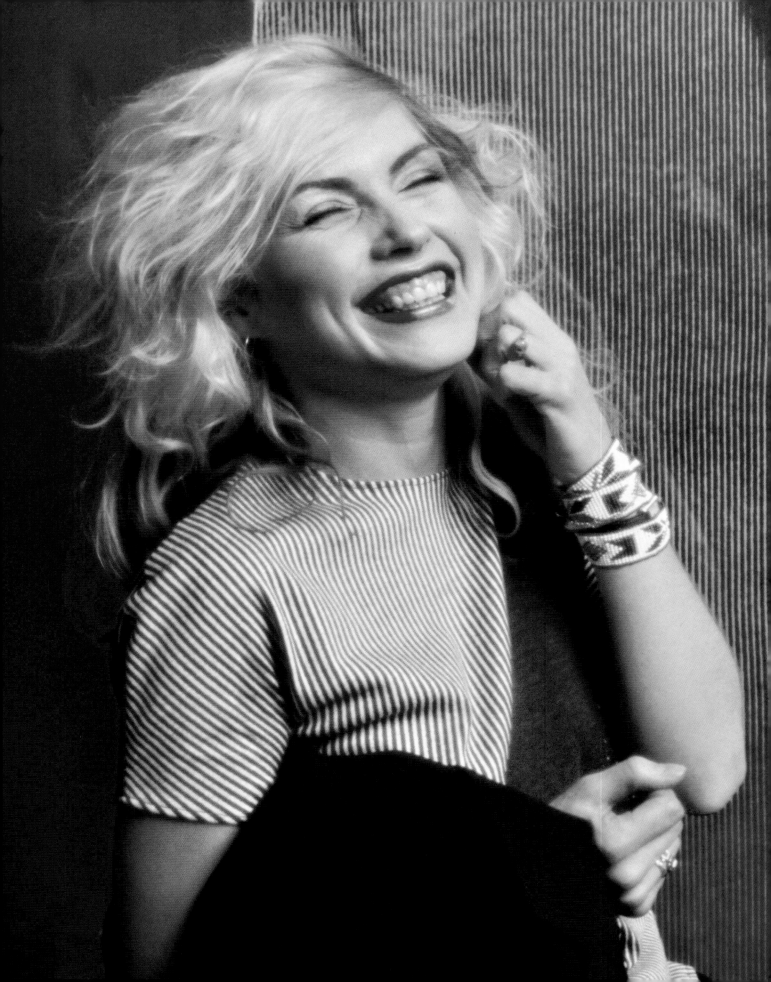

I was also struck by how unattached she seemed to her very exceptional physical beauty. It was only later that I learned that she was already over 30 at this first session, yet she seemed so fresh and untouched. I would also later learn she had already lived through about of serious attachment to heroin, which had uncannily left not a mark on her physical being. There are quite a few frames that reveal her easy sense of humour and spontaneity.

"Women are never disarmed by compliments, Men always are." OSCAR WILDE

THERE'S NOTHING FORCED ABOUT HER RELATIONSHIP WITH THE CAMERA.

SHE CLEARLY WASN'T TAKING ALL THE SHOWERING OF ATTENTION ON HER PHYSICAL CHARMS TOO SERIOUSLY.

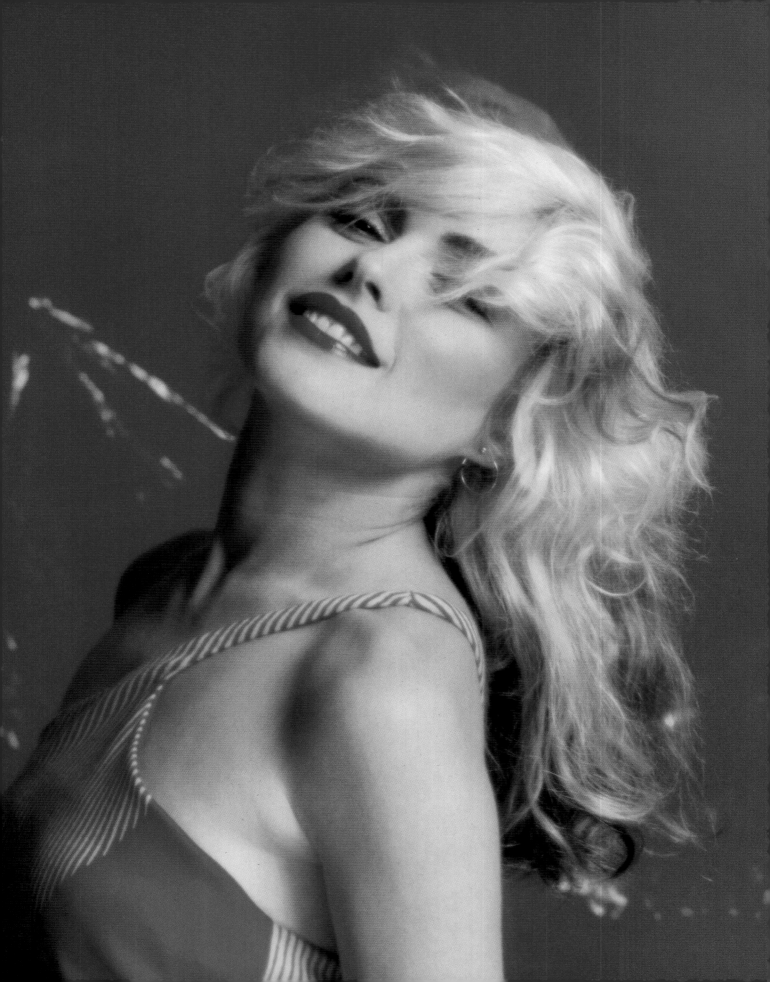

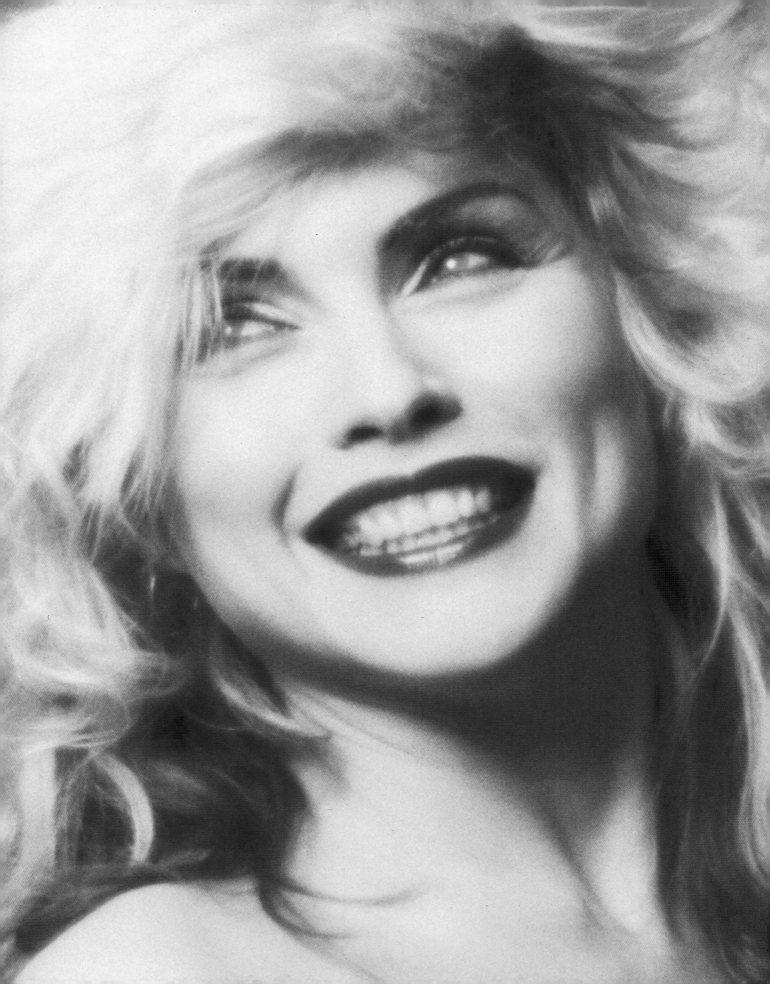

I quickly discovered that far from being an interfering 'svengali', Chris Stein was very appreciative of what he was witnessing. Debbie was obviously having a good time, and he seemed to enjoy my somewhat manic high-wire energy and the obvious enthusiasm with which I was treating his lady. He had only encouraging comments about the test Polaroids: 'that's a great expression', 'I love the makeup', 'your hair's very cool'.

I used a very slight diffusion filter on most of the close-up frames. I emphasized the silky 'Marilyn' quality of the red shots by using a slight warm filter. When I changed the background to blue, I enhanced the coolness with a mild blue filter. I also placed a large piece of Plexiglas in front of the backdrops, to add a sense of depth and texture. You can clearly see some reflections and shapes. For some of the blue frames, I draped the scarf supplied by Stephen Sprouse between the Plexi and the backdrop.

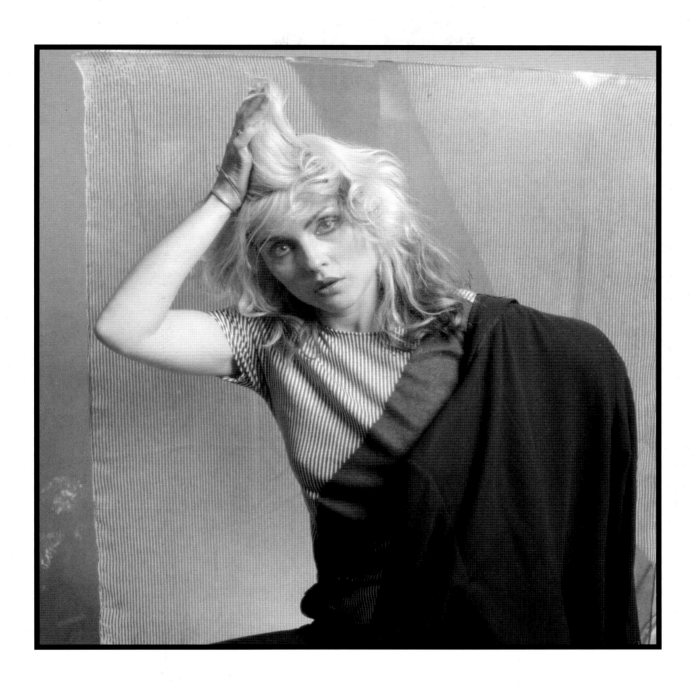

CERTAINLY THE PUNK AESTHETIC WAS FAR FROM OUR MINDS THAT DAY, THE ONLY FACTOR THAT WHISPERED 'PUNK' OR 'TRASH' WAS THAT YOU COULD QUITE PLAINLY SEE HER ORIGINAL HAIR COLOR (BROWN) LAYERED AT THE BACK OF HER HEAD. ALLOWING THE ROOTS TO SHOW HAS OFTEN BEEN A TRADEMARK OF DEBBIE'S. ALTHOUGH SHE CLAIMS IT WAS ORIGINALLY BORN OF CONVENIENCE RATHER THAN FROM A DELIBERATE AESTHETIC. 'WHEN MY HAIR IS LONGER, IT'S TOO MUCH WORK TO KEEP IT DYED BLONDE ALL OVER, ESPECIALLY WHEN I DO IT MYSELF – WHICH I OFTEN DO. I'M A LITTLE LAZY ABOUT IT, BUT I FOUND THAT PEOPLE REALLY LIKED IT, SO…'

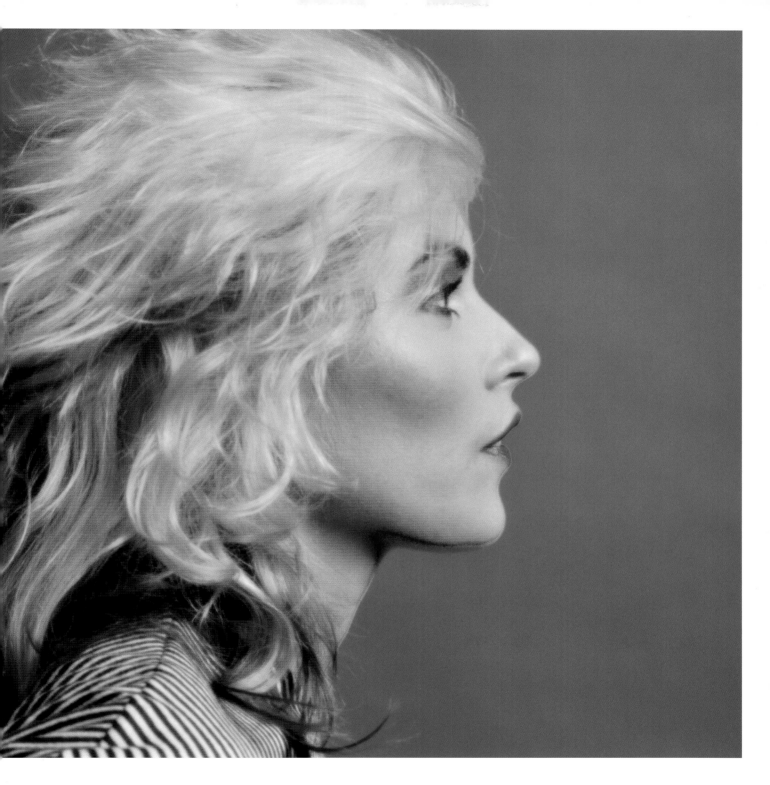

This day Debbie was a far cry from the trashy downtown tart I first witnessed in 1974. She was no longer a prisoner of the punk ethos. What I responded to that day, was the power pop princess. She had evolved into a presence for the ages. She was the first female rocker to embrace something of a classic celluloid aura – a la Harlow or Monroe. And she knew how to work it...

Everyone loved the results – Debbie, Chris, and the magazine.

I was bowled over by them.

I knew that something special had happened, but the pictures were maybe even more than I had hoped for.

Rowan immediately pulled what he regarded as the prime blue shot and had a dye transfer made. This was the most expensive print available of the pre-digital era, which could be most easily manipulated and retouched if necessary. On review we realized that what the film had captured was perfect and no reworking was necessary. The shoot had happened at the last minute and there was some haste to get on with the layout. In fact, by this time most of the magazine was already prepared for the printer. But just as the issue was about to go on the presses, I received a call from an unusually deflated Rowan. Apparently for all its innovative strength, *Viva* had always lost money. It was very admired within the publishing community but had never been able to establish a substantial enough readership and Bob Guccione had decided to put it out to pasture.

It was unfortunately at least 20 years ahead of its time. It would surely have been very successful in the much broader modern market.

SHE WAS THE FIRST FEMALE ROCKER TO EMBRACE SOMETHING OF A CLASSIC CELLULOID AURA

Viva paid the expenses for the session, but at this stage I received no fee since that depended on the publication of the photos. Since I technically owned the photos and the magazine had no plans to use them, I was able to do as I wished with them. In the '70s, the media market was much more limited than today.

Every photographer on the scene pursued Debbie and since she was by nature amenable and understood that her face helped sell the band and its music, there was a flood of images available. I made a couple of sales here and there of the 'red' shots – one used by Chrysalis Records for a European release of Sunday Girl. But mostly the photos sat in my files until late 1979 when Bob Guccione decided he wanted to run the interview. By now the band had been elevated to superstar status. *Parallel Lines*, fueled by a string of hit singles, especially the proto-disco mega-hit *Heart of Glass*, was a multi-platinum album.

Earlier in the year *Penthouse* had featured Donna Summer on the cover. Donna was at the peak of her popularity and the issue sold better than the scantily clad nymphets who traditionally adorned their covers. So Bob decided that he would try again with Debbie. Rowan sold him on the 'blue' shot, which he had originally zeroed in on, and so finally it appeared in February 1980, fifteen months after the session. When Debbie heard, she fell about laughing, totally amused that she would appear on the front of a skin magazine, clothed in black up to her neck; other than her face and hands, not a centimeter of skin was to be seen.

IT BROKE ALL THE RULES OF MEN'S MAGAZINES.
IT WOULD NEVER EVER BE CONSIDERED FOR TODAY'S
'LAD' AND 'ROCK' PUBLICATIONS, FOR WHOM THE
FLESHY FEMALE CURVES ARE MANDATORY.

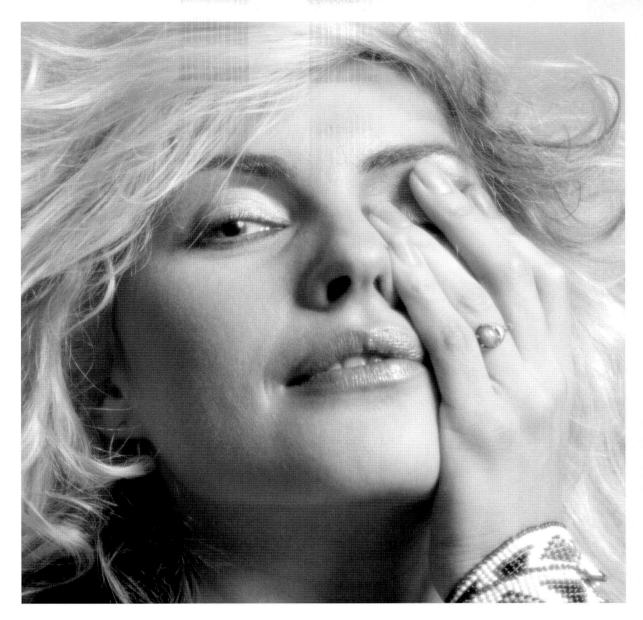

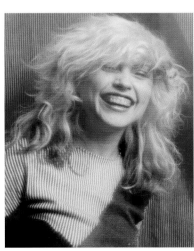

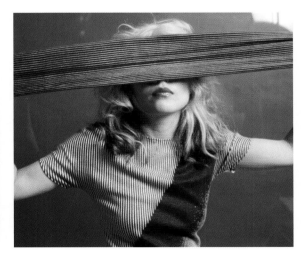

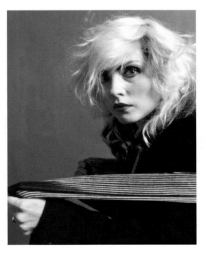

IT IS CERTAINLY A VERY SEXY PHOTO BUT ALL THE SEX IS IN THE EYES, LIPS AND THE HANDS. IT WAS A GESTURE I HAD LEARNED FROM LINDSAY KEMP, THE AMAZING AND INNOVATIVE MIME/CHOREOGRAPHER WHO HAD TAUGHT DAVID BOWIE ALL ABOUT THE POWER OF GESTURE IN STAGECRAFT AND IMAGE PROPAGATION. I HAD THROWN IT TO DEBBIE IN THE THICK OF THE SHOOT. SHE HAD MIMICKED IT PERFECTLY.

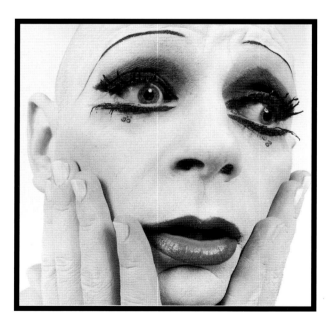

Lindsay Kemp
1974

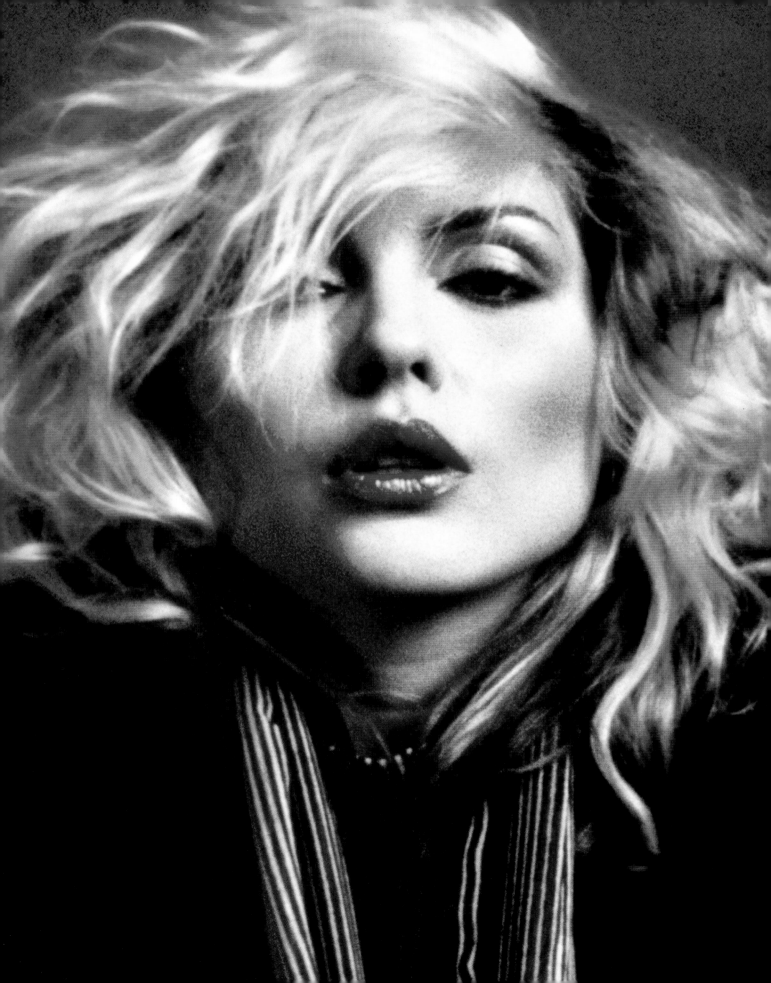

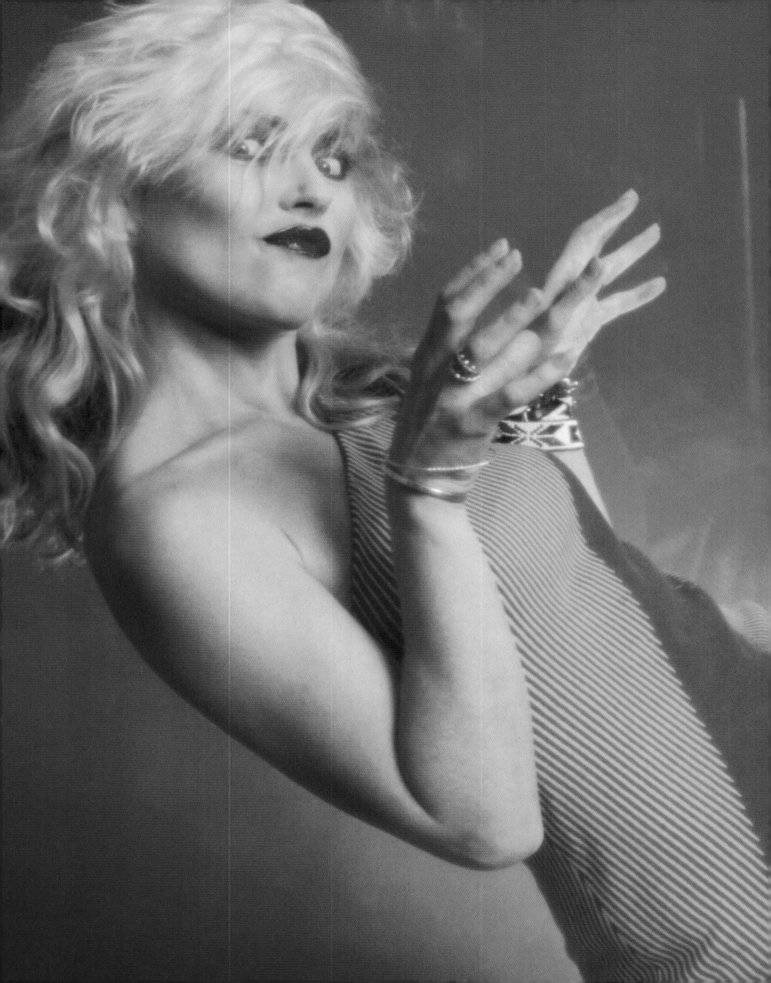

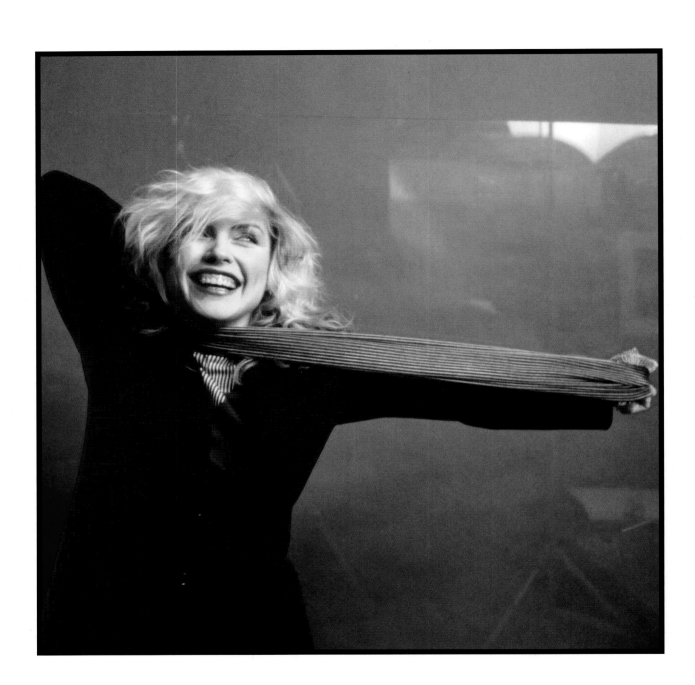

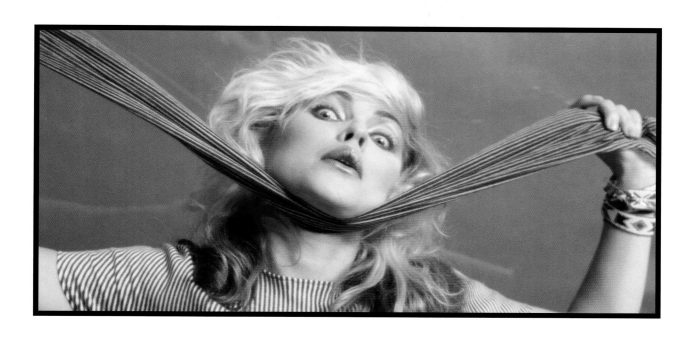

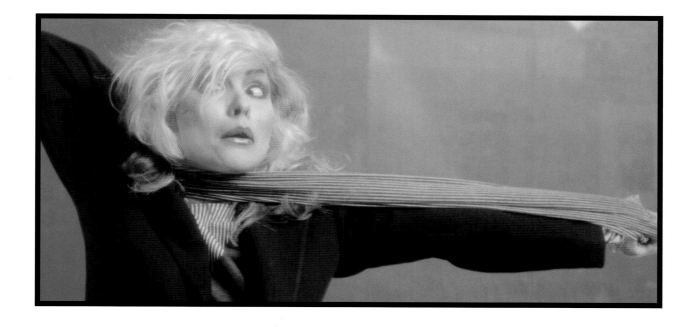

IT'S THE FIRST TIME THIS PARTICULAR IMAGE HAS BEEN PUBLISHED SINCE THE PENTHOUSE COVER. AND IT MUST BE SAID, IT STANDS THE TEST OF TIME. IT REMAINS ONE OF MY ALL TIME FAVE IMAGES, AND, I DARE TO CLAIM, ONE OF THE BEST EVER TAKEN OF DEBBIE. 'ONE FOR THE AGES', AS LESTER BANGS, THE LONG DEAD LEGENDARY ROCK CRITIC ONCE TOLD ME. 'I'VE HAD WET DREAMS OVER THAT PIC. IT STIRS ME DEEP IN MY PRIVATE PARTS...'. THAT'S ONE MAN'S OPINION OF COURSE, BUT HE HAS A POINT.

Lester used another frame from the session – a 'red' one for his 1981 unauthorized account of the rise of the band, Blondie. Like certain of my early photos of Syd Barrett, David Bowie, Lou Reed, Iggy Pop, Queen and Johnny Rotten, this stands as a definitive session. The *Penthouse* cover and Lester's book cover have assumed iconic status.

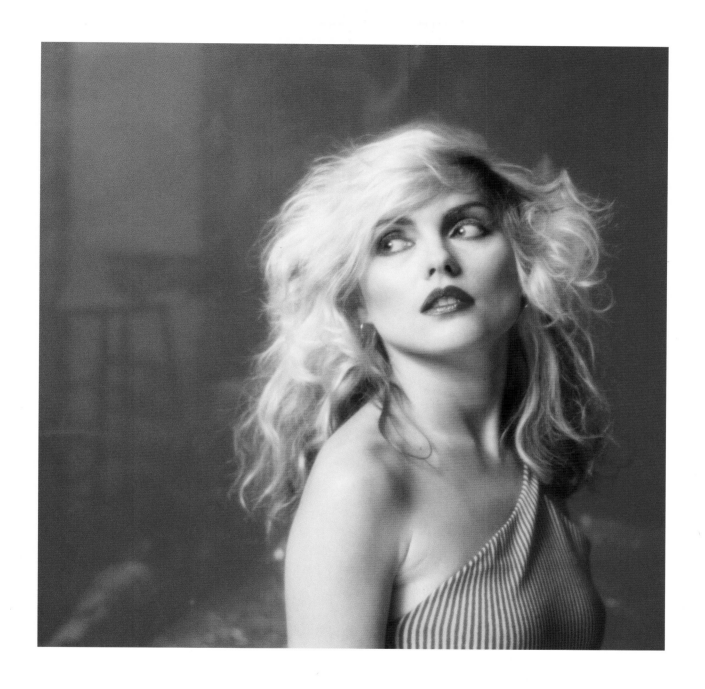

"There is a rare kind of beauty, whose rhythm can propagate symbols and simulate dreams."

REMY DE GOURMONT

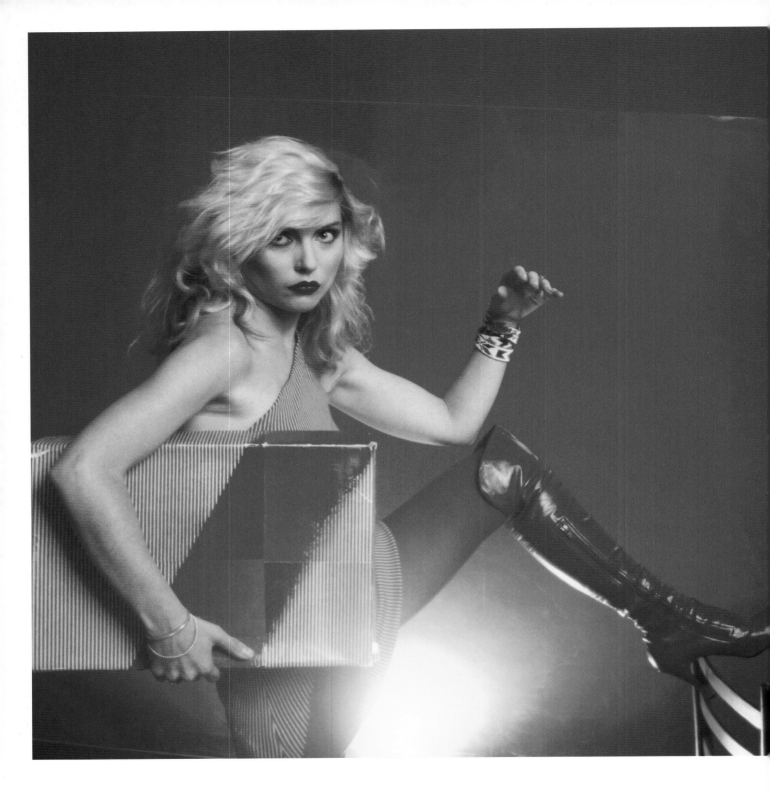

WHY CERTAIN IMAGES STAND OUT FROM THE
PLETHORA OF FROZEN MOMENTS GENERATED
BY THESE PARTICULAR PERFORMERS IS IMPOSSIBLE
TO DEFINE OR ARTICULATE. I LEAVE THE WHYS AND
WHEREFORES IN THE HANDS (AND WORDS) OF
WISER, MORE DETACHED INDIVIDUALS...

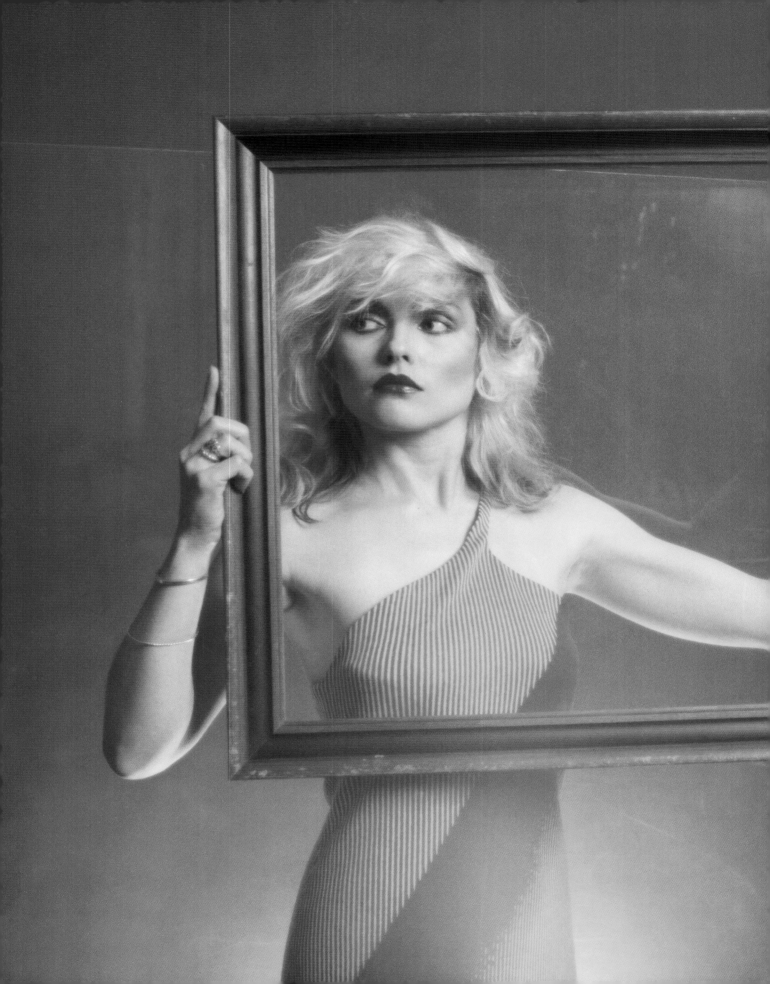

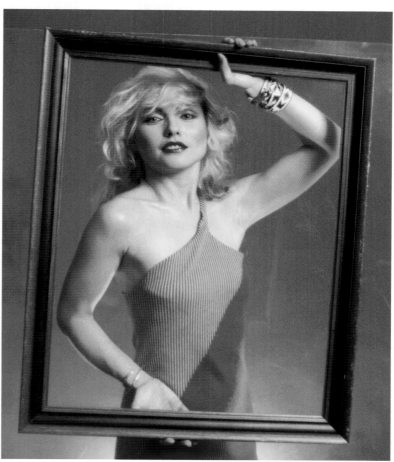

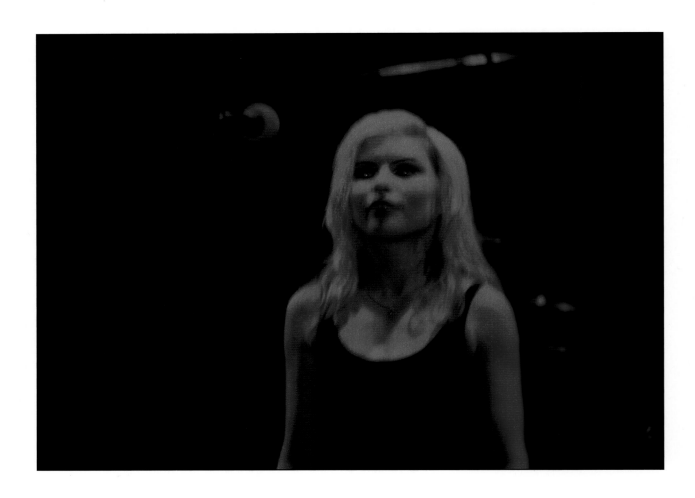

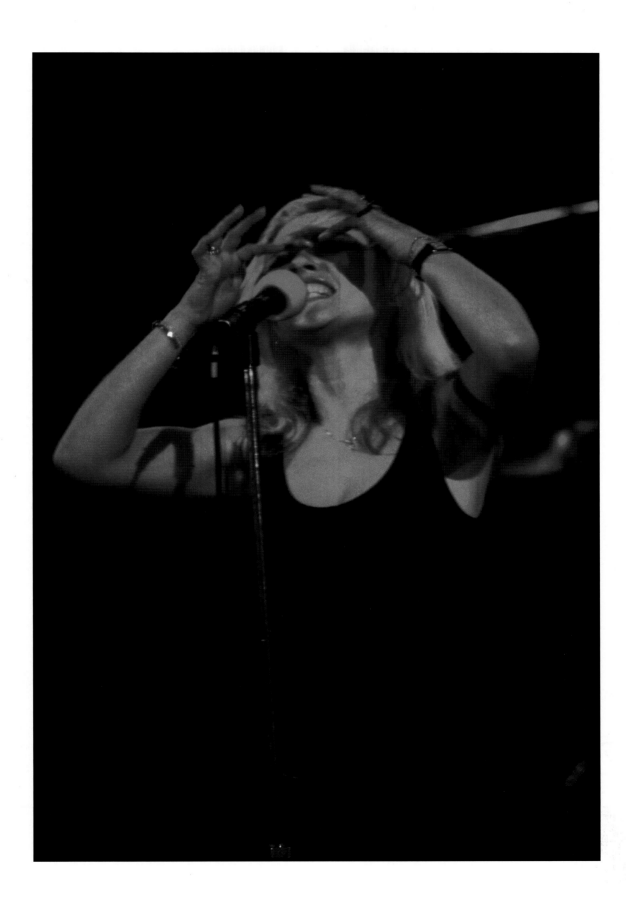

Early in 1979 Blondie played a show at the Palladium Theatre on 14th Street in Manhattan. It must have been within a couple of months of the *Viva/Penthouse* session, because Debbie's hair still had the same cut and look that I never quite saw again in that period. Quite often, as the photos from that era testify, it was cut short or mid-length, or if it was longer it had more of a fringed look. I remember I had recently returned from London, and I had spoken to their agent Johnny Podell the day of the show and he facilitated my entry.

And therein lies a tale or two…

In 1976 Johnny was managing Lou Reed and it was he who phoned me that August to tempt me to come to New York to work on Lou's *Rock and Roll Heart* album cover and tour. He met me at JFK airport late one afternoon and swept me off into his limousine. Within five minutes he had me ducking down in the back of the car while he filled my nostrils with some superb great white. Although I had certainly dabbled in the art of chemistry over the years since my initiation in my first year at Cambridge, this was something different. That autumn I discovered what the words 'quality' and 'quantity' meant and I didn't look back from that first encounter with the charming, wild and imaginative Johnny.

IT OPENED A NEW ERA OF CREATIVE AND SENSUAL EXPLORATION IN MY LIFE AND FROM THAT MOMENT I KNEW THAT I COULDN'T STAY AWAY. FOOD AND SLEEP BECAME REDUNDANT WORDS. I WAS OFF TO THE RACES AND THERE WERE NO HOLDS BARRED.

Thanks, Johnny…

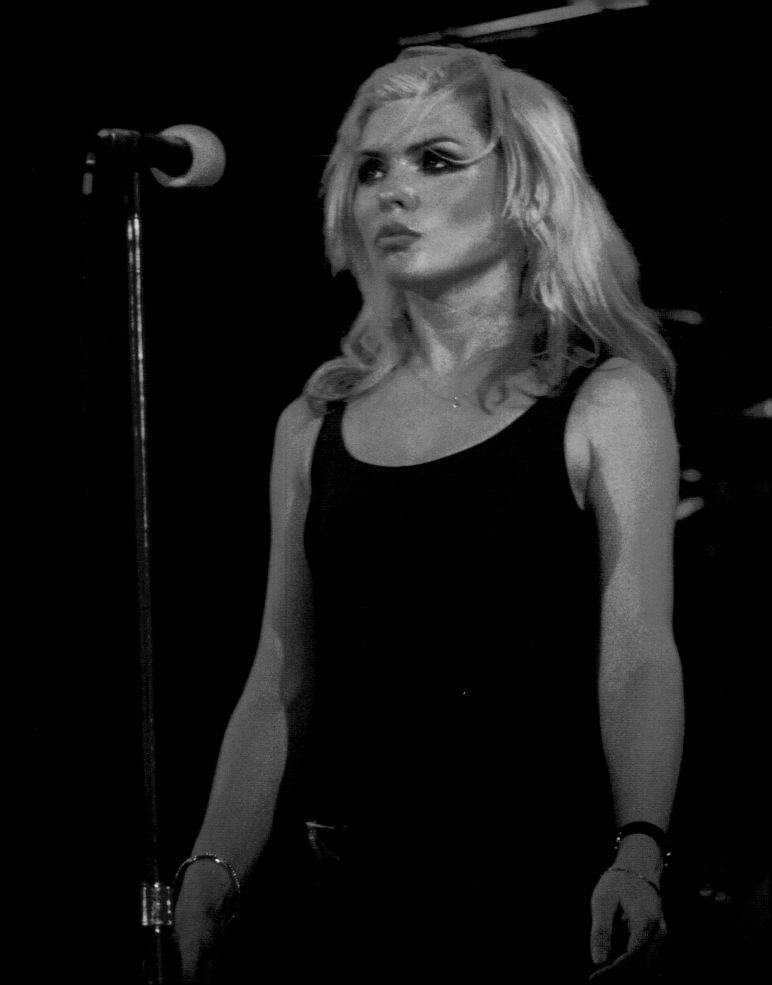

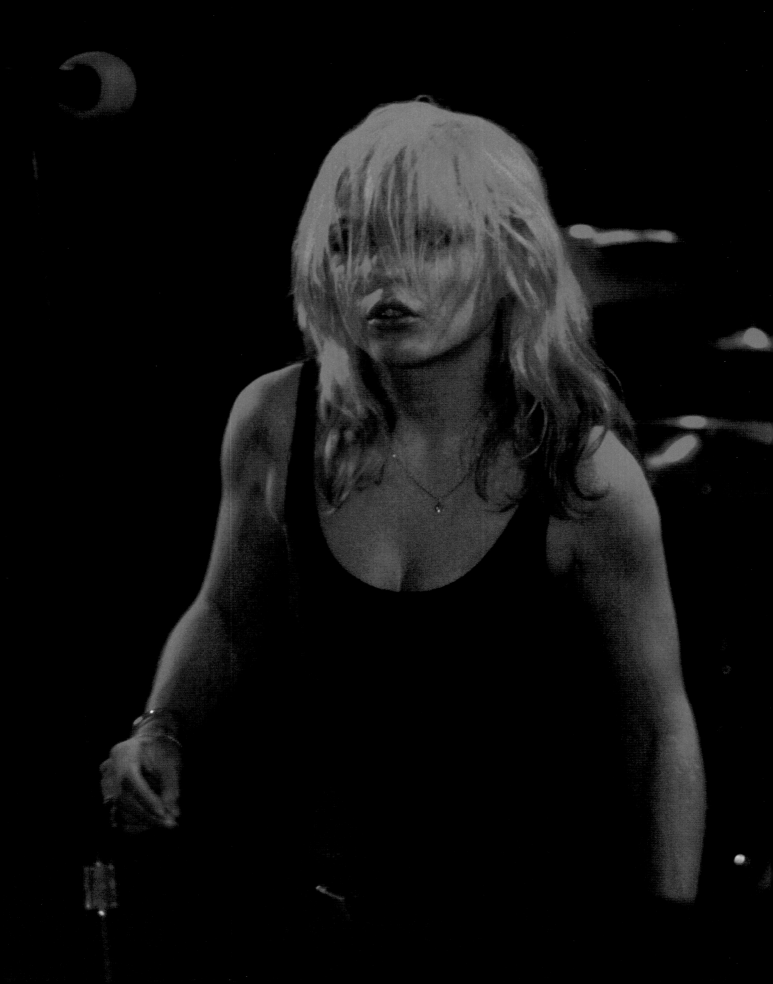

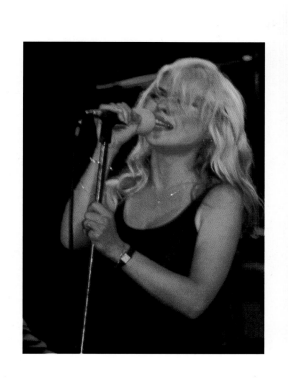
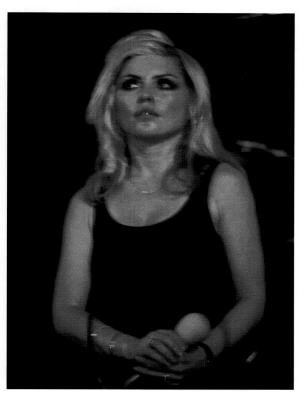
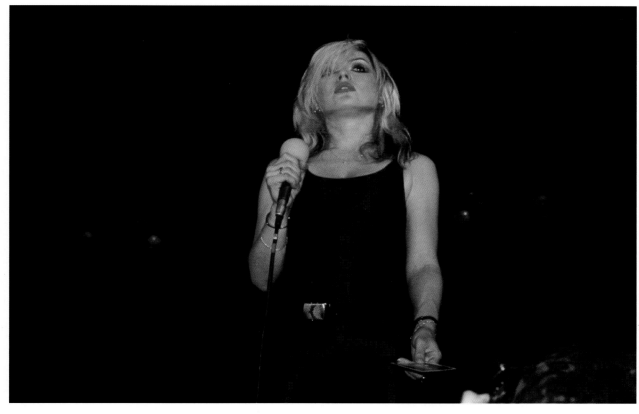

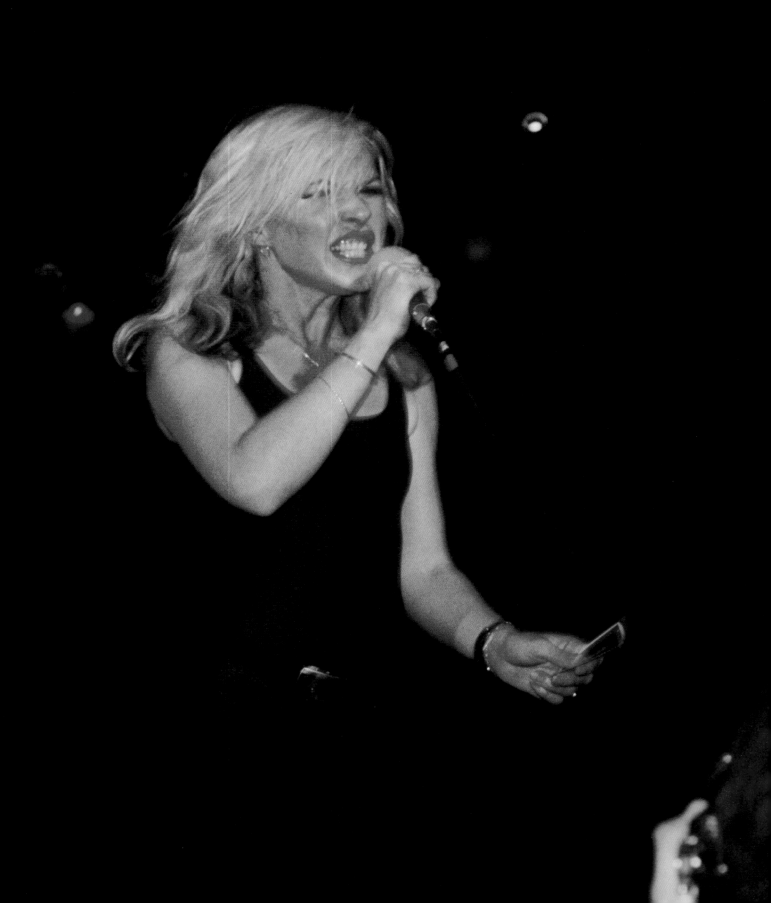

I had forgotten to request a photo pass but I remember Debbie looked so terrific in her all black garb that I was tempted to make my way to the stage to snap a few frames. Suddenly, I felt a set of firm hands on my shoulder. Forcefully, the large gnarly gentleman looming over me seized my camera and gestured for me to step back. I was starting to comply when Debbie noticed what was happening. She waved to my tormentor to let me be and after a moment of puzzlement he released his grip on the camera and me and left me alone.

DEBBIE APPLAUDED AND BLEW ME A KISS.
SO I WAS ABLE TO SHOOT A COUPLE OF ROLLS.

THIS TURNED OUT TO BE THE LAST TIME I SAW
BLONDIE PERFORM DURING THEIR FIRST GLORIOUS
RUN AT FAME.

This was also one of the last major shows I lensed of anyone anywhere. The thrill of jostling around for position in the pit had dissipated. Occasionally, over the last 20+ years, I have seized a snap or two of friends playing in clubs, but such work no longer interested me. I had started out shooting set-ups with my friend Syd Barrett but it was my relationship with Bowie, Lou, Iggy and Queen, which had turned me on to the buzz of shooting live and set-up sessions.

FROM NOW ON I ONLY WANTED TO SHOOT WHEN I COULD CHOREOGRAPH WHAT WAS HAPPENING IN FRONT OF MY CAMERA. I HAD SEIZED MANY MEMOR- ABLE LIVE FRAMES BUT HAD ALSO PROVEN MYSELF AS A STUDIO PHOTOGRAPHER WITH A STRONG SENSE OF LIGHTING.

I HAD CERTAINLY PAID MY DUES ON ROCK 'N' ROLL'S FRONT LINE.

I WANTED TO CONCENTRATE SOLELY ON EMULATING A HURRELL, OR MY NEWFOUND HERO, MAN RAY. I WOULD ENJOY MY LIVE ROCK FROM THE AUDIENCE FROM NOW ON.

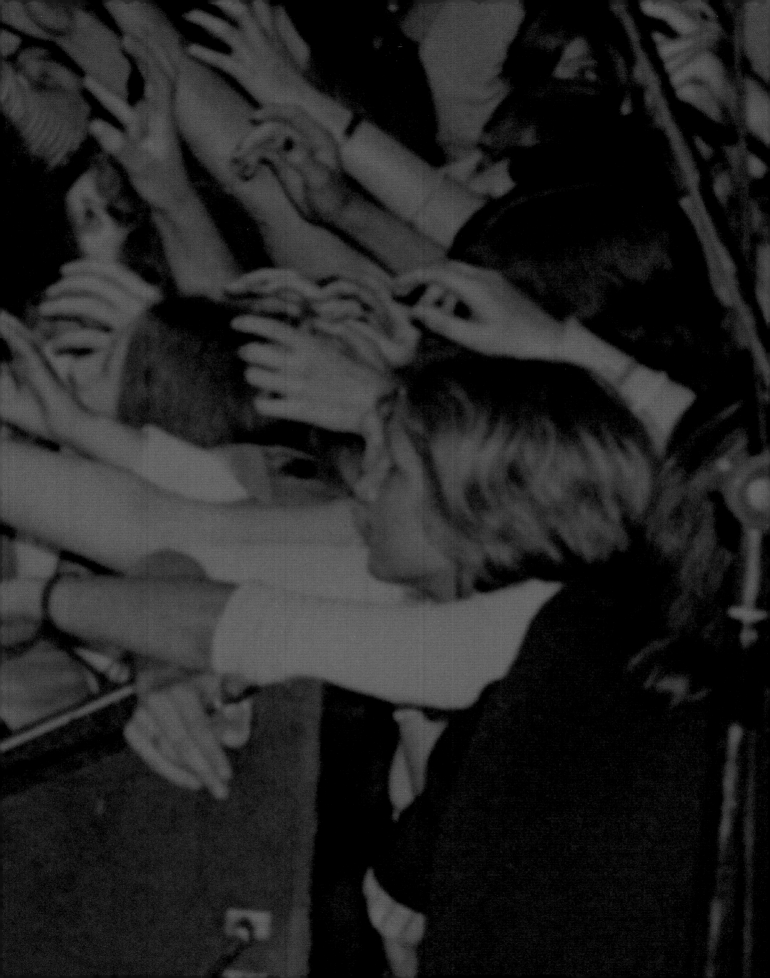

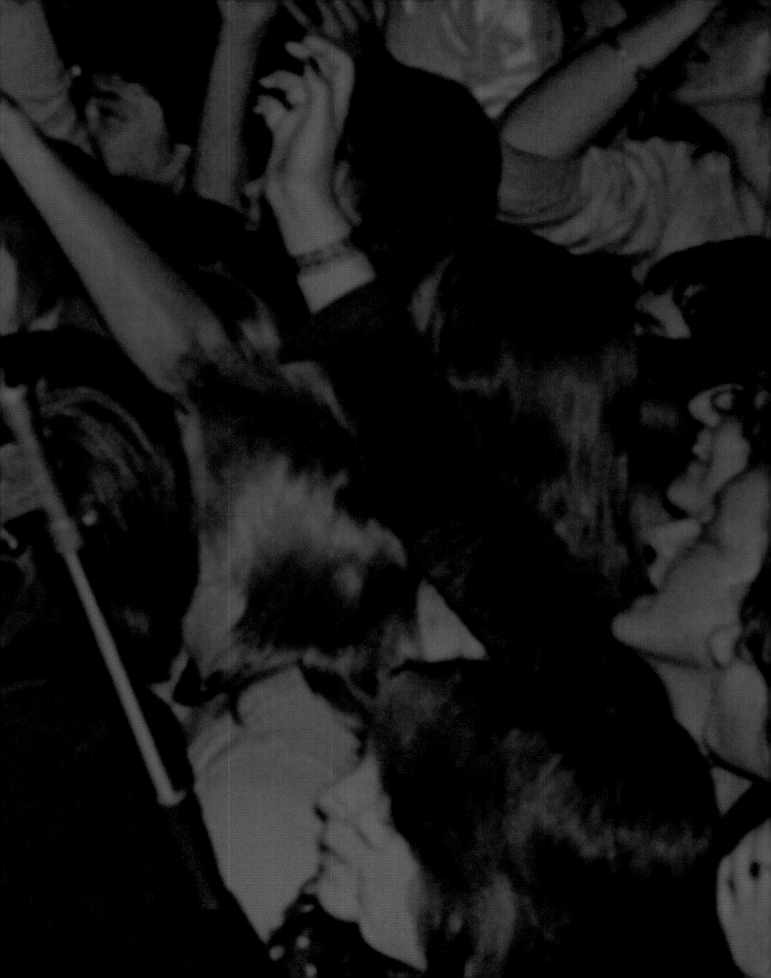

I HAD CERTAINLY PAID MY DUES ON ROCK 'N' ROLLS FRONTLINE

"All art is at once surface and symbol."

OSCAR WILDE

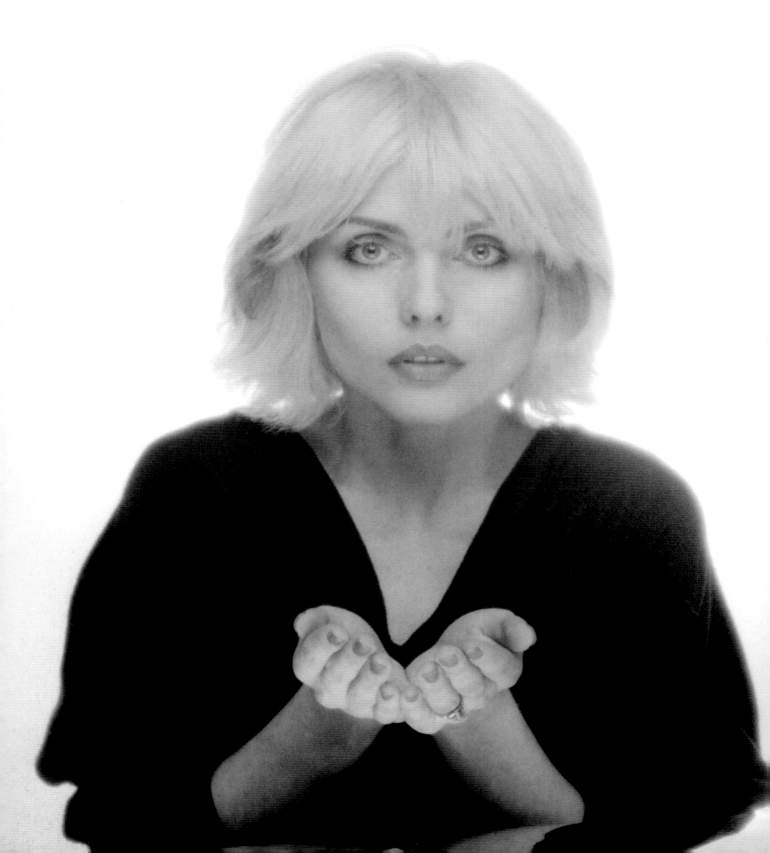

In the spring of 1979 a Japanese music magazine I had contributed to for about 4 years, *Music Life*, asked me to shoot a cover of Debbie. She had recently gotten fed up with her long hair. 'It just got too dried out with all the stripping and dyeing. It's so hard being Blondie, plus, it's so much easier to dye it blonde all over when it's short.'

So she showed up with the shortest cut I'd ever seen on her. Maybe because it was not only short but also straight, she looked a lot less 'Marilyn' than before.

Ironically neither of the super-blondes, Harlow or Monroe, ever wore their hair long. The main difference is that both Jean and Marilyn waved their hair and Debbie's hair tends to wave more when it's longer.

NOT THAT HER ALLURE WAS ANY LESS POTENT, FOR HER APPEAL DID NOT (AND DOES NOT) RESIDE SOLELY IN HER BLONDNESS. IT'S AN INNATE QUALITY. THERE HAS ALWAYS BEEN A SOFTNESS, A NON-NARCISSISTIC CASUALNESS ABOUT THE WAY SHE DEALS WITH HER PHYSICAL APPEAL.

Unlike, say, the ambitious one: Madonna, who claims to have been hugely influenced by Debbie in her early years. Debbie's look never seems too studied. Although of course anyone who has spent as much time in the public glare as she has wants to look good and her choice of attire has always been very shrewd.

Her appeal is not delivered as a challenge, the way a Pamela Anderson demands that a man puts his masculinity on the line. She is essentially a sweet soul, although also as time has proven, a very bright and canny one. She is simultaneously totally glamorous and equally reassuring. She may be a photographic goddess, but she's the goddess next door. As post-modern and proto-feminist as her reputation may be, she still retains the appeal of an old-fashioned girl that even mother would approve of. This is helped by the softness of her speaking voice and the generally low-key manner with which she conducts her life. She has provided little fodder for the gossip columns in her 25+ years in the public eye. No lurid tales of wayward behavior and lunatic boyfriends. No strong-arm bodyguards or late night canoodling in sleazy nightclubs.

THIS DOWNTOWN GIRL HAS ALWAYS CONDUCTED HERSELF LIKE A LADY, A ROCK 'N' ROLL LADY NO DOUBT, BUT A LADY TO SOOTHE YOUR SOUL...

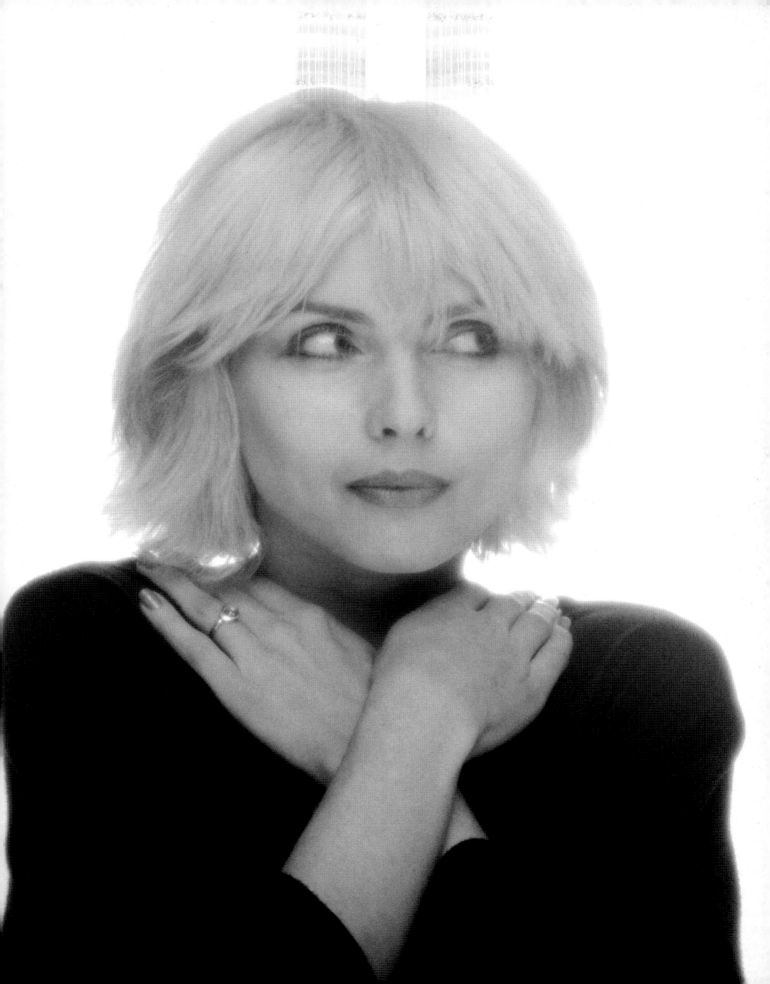

By the time of this second session, I was in my new studio on 32nd Street and Madison Avenue. The first loft had become too full and I needed more room, so I kept it solely as a living space. I had met a photographer through the young lady I was now co-habiting with on 21st Street, Lisa. He was from a wealthy family and didn't need to shoot to pay the bills. He'd had a sudden surge of ambition and decided that he needed a studio to develop his commercial chops and he invited me to share the space with him. He certainly didn't lack for talent and occasionally he would pick up a fashion gig such as a L'EGGS leg wear ad campaign. But mostly I believe he wanted to impress the young fashion models he liked to spend time around.

He was a pleasant man who indulged in the same habits as myself and I enjoyed his company whenever we hung out. The beauty of the situation for me was that for the next three years he paid half the rent and was rarely there.

Sharon Slattery again did the makeup, as she did on all the Debbie/Blondie studio sessions. Debbie loved Sharon's cosmetic style and was entertained by her friendly personality. In many ways she was my all-time fave face-painter; even more than the amazing Pierre Laroche – famous for his work on David Bowie in his Ziggy Stardust era. Check out Pierre's superb and dramatic work on *Pin Ups* or *Aladdin Sane* or my Life On Mars music video. But Pierre was less inspired with women and was a huge pain in the buttocks to deal with.

David and I and the Ziggy coterie used to call him Pierre Le Poof – not to his face, because he didn't have a great sense of humour about himself. Eventually David stopped using him because he had such an overbearing personality. He moved to New York from London in the late seventies, and occasionally I would use him.

I remember a shoot in the early eighties: he kept interrupting the session with irritable, conde-scending suggestions. Now I learned early on that patience was an essential ingredient for photographic success, but Pierre pushed it too far that day.

I stopped and handed him the camera. 'Here Pierre, you know everything. Who needs a photo-grapher?' My exasperation startled him and he retreated in silence for the rest of the session. I could never bring myself to use him again.

Unfortunately he succumbed to AIDS in the late '80s. He could produce brilliant, mask-like make-up but didn't work as much as he should have, because he couldn't bring himself to do 'light', girl-like make-up. Still he undoubtedly raised his work to an art form and in many senses was way ahead of his time.

Sharon was a lot more fun and knew her place better in the grand order of the session. She was also much more versatile than Pierre. Not only could she do sexy make-up on the girls, but she could also render low-key grooming for the boys, as evidenced by her work on my shoot for the Ramones *End of The Century* album cover. Imagine that, make-up for the Ramones!

They didn't even complain too much. After all, they were a little spotty.

They may have been the quintessence of punk but I didn't feel they needed to parade bad skin.

Pierre Laroche with David Bowie on the set of the Life On Mars video
Summer. 1973

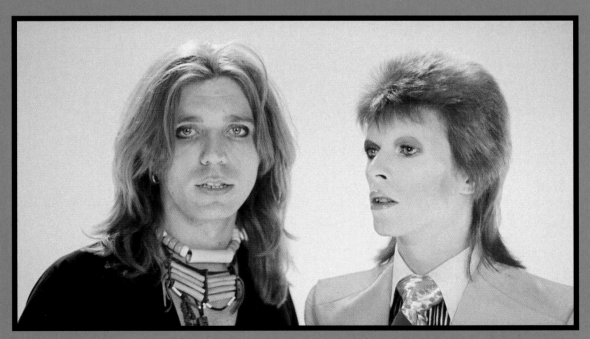

From the first session I knew that red and blue suited Debbie's skin tones.

This time I used a nylon diffusion screen and placed alternatively red and blued gels over the light behind it. The filtered red light came through a pretty pink, especially when I over-exposed the film. I found that a slight over-exposure worked well with Debbie's pale, reflective skin.

She wasn't a creature of the sun. I never remember her with a tan, or seeing any photos of her in a swimsuit. In that she was very punk. She was a lady who felt more comfortable when night fell. Again she wore black. In a sense it never mattered what she wore, as long as she felt comfortable; witness the myriad of clothes and colors she's sported over the years.

But I've always liked the starkness of dark tones contrasted against her innate softness.

THE FEMALE SHOULDER IS ONE OF THE SEXIEST PARTS OF THE BODY; A DASH OF SKIN WHICH SUGGESTS MUCH MORE – SLIGHTLY RAVAGED, THE BEGINNING OF A STRIP, A HARBINGER OF DELICIOUS THINGS TO COME.

So for these pics, I encouraged her to show me a little shoulder. In truth, I don't recall any pix of Debbie in anything too revealing. Maybe a short skirt – well, often a short skirt and if you looked hard you could sometimes catch a glimpse of her panties when she performed.

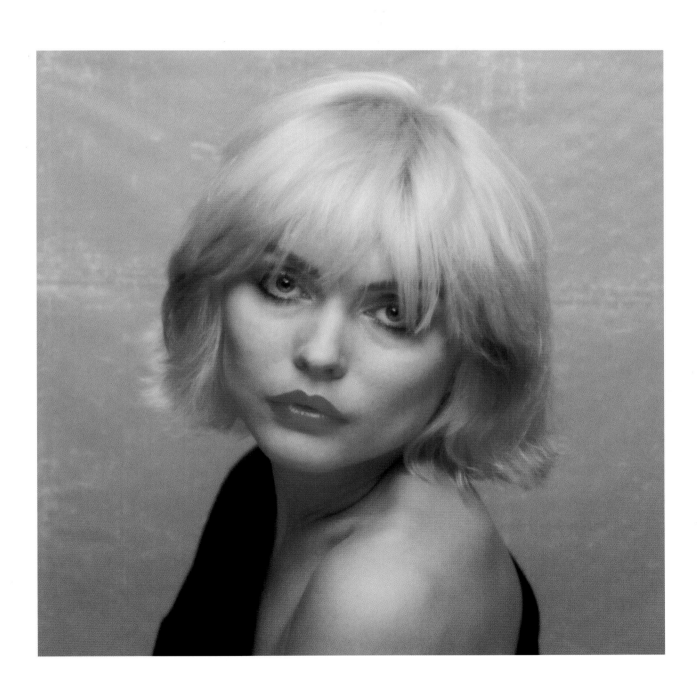

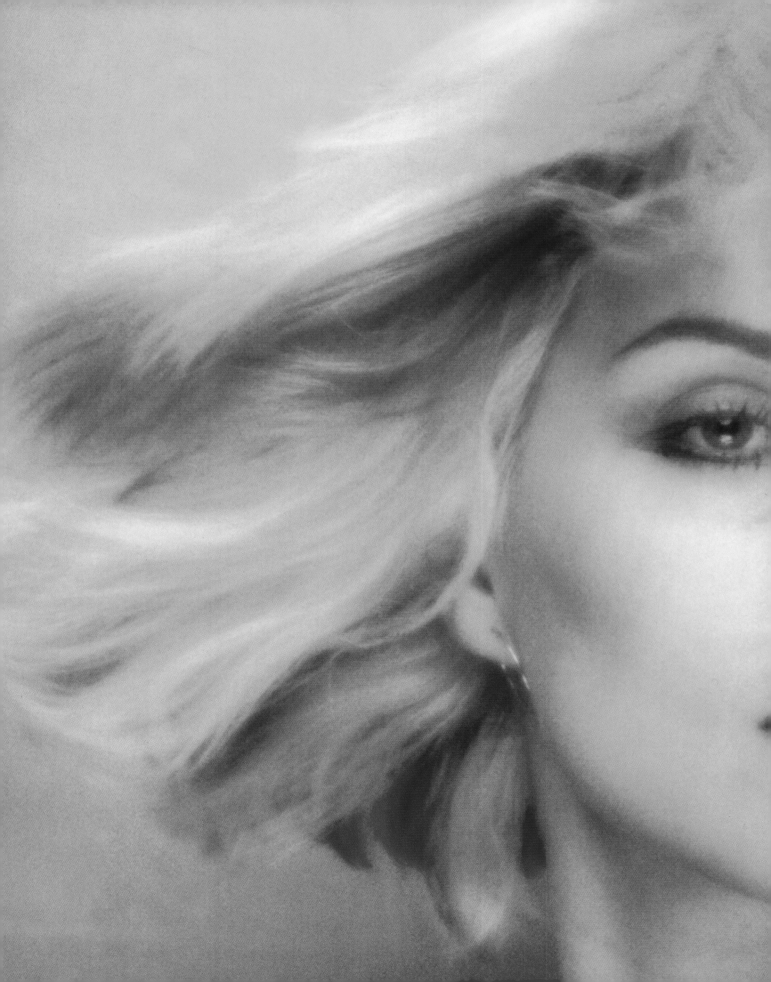

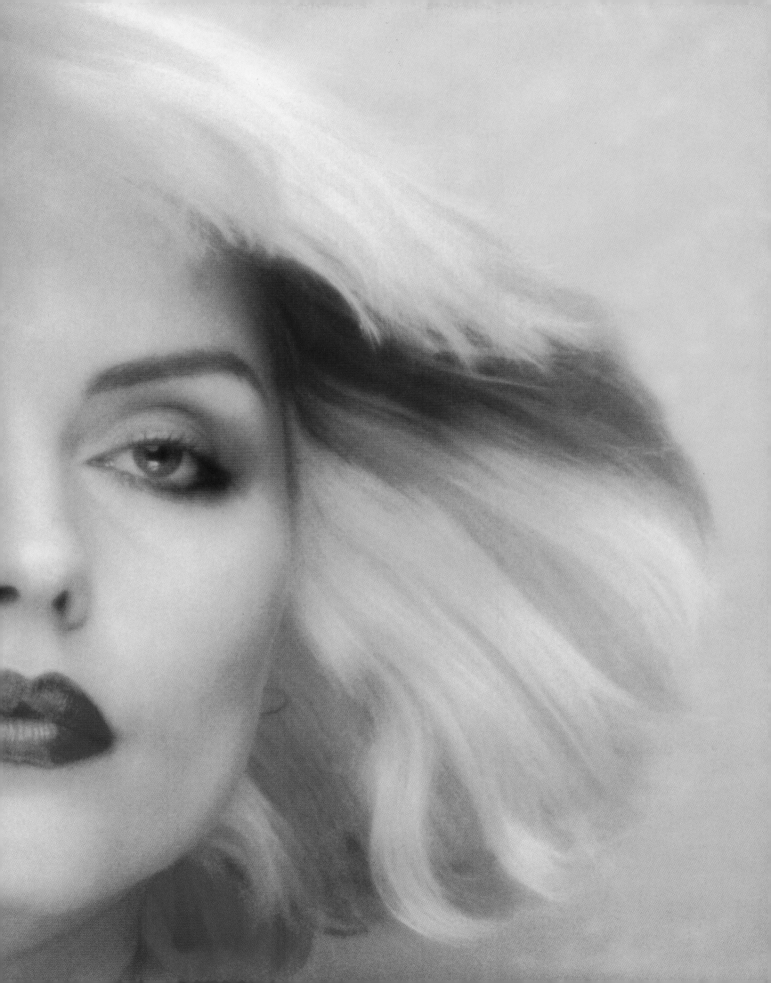

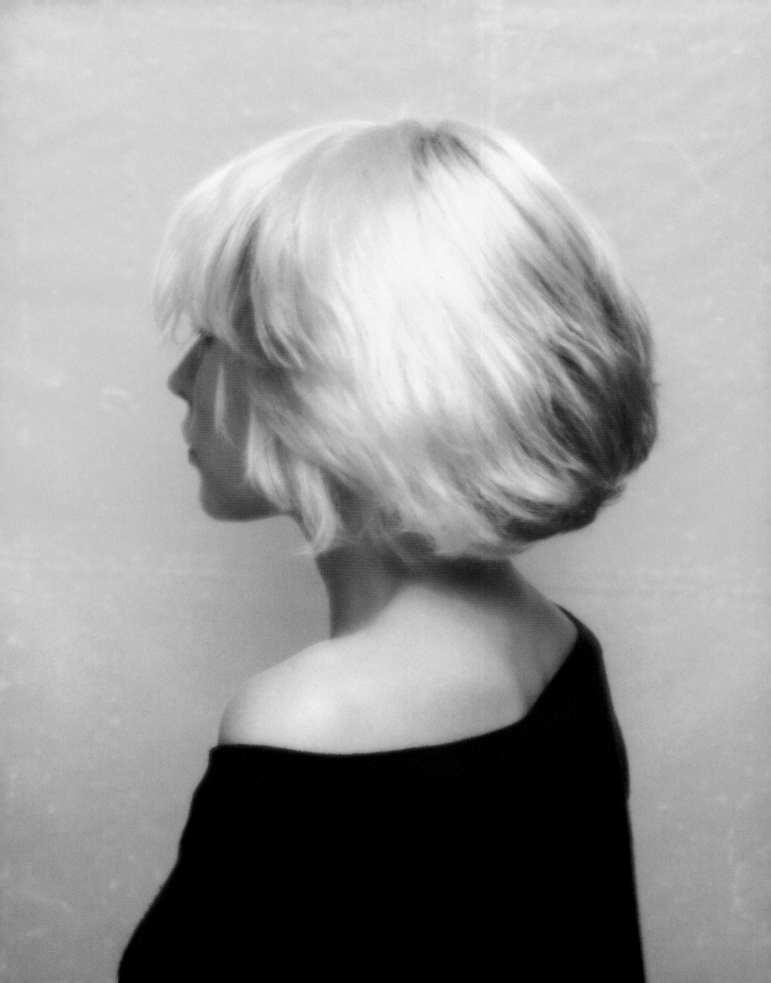

She seemed to however instinctively understand that what you don't reveal is often more exciting than what you do. She rarely, if ever, revealed her cleavage (either boob or butt) in the modern fashion – like Britney or Christina. Maybe sometimes she'd reveal a glimpse of bra or navel, but never in any of our classic sessions. But in so many ways her image remains sexier than all of them: the lips, the eyes, a little thigh or shoulder – for her that says it all.

It's also true that God gave her a better facial bone structure than all of them. Even today in her mid-fifties, she remains a very sexy lady. She seems to have understood that if you have the right tools, the human imagination needs just a little encouragement.

A week later she returned to my studio with the boys in the band...

IF YOU HAVE
THE RIGHT TOOLS,
THE HUMAN
IMAGINATION
NEEDS JUST
A LITTLE
ENCOURAGEMENT

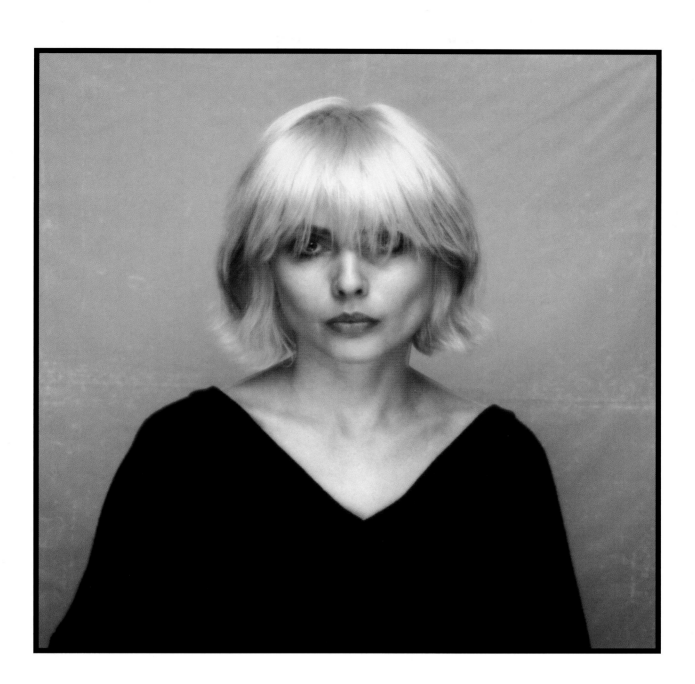

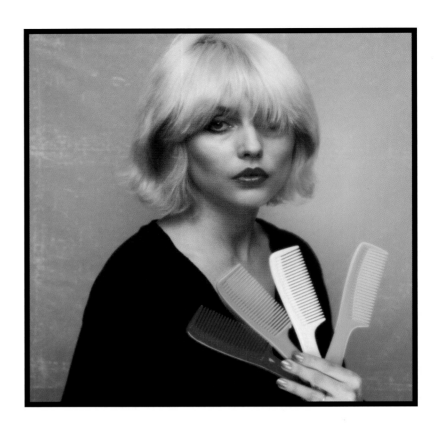
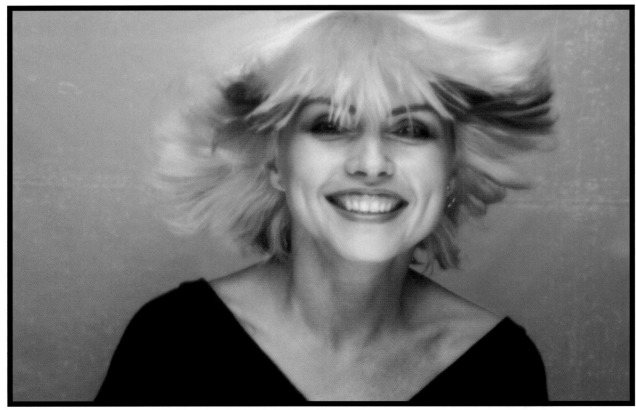

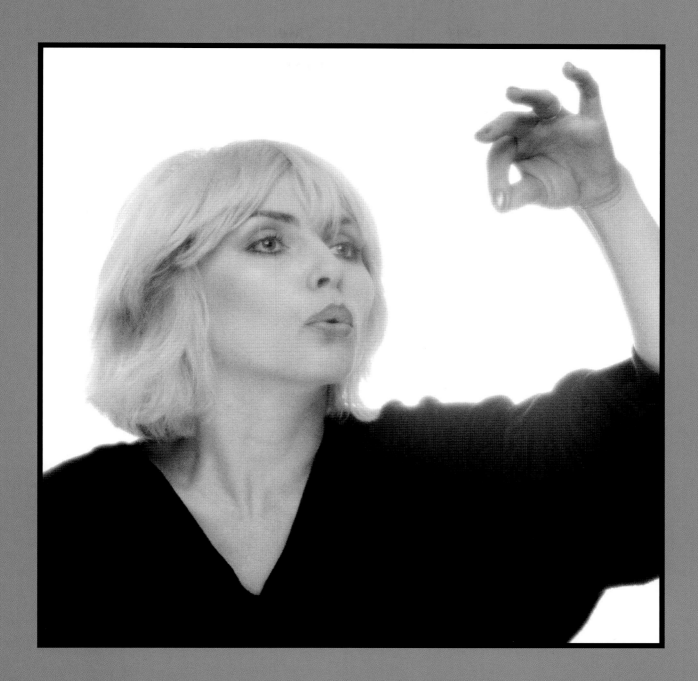

I WAS ASSISTED ON MANY OF THE SESSIONS FROM THAT PERIOD BY MY PARTNER-IN-CRIME, ERNIE THORMAHLEN, WHO PROVIDED THE GRAPHICS ON A PLETHORA OF ALBUM COVERS WE WERE COMMISSIONED TO PRODUCE IN THAT PERIOD. ERNIE WAS ALSO A GREAT AIRBRUSH ARTIST AND WE COLLABORATED ON MANY ILLUSTRATIONS FOR RECORD COMPANIES AND MAGAZINES INCLUDING HIGH TIMES AND A VARIETY OF MEN'S PUBLICATIONS.

I would provide the basic photo and he would add the special effects. He allowed me to expand the range of my visual ideas. This was many years before the digital revolution made those particular skills redundant. I still love the work we did together. We received a Grammy nomination for a cover we did for a band called Fotomaker of a little blonde eight-year-old girl made up to take on a provocatively mature aura, an image simultaneously adorable and disturbing. In fact, we received a lot of flack for this photo that some people found exploitative. It was of course done with the full co-operation of her parents. Ironically, her father was the managing editor of two British based men's magazines, *Men Only* and *Club International*. He died a few years later when he fell asleep with a cigarette in his hand and set his apartment on fire.

Ernie and I did three album covers for Fotomaker in all. Unfortunately they were not successful sales-wise, and are mostly remembered for our album covers and for the fact that they were produced by Jimmy Iovine – now president of the very successful rap-orientated label Interscope Records.

Many people I knew in that period are also now deceased, including Ernie. He died of a heroin over-dose in LA in the early '80s. Now Ernie had certainly dabbled in the heavier arts, but only occasionally and purely recreationally.

Those were times when my generation was committed to all manner of experimentation. Early in life at age 20, I had two friends die in similar circumstances, which ensured that this particular chemical was never on my menu. Apparently Ernie was trying to make a foray into a particular young lady's panties and to please her, he allowed her to shoot him up. It was a stronger strain than Ernie was used to – or thought. Not too strong for the lady that gave it to him and who it transpired had a heroin habit.

The circumstances are very reminiscent of the way the great American comedian John Belushi died. His death also happened in LA and he also allowed a lady to shoot him up. I had originally met Ernie in London in 1972 when Lou Reed came to record *Transformer* with David Bowie and Mick Ronson. Ernie was acting as Lou's road manager, and he art directed the album cover for *Transformer*. He is also the gentleman on the back cover with the bulging groin. As I recall Ernie was decently endowed, but a banana – wrapped in a sock – produced that excessive bulge.

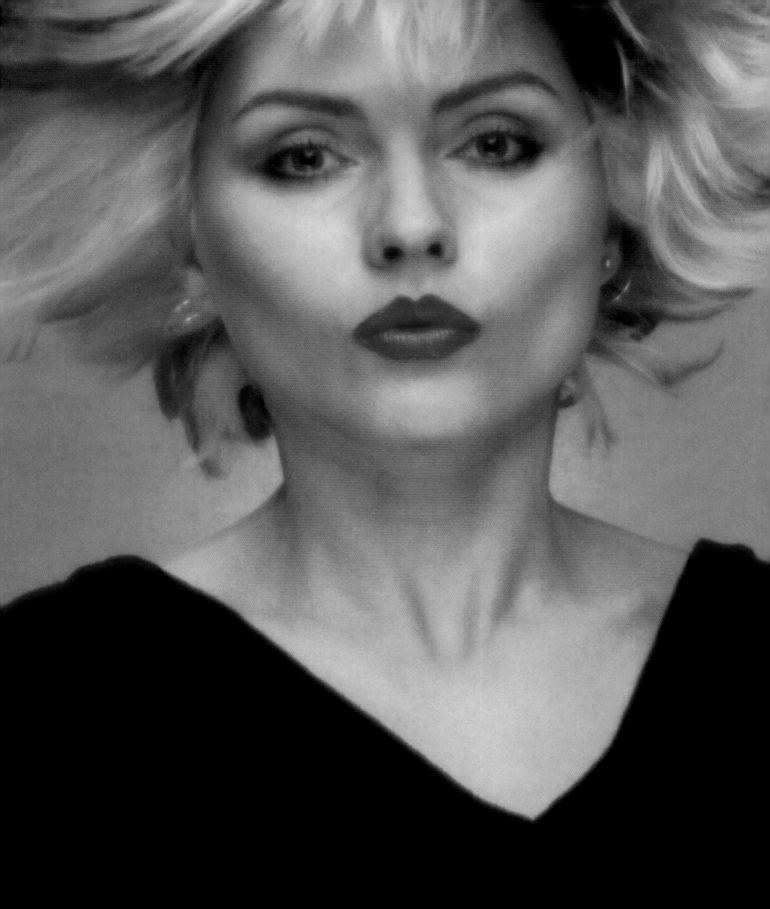

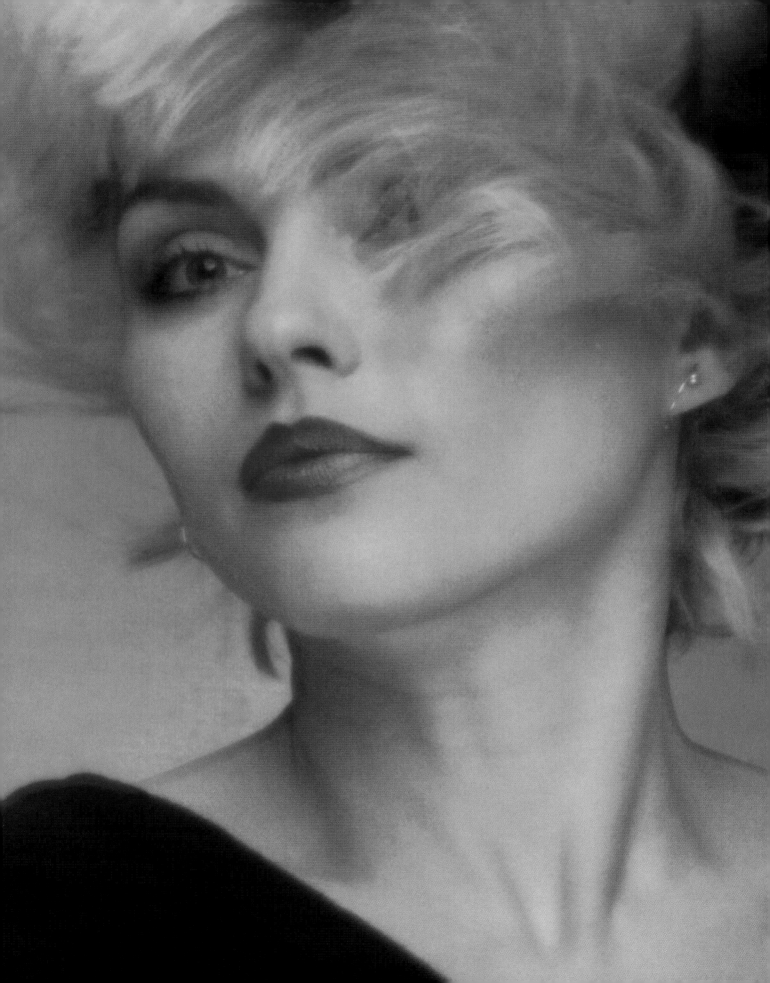

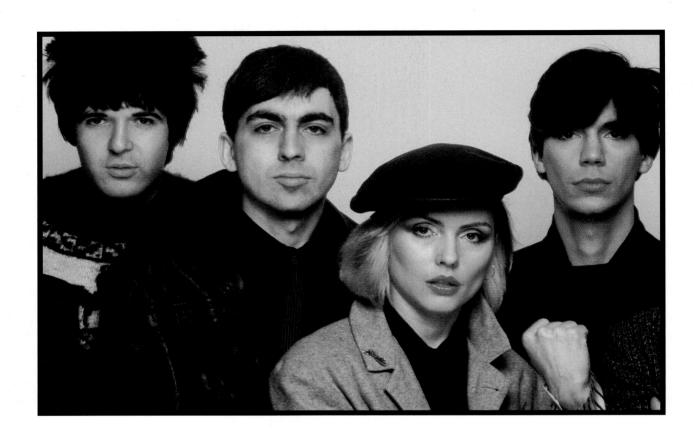

So finally I had the entire Blondie line-up in front of my camera and I realized that notwithstanding the constant media focus on Debbie, this was by all normal standards a good-looking band.

THEY WERE ALL ROCK 'N' ROLL SKINNY AND WERE ENDOWED WITH A GOOD HEAD OF HAIR. JIMMY DESTRI AND CLEM BURKE CERTAINLY HAD PIN-UP QUALITIES AND THE OTHER THREE: CHRIS, FRANK INFANTE AND NIGEL HARRISON WERE NOT WITHOUT THEIR APPEAL.

THE PHOTOS TELL THE STORY.

THEY HAD A GREAT ROCK 'N' ROLL LOOK.

THEY CERTAINLY COMPARED VERY FAVORABLY WITH ENGLAND'S PRE-EMINENT PUNKERS, THE SEX PISTOLS AND THE CLASH. AND JUST PUT THEM ALONGSIDE THE RAMONES…THEY PERFECTLY FITTED THE MONIKER OF A POWER POP COMBO. I'VE COME ACROSS FEW BANDS WHO WERE BETTER LOOKING AND I HAVE, LET IT BE NOTED, LENSED A FEW IN MY TIME.

IT'S JUST THAT DEBBIE WIELDED SUCH OVERWHELM-ING PHYSICAL APPEAL.

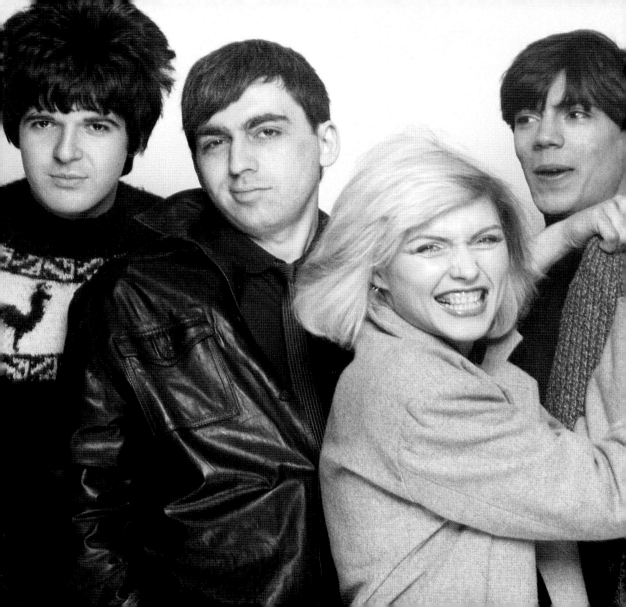

AS A LINE-UP BLONDIE WORKED VERY WELL VISUALLY.

ALL THE BOYS WERE BRUNETTES, WHICH SET DEBBIE'S
BLONDNESS OFF EVEN BETTER.

Over the years they've all spoken about the tensions and animosities within the band in those years but in those months in 1979/80 when I worked with them, I saw no signs of it. The over-indulgences of that period, rampant in the music business generally and in New York's downtown creative scene, certainly put all of our nervous systems to the test. Our overstimulated glands and organs certainly made a lot of us manic and paranoid at times. And maybe that was a large part of it.

Rational thought didn't rank high on our list of priorities...

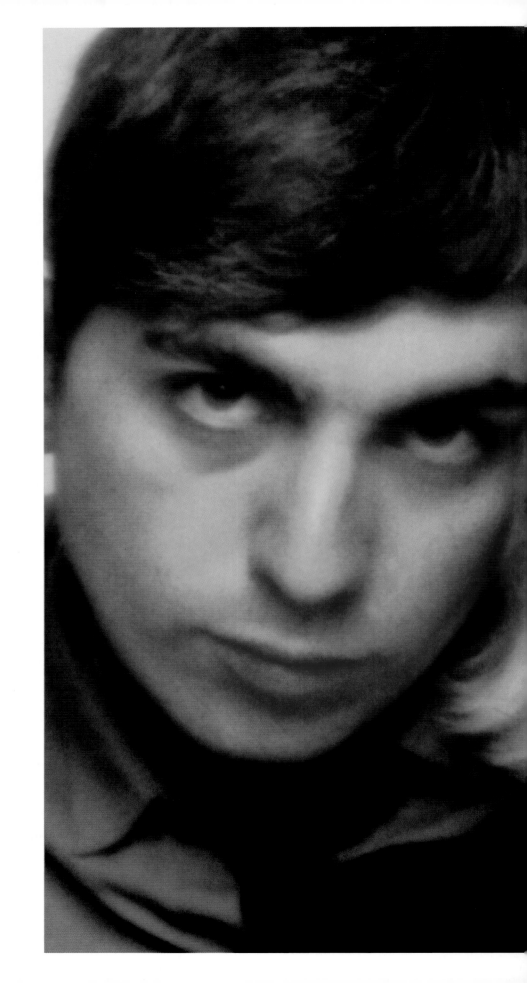

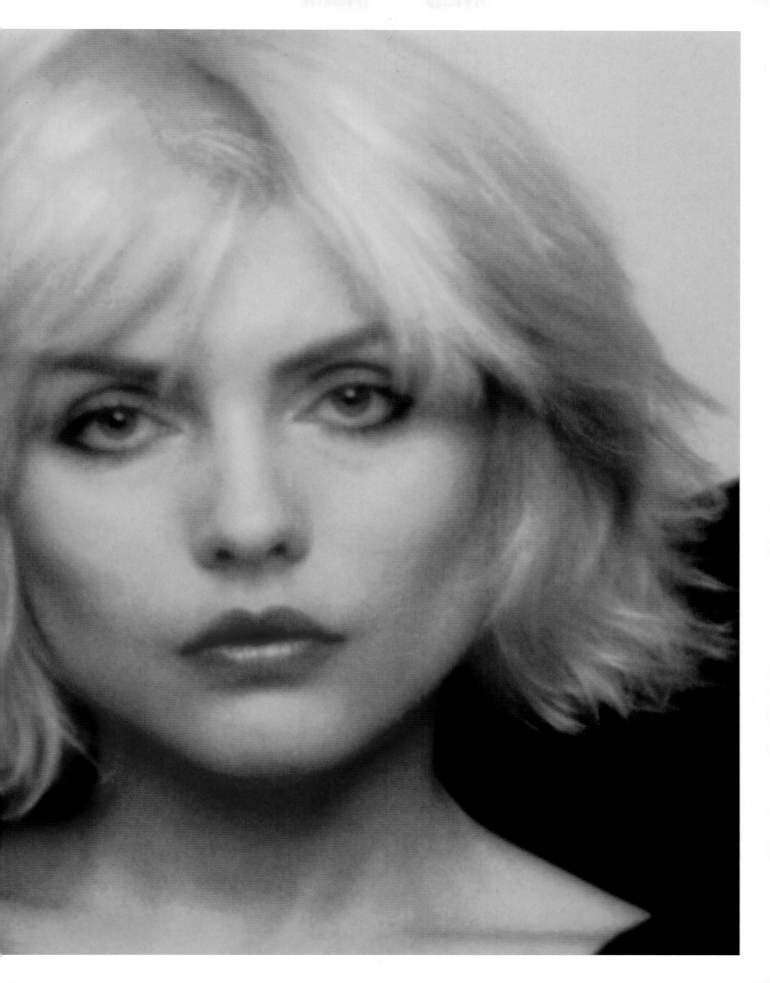

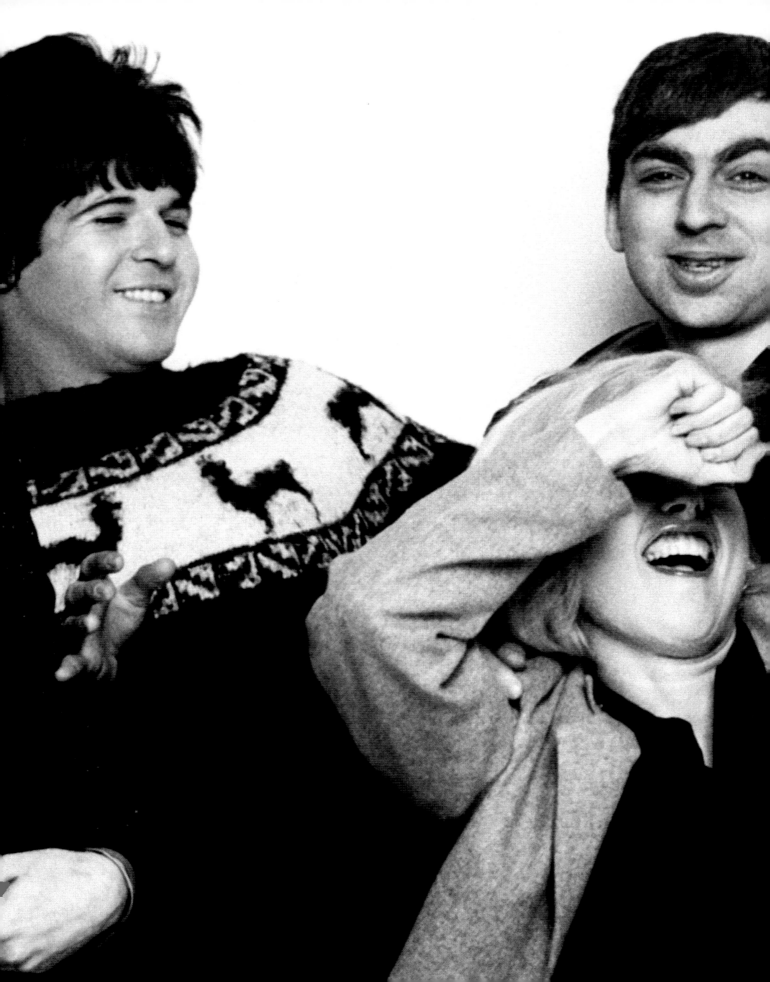

BUT CHECK OUT THE IMAGES. THEY ALL SEEM TO BE HAVING A GOOD TIME WITH EACH OTHER. MAYBE MY TRADEMARK ANTICS HELPED THINGS ALONG. BUT AN AMUSING LENSMAN CAN ONLY SPREAD SO MUCH CHEER IF THEY REALLY DIDN'T CARE FOR EACH OTHER. I FOUND THEM TO BE A CHEERFUL, PLAYFUL BUNCH, COL-LECTIVELY AND INDIVIDUALLY WITH AND WITHOUT A CAMERA IN HAND.

THEY WERE TOTALLY SELF-STYLED. I MADE NOT ONE SUGGESTION ABOUT THEIR ATTIRE. I DIDN'T NEED TO. THEY LOOKED TERRIFIC. BY THIS PERIOD THEY HAD GROWN WELL BEYOND THEIR PUNK ROOTS. THEY DRESSED VERY SHARP, MOD, AND POP LIKE A SQUAD OF CUTE HIT MEN.

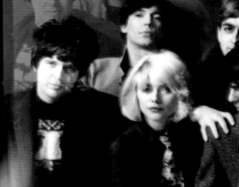

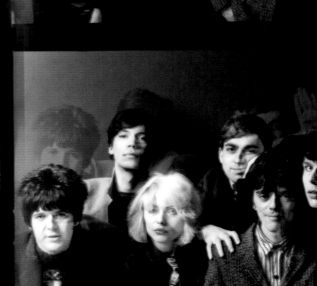

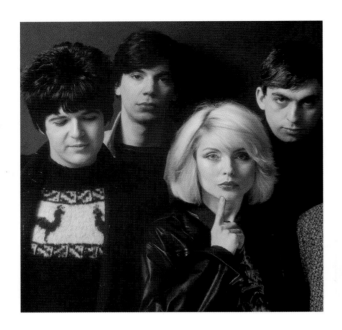

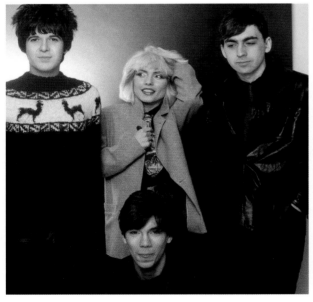

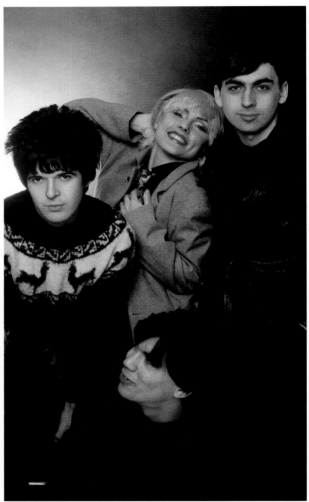

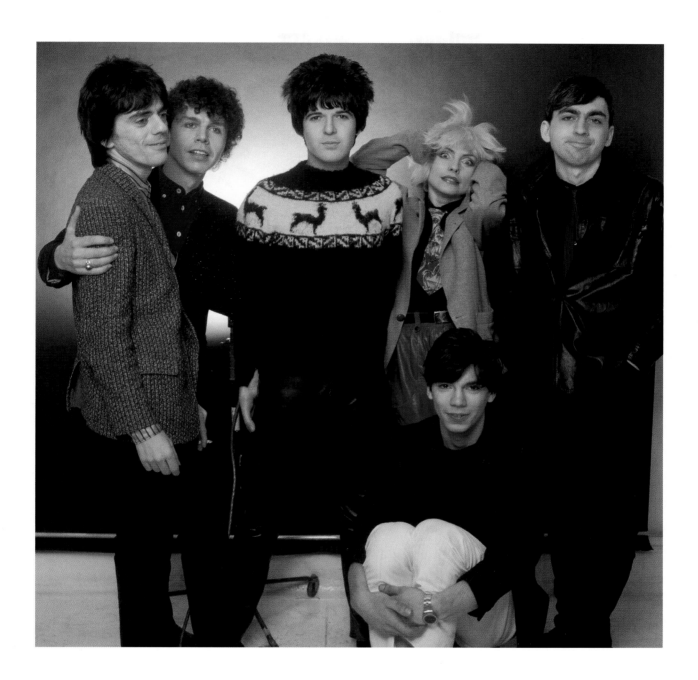

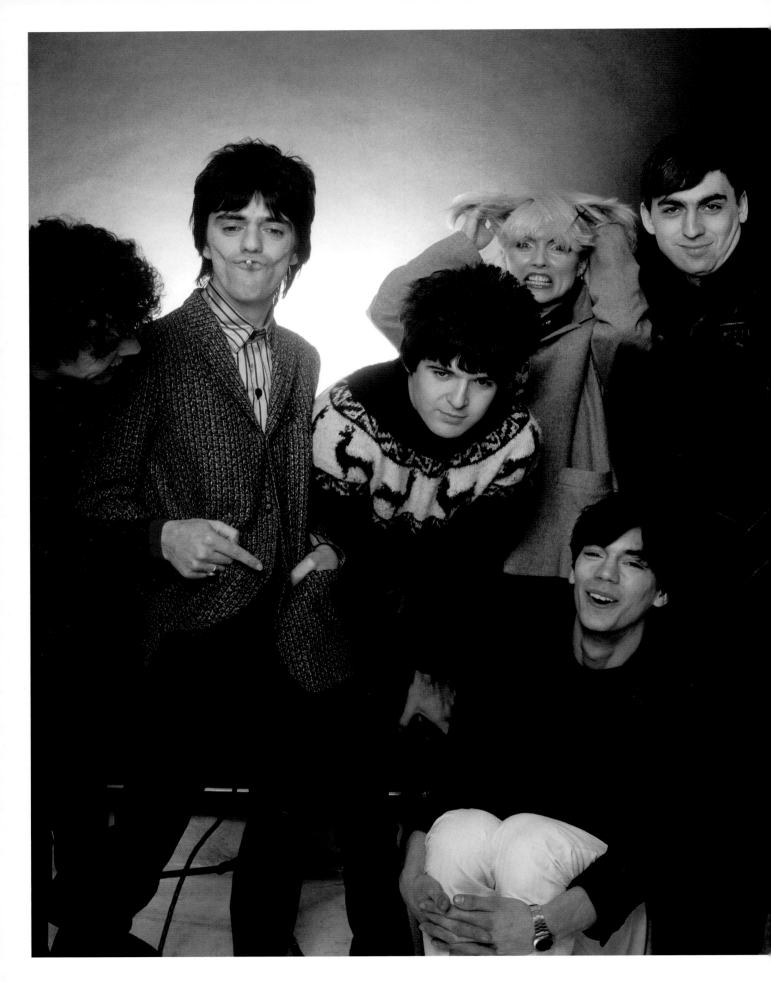

I can't remember why we did the session.

Maybe some of the pix were for the record company. Maybe everyone just wanted to shoot because Chris and Debbie had put in the good word and we knew there was a market for the pix. At this moment, they were after all one of the biggest acts in the world.

Strangely enough, although these images are probably as strong as any taken of them at this time, I don't recall many of them being published over the years. For sure I was not the smartest at marketing my photos in the '70s. If you didn't ask, they wouldn't get seen. I was too busy with my latest assignment or obsession...

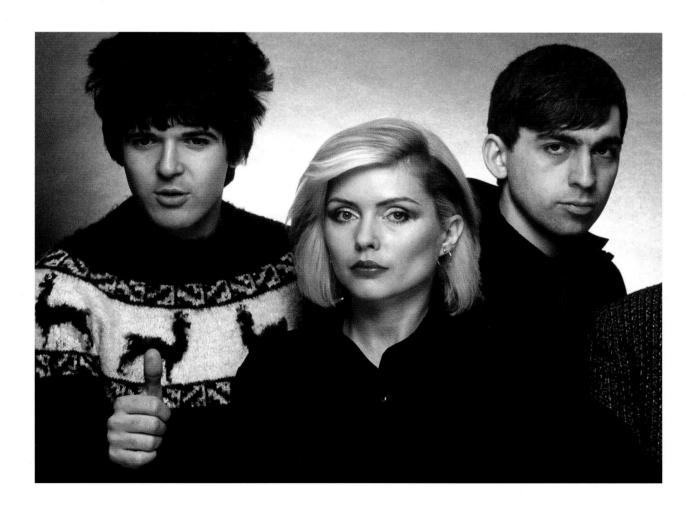

I LOVE THE WAY DEBBIE IS JUST FOOLING AROUND IN MANY OF THE FRAMES, LIKE SHE'S JUST ONE OF THE BOYS

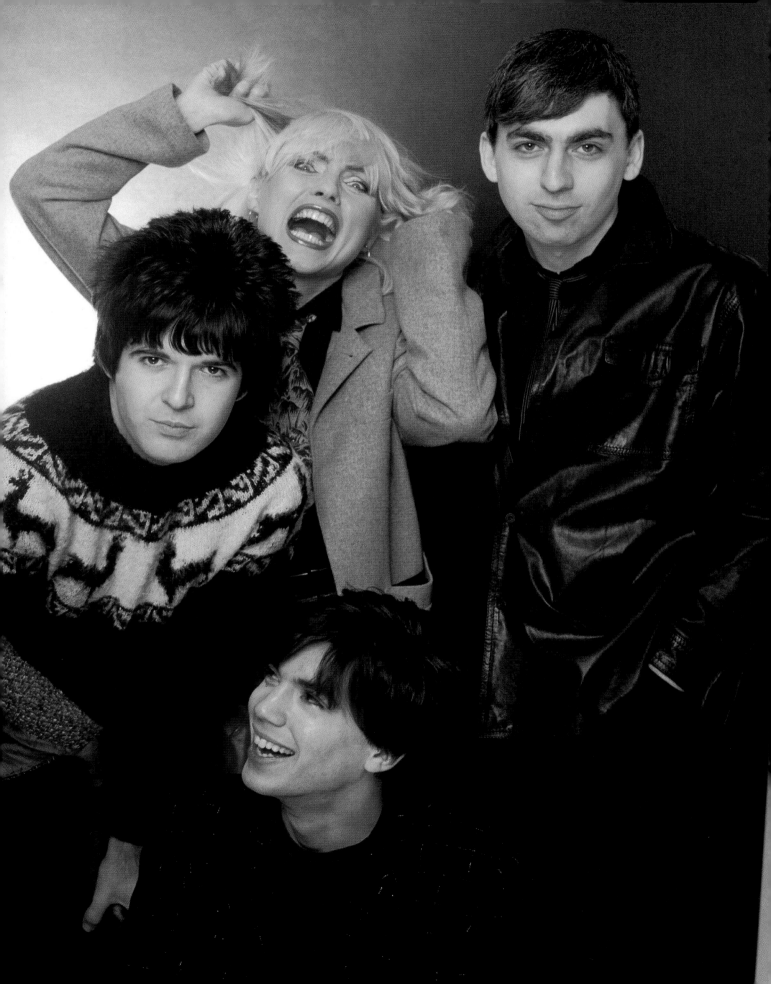

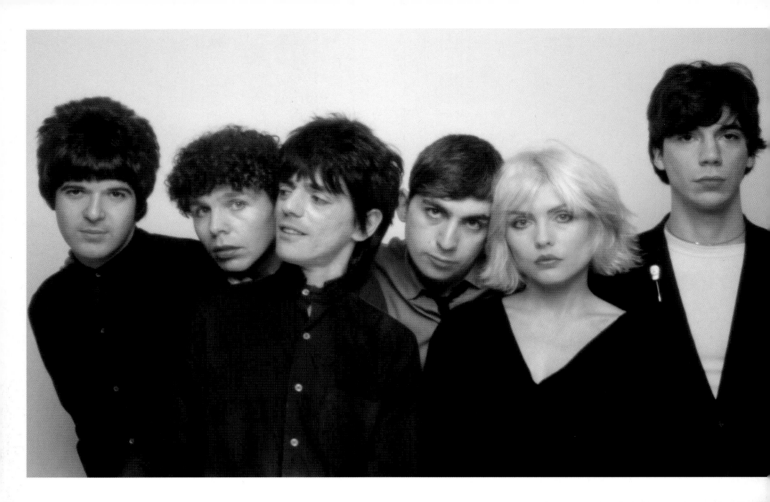
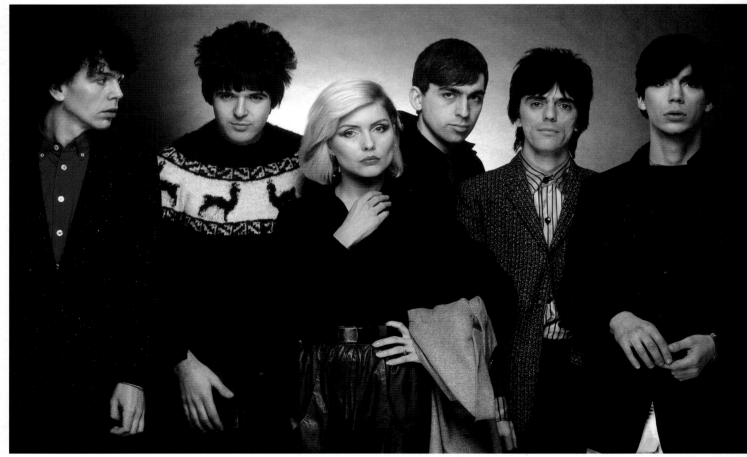

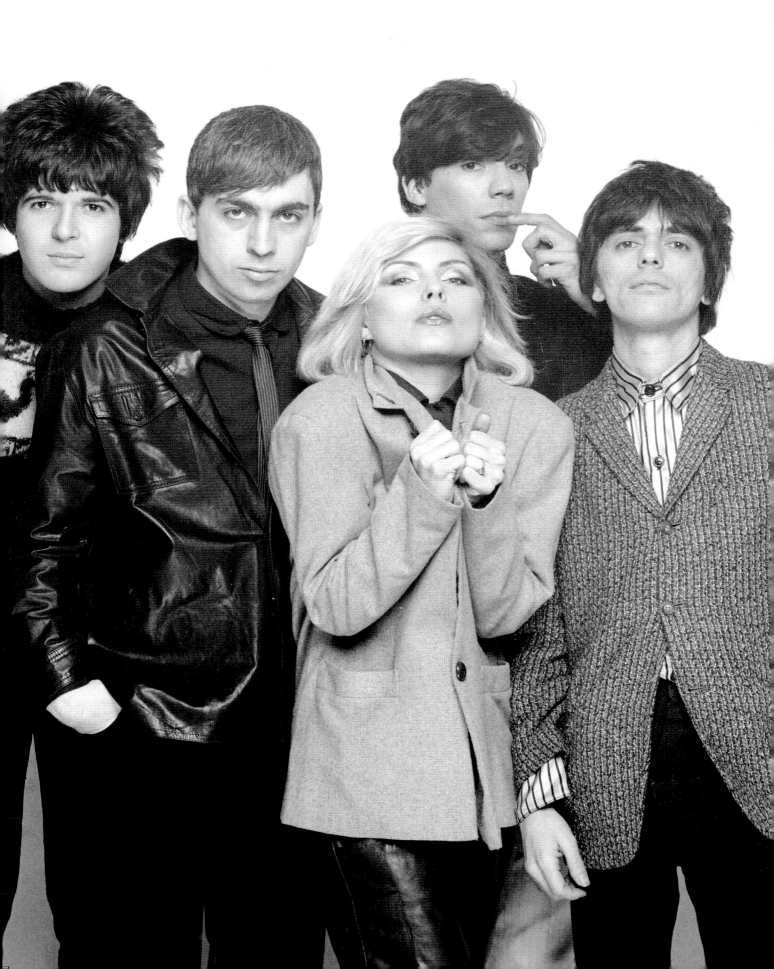

I WAS A VERY 'TODAY' KIND OF BOY: ALWAYS LOOK-
ING FOR SOMETHING NEW – BORED OF YESTERDAY'S
PHOTOS. MOSTLY IT'S BEEN THE IMAGES AGAINST THE
BLUE-GRAY BACKGROUND WITH ALL THEIR HEADS
PRESSED CLOSE TOGETHER THAT HAVE BEEN USED.
ONE WAS A DOUBLE PAGE SPREAD IN LESTER BANGS'
BOOK. THE FUN OF DOING A BOOK SUCH AS THE ONE
YOU ARE HOLDING IS THAT I GET TO SHOW A LOT OF
IMAGES THAT HAVEN'T BEEN SEEN BEFORE.

Blondie were an easy, good-natured bunch to work with and I came to respect and like them all
individually. Above all I love the way Debbie is just fooling around in many of the frames, like she's
just one of the boys. In fact, in this session, whatever the clothing change, she's dressed very
much like one of the boys.

She could dress as masculine as she wanted, she still came over as totally femme and sexy...

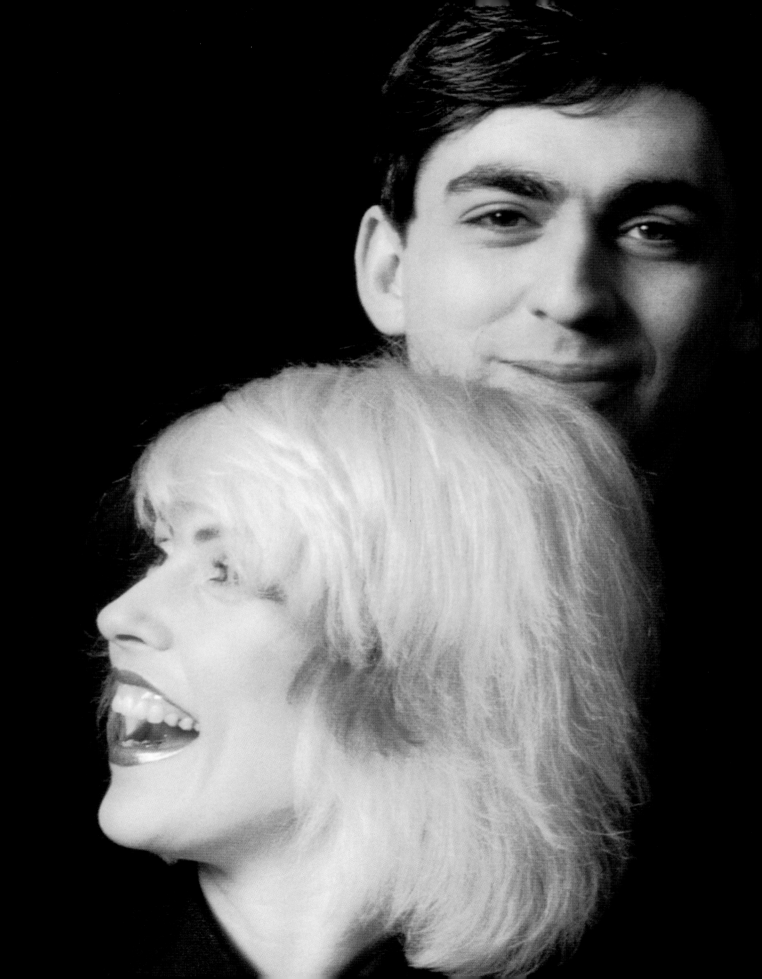

Two days after this session, Ernie was alone in the studio with our studio manager Annie Toglia, whom I had first encountered when she was working as assistant to *High Times'* art director, Toni Brown. This being New York in the lawless '70s, security was at a premium. The city was awash with drugs and police corruption was rife. Pimps, hookers, transvestites were everywhere. It was the naughtiest city in the world. It had a wide-open atmosphere, like the Wild West, which of course added to the aura that excited us all so much. It was a very different place from the post-Guiliani city of today, when even Times Square and the East Village have been rendered safe and gentrified.

It was around tea-time. Ernie and Annie were awaiting my arrival. We were going to discuss up-coming sessions and I had been to the bank to get us some cash. They had left the elevator and the gate into the studio unlocked because of my imminent arrival. As they later recounted the events to me, they were in the office and hearing the elevator arrive at our floor they assumed it was yours truly. Ernie called out my name and when he received no response, he poked his head around the door to find a pistol leveled at his head. The gentleman in question after gesturing for Ernie and Annie to raise their hands explained that he was really more interested in the garment manufacturer two floors down (we were located on the 6th, the top floor) whom he had heard kept a lot of cash around. Unfortunately for him (and us!) for some reason they had closed up early that day, so he had come to the next open floor – ours! – and he wanted money, immediately. He put the barrel of the gun right at Ernie's temple and threatened to blow him away if he didn't hand over all the cash on the premises.

He ordered Annie to cut all the phone wires.

He had come to the building expecting a sizable score, so he was very irritated by the fifty dollars they were able to scrape together.

He made them open all the filing cabinets and cupboards on the premises for him to rifle through, and kept asking whether anyone else was going to come. He was very nervous and Ernie and Annie were scared the gun might go off by accident. He was clearly high on speed, Ernie observed, with his darting eyes and the manner in which he kept grinding his teeth. All the time they both kept thinking that I was going to arrive.

I had been delayed by the charms of a young lady of recent acquaintance who lived near the studio and had insisted on entertaining me that afternoon. I was very easily led astray in those years, fortunately for me. Somehow Ernie kept his cool and eventually managed to communicate to the gentleman in question that this was a photo studio and not a regular business. We didn't keep cash around. To alleviate the tension, he offered him my Hasselblad!!! That would bring him some money on the street. It was, he underscored, the most expensive camera in the world. After much cursing and more threatening gesticulations, the robber grabbed the camera. He warned Ernie and Annie not to go for help for thirty minutes; he'd be watching the building and would blow them away if he saw them trying to leave. I arrived fifteen minutes later with a pocketful of cash that I owed to Ernie.

'Just as well you were late as usual', blurted Annie.

I was a little miffed that Ernie had given up my camera. The guy clearly didn't have a clue about the camera's worth and probably sold it for a fraction of its real value. However, I did say a quiet prayer for the young lady who had made me late.

Subsequently, we put up big notes to remind us to always lock the elevator and the gate from then on...

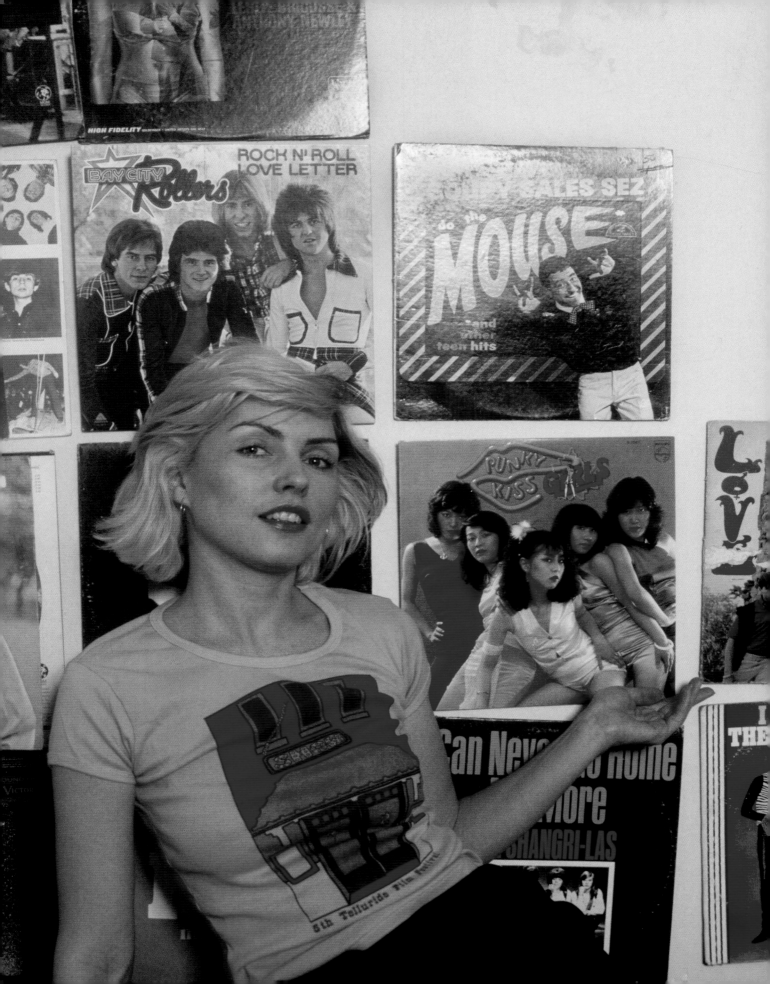

Another magazine I did occasional freelance work for was a German rock magazine called *Bravo*. They wanted some photos of Debbie and Chris at home.

THEY WERE VERY ACCOMMODATING. THEY JUST DIDN'T WANT ME TO BRING ANY ASSISTANT AND DEBBIE WOULD TAKE CARE OF HER OWN HAIR AND MAKEUP.

At the time they lived in a medium-sized penthouse apartment on West 58th Street between 7th and 8th Avenues. They were late risers, as was I, so we decided to do it one evening. I brought my Hasselblad and a small electronic flash kit with one head.

The magazine briefs in those days were minimal, so I had no idea how many photos would be used. Not that it mattered to me. I just liked to shoot and would point my lens at whatever caught my eye. The décor in the apartment was eccentric bohemian, very 'downtown' in spirit. I don't recall any curtains in the living area or anything elaborate or expensive in the décor. They lived very much like I lived.

For the first setup they pinned an interesting mosaic of fun-looking album covers to the wall, so I could photograph them in front of them holding their gold records. Considering how many records they must have sold by then – the summer of 1979 – they sported few of the trappings or excesses of rock 'n' roll success. They had some quality audio and tape equipment, but otherwise it was all very 'arty' and hip-domesticated. They seemed very comfortable and relaxed and affectionate and clearly enjoyed each other's dry sense of humour. Above all they gave an impression of not wanting to take their success too seriously. Later I realized that for all the money they were generating only a certain amount was sticking to them.

There were so many advances, ex-managers and loans to pay off. Plus there were six of them to share in the royalties.

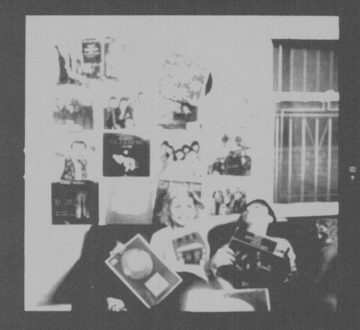

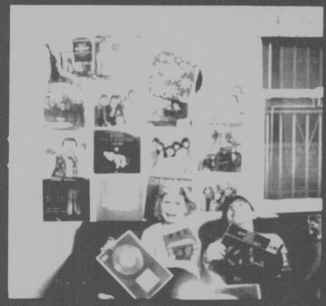
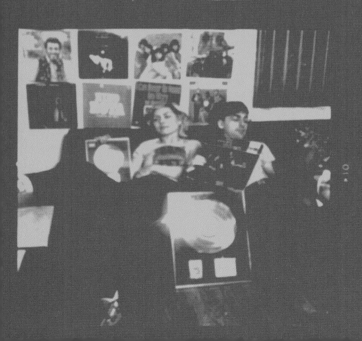
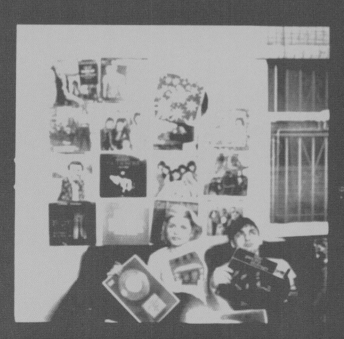

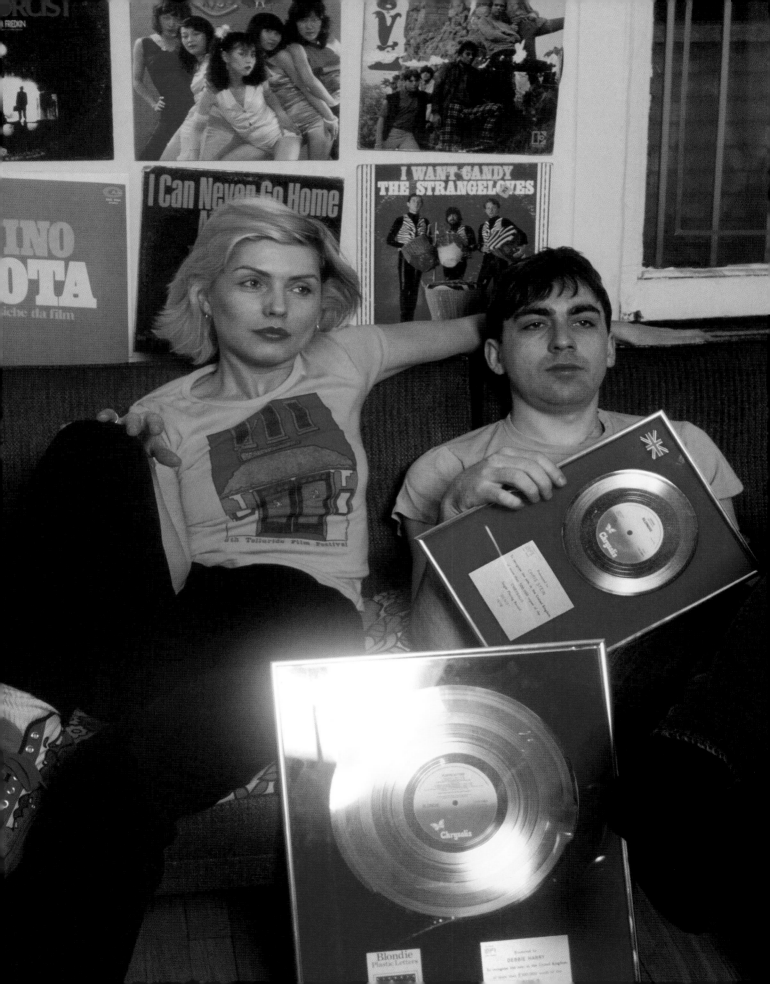

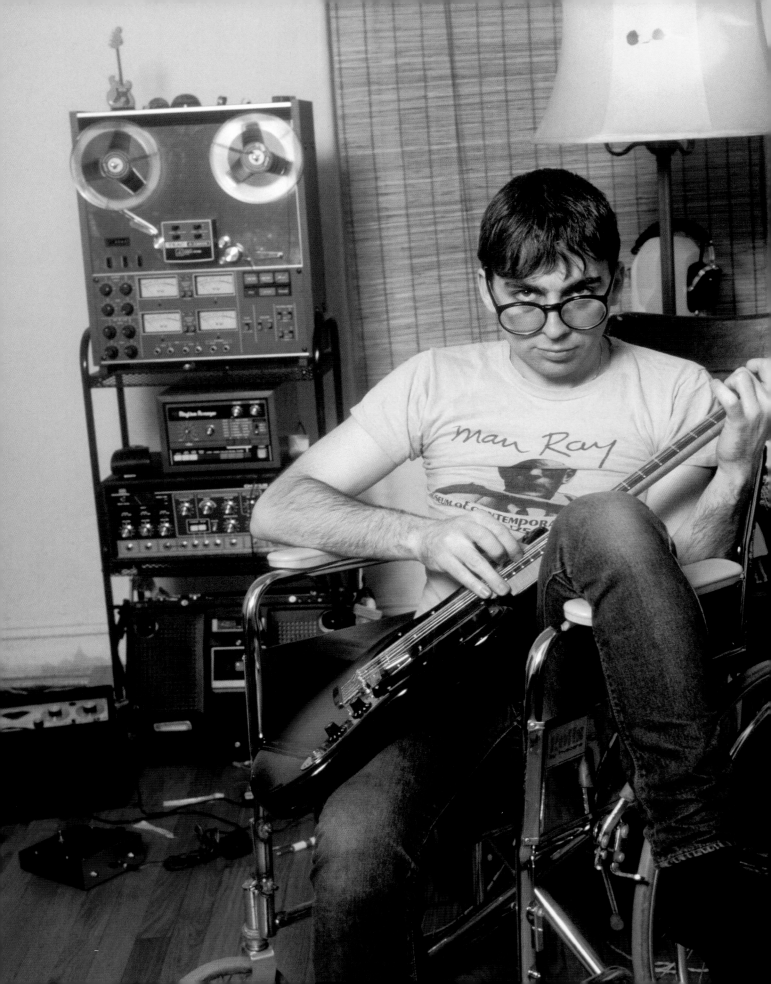

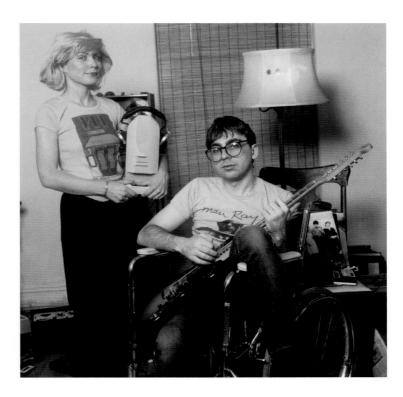

Chris was obviously tickled by his wheelchair.

'What we do is cripple rock', he laughed.

They had lots of fun play acting at roasting troll dolls in the kitchen.

THEY WERE VERY OPEN AND UNPRETENTIOUS.
THIS WAS REALLY THEM AT HOME, GOOFING AROUND,
MUGGING FOR THE CAMERA, AND ENJOYING THE
SHOOT. I ESPECIALLY LIKE THE FRAMES IN THE
BEDROOM. THEY LOOK SO REMARKABLY YOUNG AND
AT EASE — INNOCENT ALMOST. THEY HAD BEEN
THROUGH A LOT TOGETHER AND THE TRUST BETWEEN
THEM RAN DEEP AND IT SHOWED.

Bravo ran maybe three or four shots and that was it.

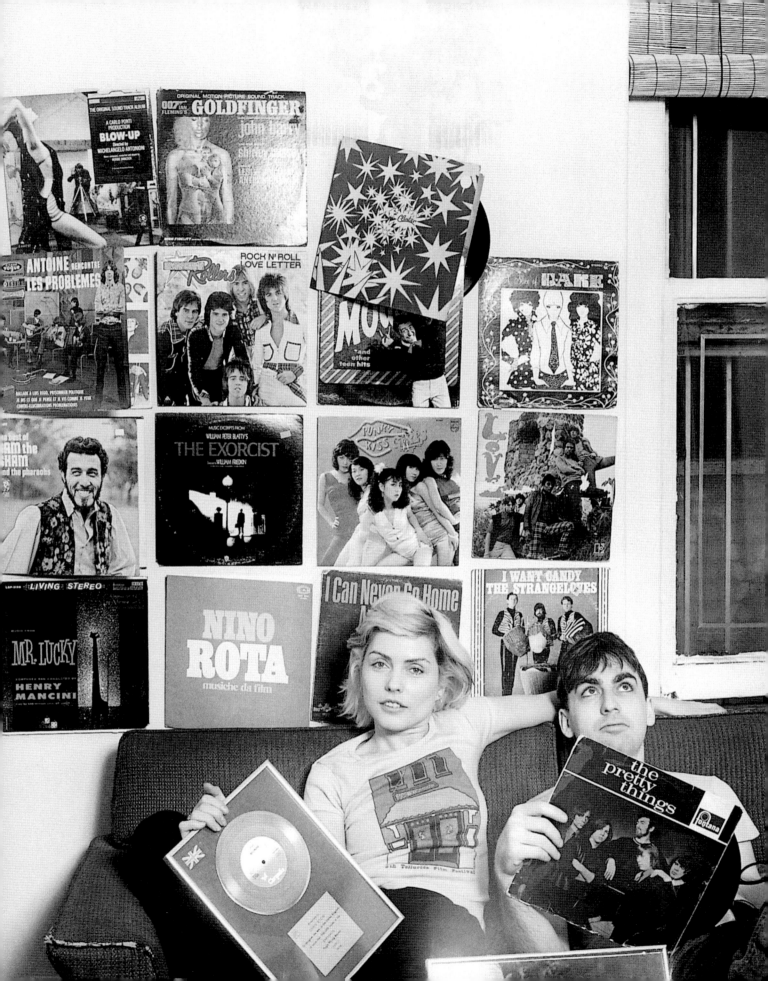

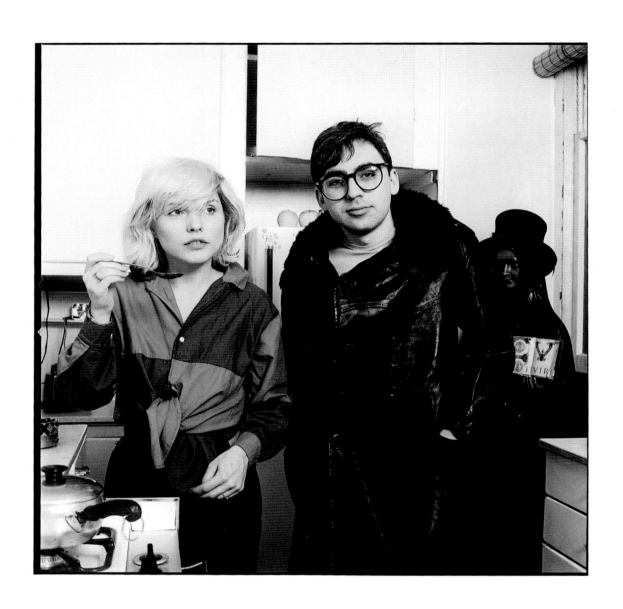

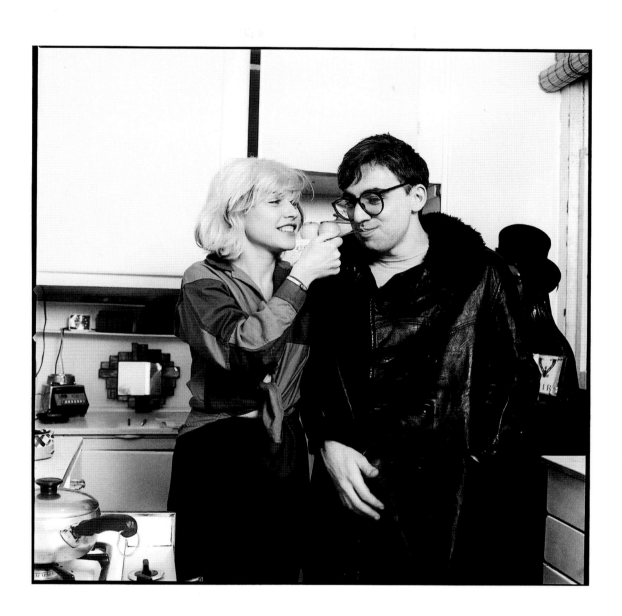

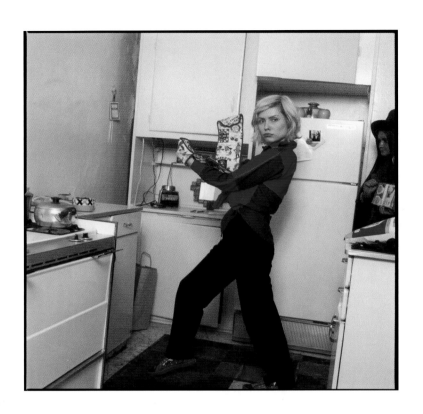
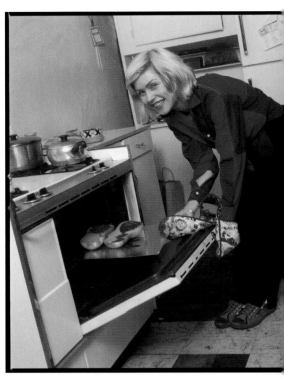

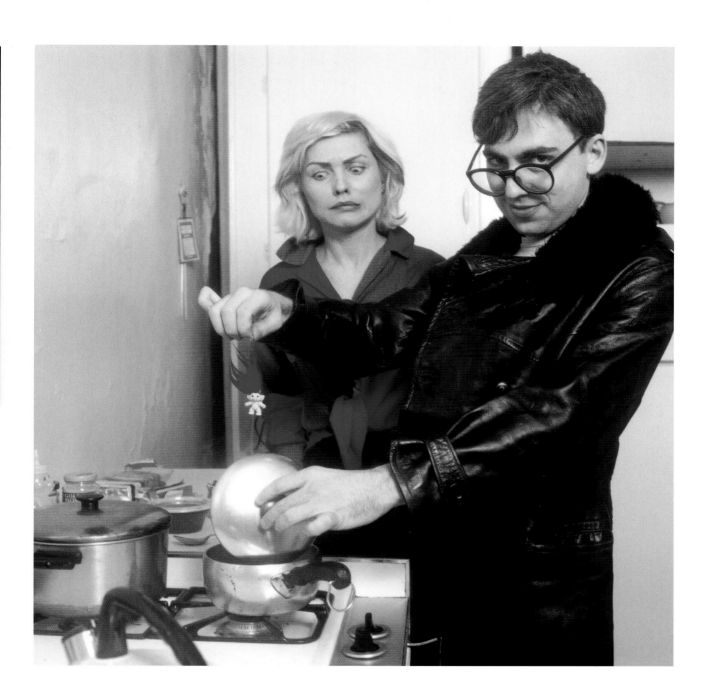

OTHER THAN A COUPLE OF THE KITCHEN BLACK AND WHITE PICS WHICH EVENTUALLY SHOWED UP IN MY COLLECTION OF GLAM-PUNK PICS *BLOOD AND GLITTER*, PUBLISHED IN 2001, THIS SESSION LAY BURIED UNTIL I SIGNED THE DEAL FOR THIS BOOK AND STARTED RUMMAGING. PROBABLY BECAUSE THEY ARE NOT THE ICONIC KIND OF IMAGERY THAT NORMALLY STIRS MY IMAGINATION AND THAT ARE MOSTLY ASSOCIATED WITH MY NAME, I HAD COMPLETELY FORGOTTEN ABOUT THIS SESSION.

BUT AS I REVIEW THEM NOW, I'M REALLY TAKEN WITH HOW MUCH THEY REFLECT, IN THEIR VERY RELAXED WAY, DEBBIE AND CHRIS' TRUE PERSONALITIES AT THIS TIME: THE HUMAN TOUCH BEHIND THE PUBLIC IMAGE.

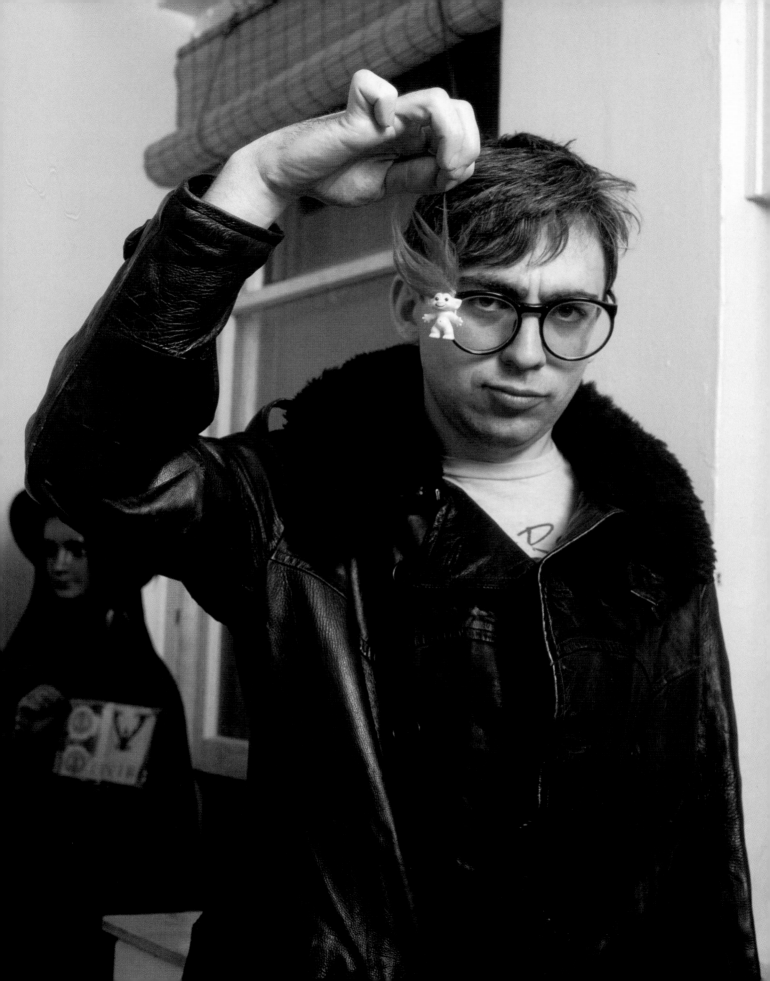

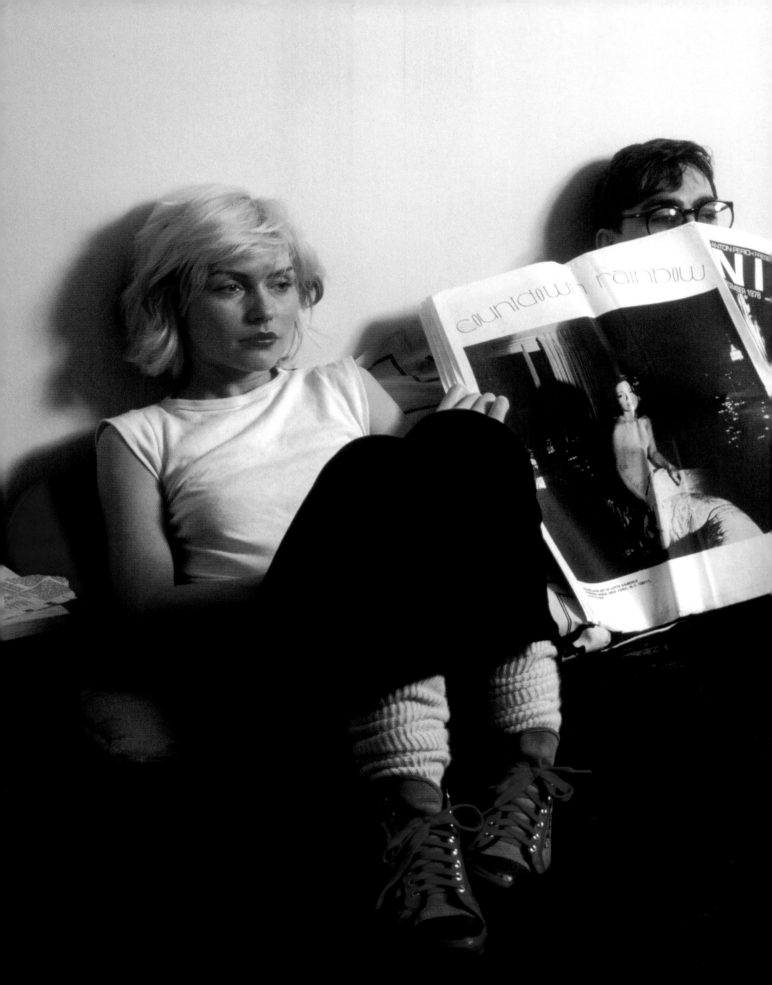

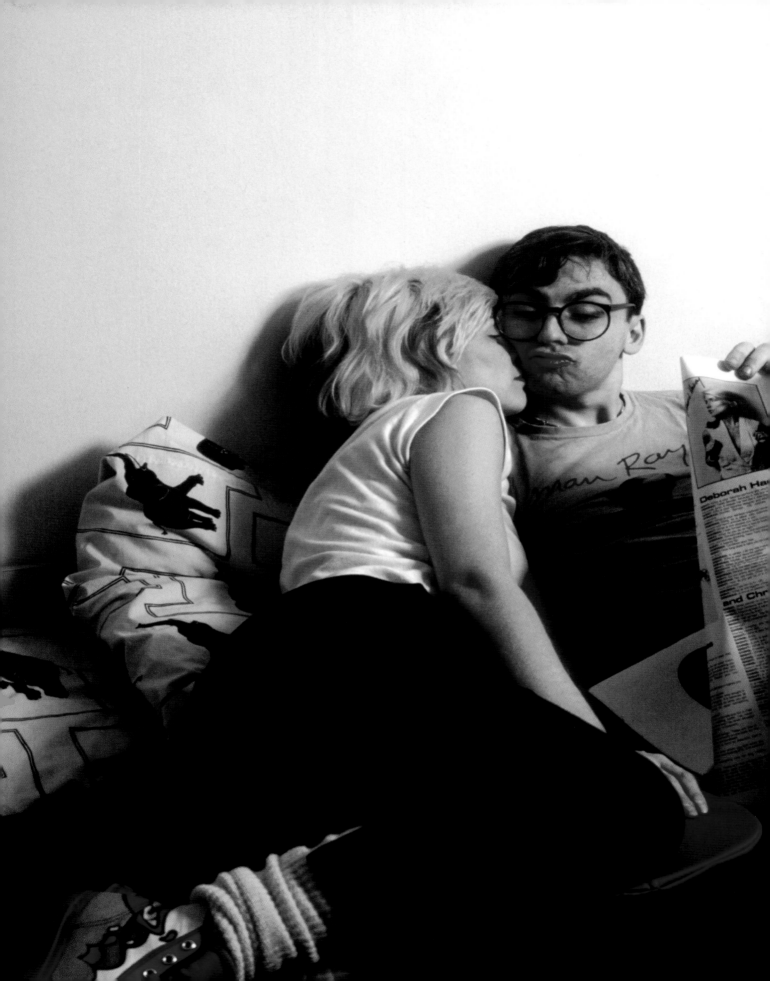

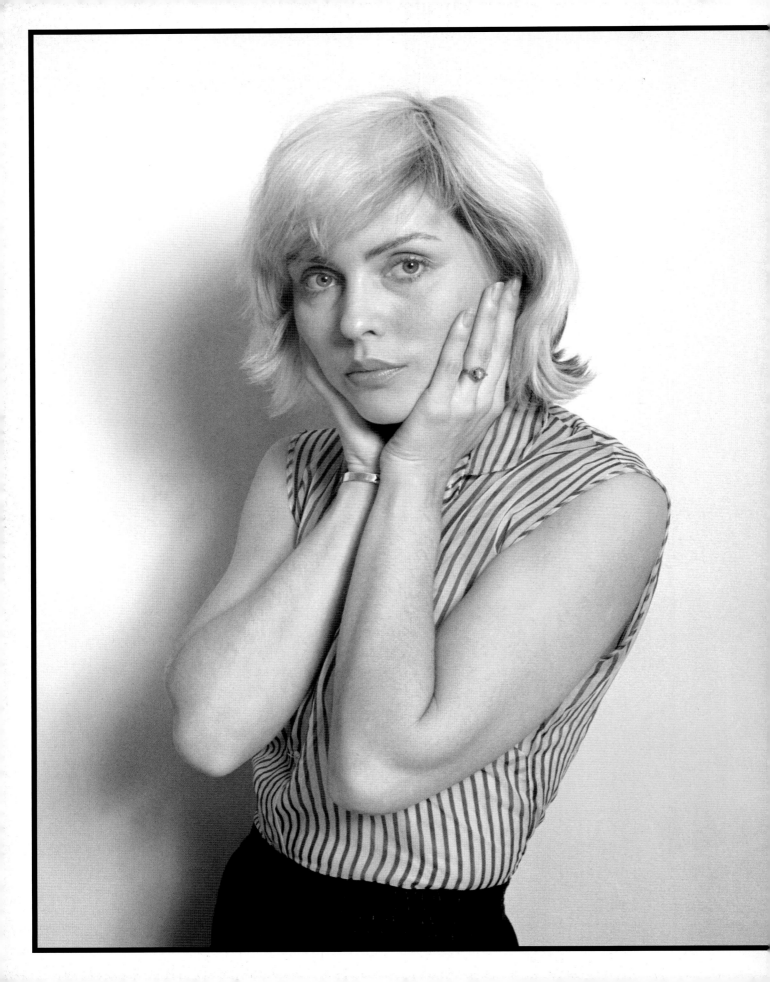

I MUST HAVE SPENT THREE OR FOUR HOURS
CHATTING AND SHOOTING, AND AT THE END,
I TOOK A COUPLE OF BLACK AND WHITE ROLLS
OF DEBBIE AGAINST A WHITE DOOR. AGAIN
THERE'S A NATURALNESS ABOUT THESE IMAGES
THAT I COMPLETELY UNDERESTIMATED AT THE
TIME. I WAS ALWAYS IN SEARCH OF SOMETHING
DRAMATIC, EXTREME, AND ICONIC. BUT THERE'S
FRESHNESS AND INNOCENCE, AND AN ALMOST
COMPLETE LACK OF SELF-CONSCIOUSNESS THAT
ISN'T QUITE PRESENT IN OTHER PHOTOS OF
DEBBIE; TOTALLY DEVOID OF ANY ATTEMPT TO
PLAY TO HER 'BLONDE' IMAGE.

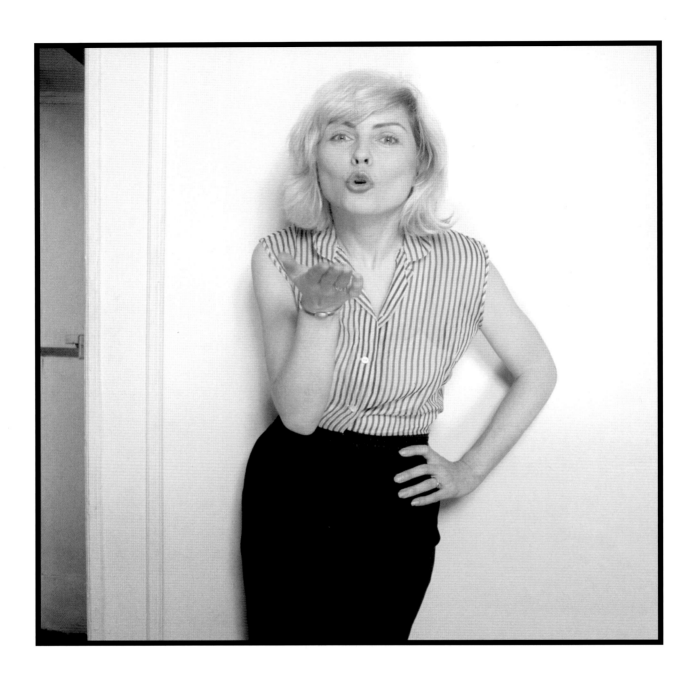

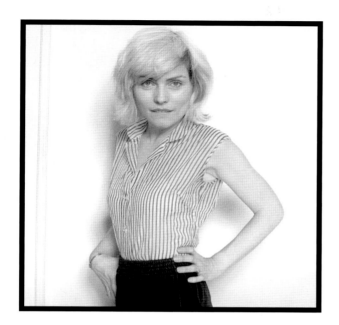 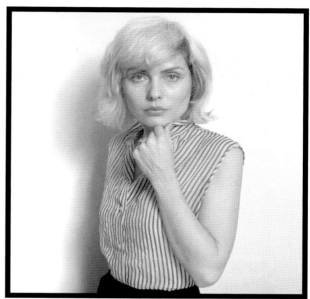

THE PASSAGE OF TIME (AND THESE WERE TAKEN
NEARLY A QUARTER CENTURY AGO, IT'S SHOCKING
TO REALIZE) LENDS A COMPLETELY DIFFERENT
RESONANCE TO CERTAIN PHOTOGRAPHS.

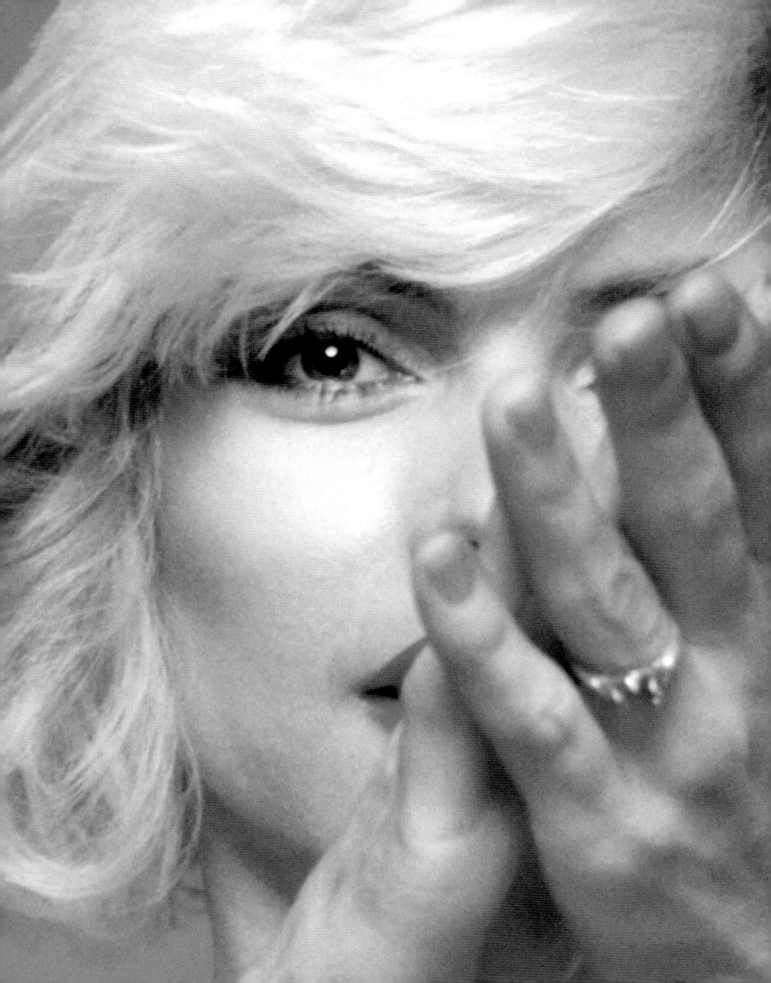

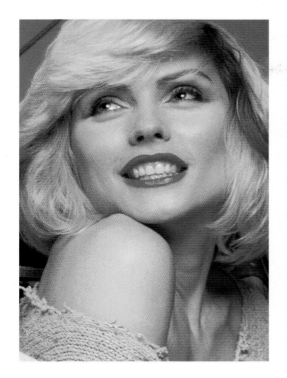
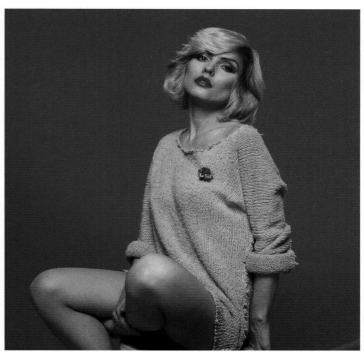
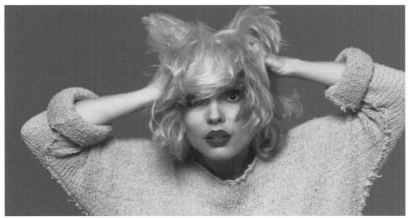
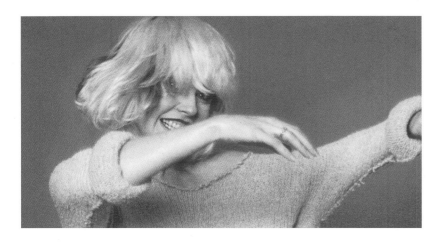

THE FINAL SESSION OF THAT PERIOD WITH DEBBIE
AND THE FABULOUS BLONDIE BOYS CAME IN THE
AUTUMN DURING THE EAST COAST OF AMERICA'S
INDIAN SUMMER. MY NERVOUS SYSTEM WAS GOING
SO FAST (AND GETTING FASTER BY THE DAY!) THAT
I CAN'T QUITE RECALL WHAT THE MOTIVATION FOR
THE SESSION WAS – PROBABLY FOR YET ANOTHER
MAGAZINE. SOMEWHERE I HAVE CLIPS FROM AN
ENGLISH TEEN FASHION MAGAZINE WHICH
FEATURES A FEW FRAMES.

I DO REMEMBER THAT AS WAS TYPICAL OF ME
IN THOSE DAYS, ALL MY PREPARATION WAS VERY
LAST MINUTE. I HAD COME UP WITH SOME KIND
OF CONCEPT, AN IRONIC COMMENT ON POP
SUCCESS, POSSIBLY?

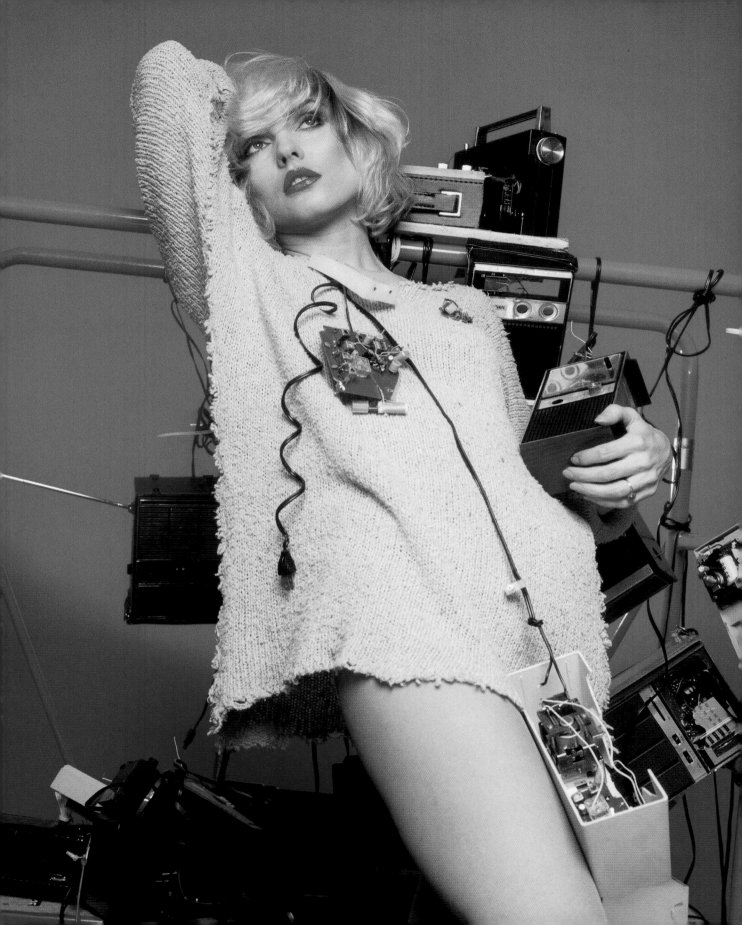

So the first essential move was the obtaining of the radios. The session was scheduled to start mid-afternoon and for some reason I distinctly remember it was a Saturday. As usual, I had probably been up all night. So, late that morning, Annie Toglia and I ventured down to Chinatown's Canal Street. We must have decided we would find some cheap, second-hand radios in some of the junk shops, of which there were many, and we were obviously successful because there are plenty of radios evident in the photos. Annie was privy to much of the madness in my years at the Madison Avenue studio, most of which she seemed to find very amusing. Ostensibly she was the studio manager, certainly she typed the invoices, chased the money and made sure the bills got paid. She also did her best to guard me against some of the more dangerous and destructive elements that I would leave myself open to; although not always as effectively as she would have liked. But she did her best, while also not being averse to a little self-indulgence herself. She became a great friend and hangout pal. She saw the dawn rise with me after many of my crazy all-night marathon shoots...

But the details of 'those' sessions are for another time and space. Suffice to say she was probably the most informed about my constant and persistent libidinal peccadilloes. She was the one who covered my rear end on many occasions, and remains a friend to this day.

Thank you, Annie.

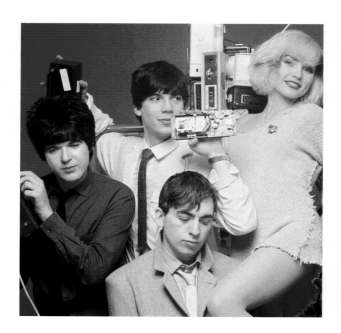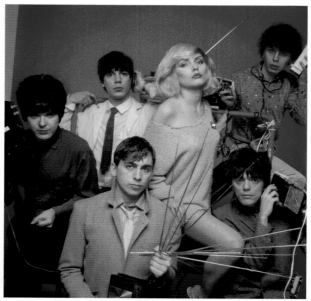

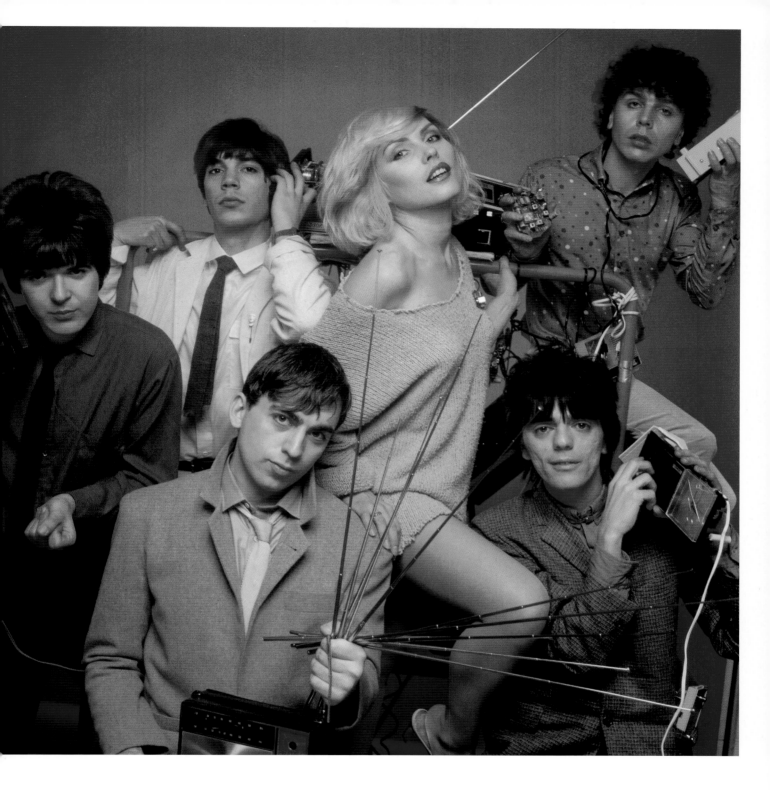

NONE OF THIS WAS VERY THOUGHT OUT: JUST THIS QUICK FLASH OF BROKEN TRANSISTOR RADIOS (BROKEN DREAMS, MAYBE?)

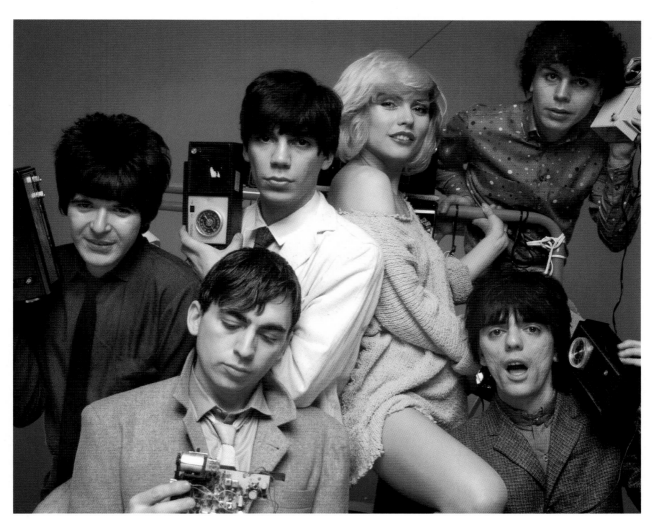

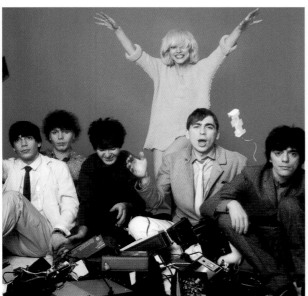

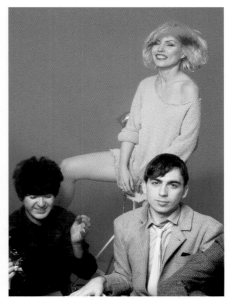

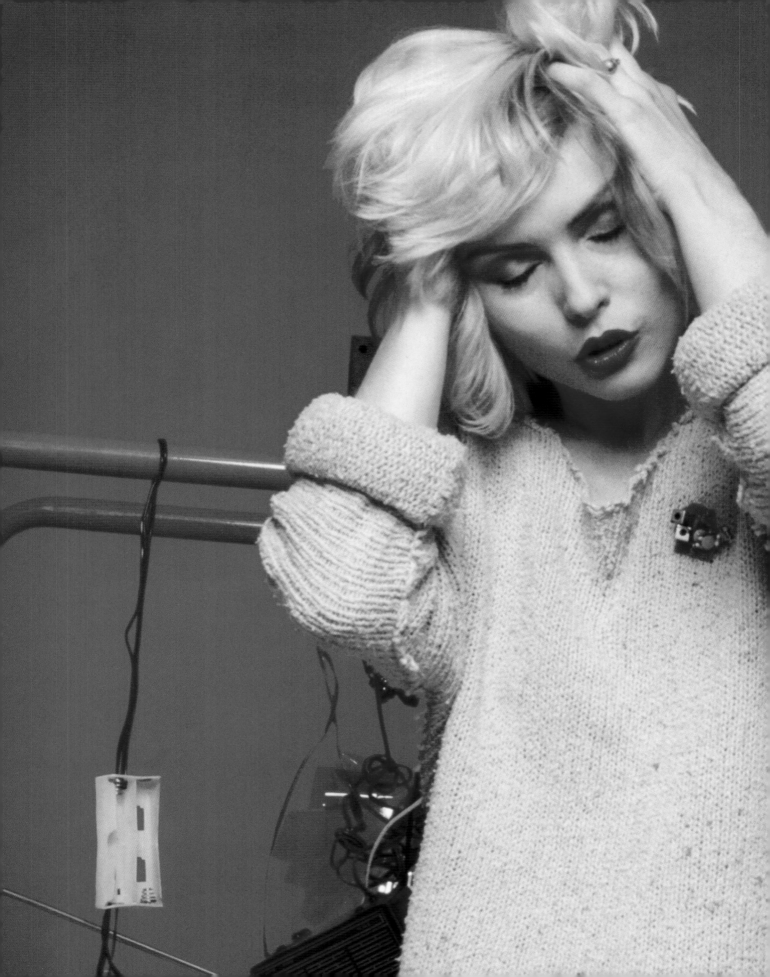

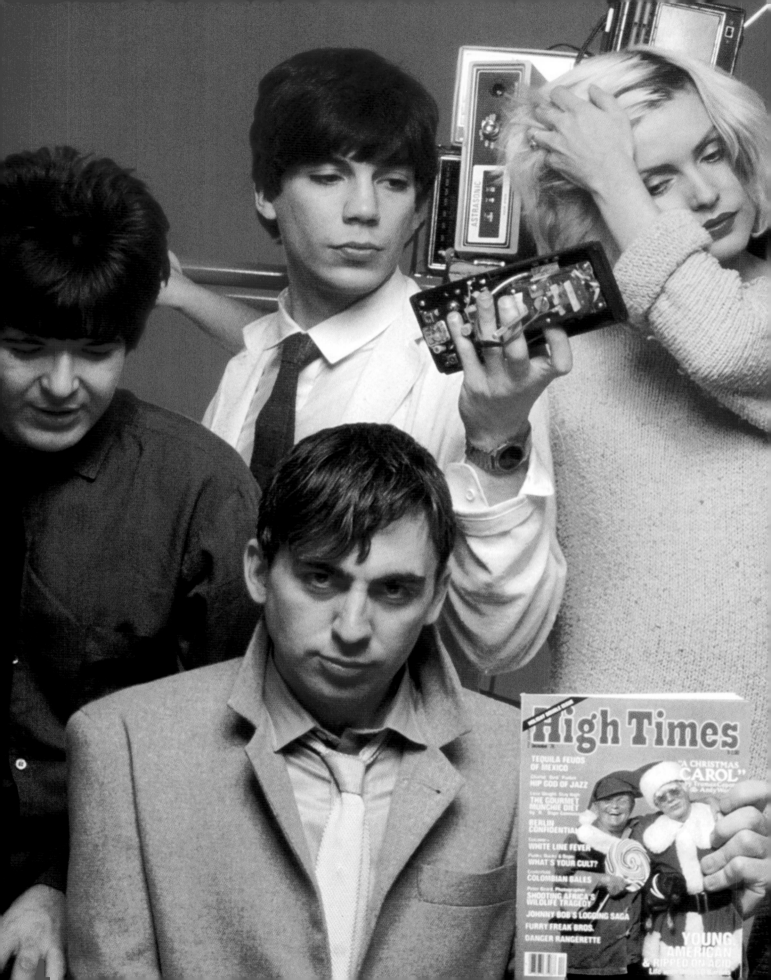

High Times

TEQUILA FEUDS
OF MEXICO

HIP GOD OF JAZZ

THE GOURMET
MUNCHIE DIET

BERLIN
CONFIDENTIAL

WHITE LINE FEVER

WHAT'S YOUR CULT?

COLOMBIAN BALES

SHOOTING AFRICA'S
WILDLIFE TRAGEDY

JOHNNY BOB'S LOGGING SAGA

FURRY FREAK BROS.

DANGER RANGERETTE

A CHRISTMAS
CAROL

YOUNG
AMERICAN
& RIPPED ON ACID

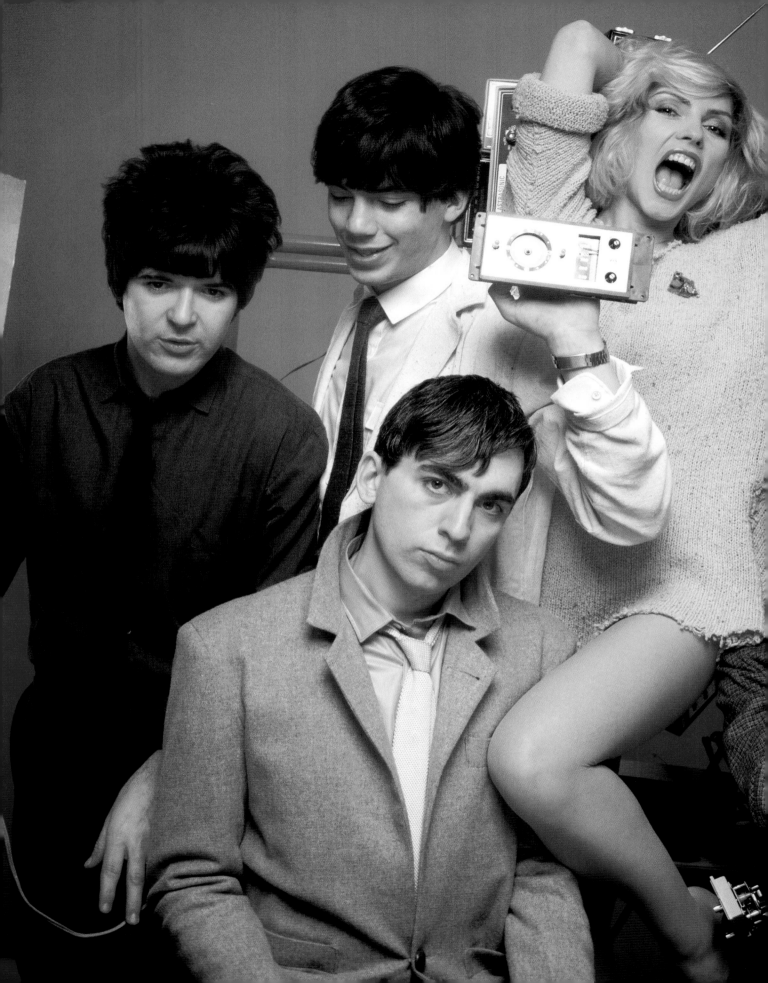

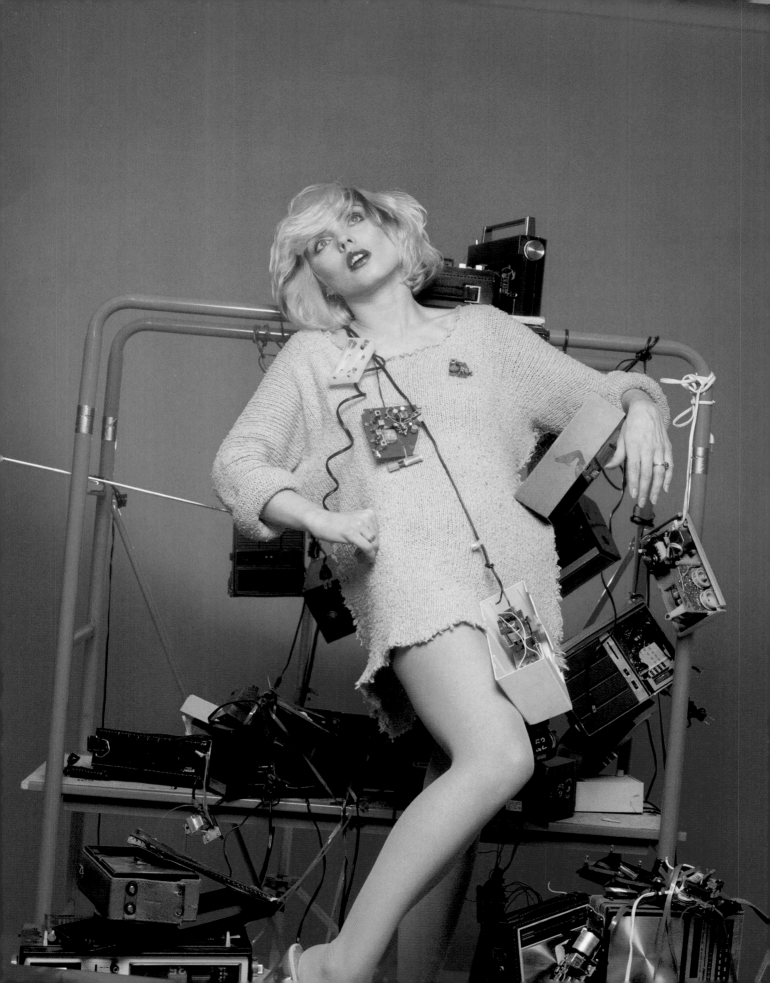

I had this orange mobile trolley with a corked platform. The photographer I shared space with had brought it to the studio. I believe it was a kind of trestle to stand on while painting walls and the ceiling. Buried somewhere I have some bizarre pix of John Cale, up with me for three days, hanging off it.

On another occasion, I draped it in black gauze and had a couple of naked young ladies cavort on it for an 'art photography' session…anyway it provided the perfect vehicle for the band to climb onto and to drape with the radios and their leads. It's all a little bizarre and I couldn't say what it means, but the lighting was good, the make-up (by Sharon Slattery) was excellent and everyone came across to their best advantage.

Finally in 2002 one of these images, with Nigel and Frank (who weren't invited to join the reformed Blondie of the late '90s and the present) edited out, made it on to the cover of the UK pressing of Blondie's greatest hits on CD and DVD.

"She could melt your sanity with a single curl of her lashes." GUSTAVE MOREAU

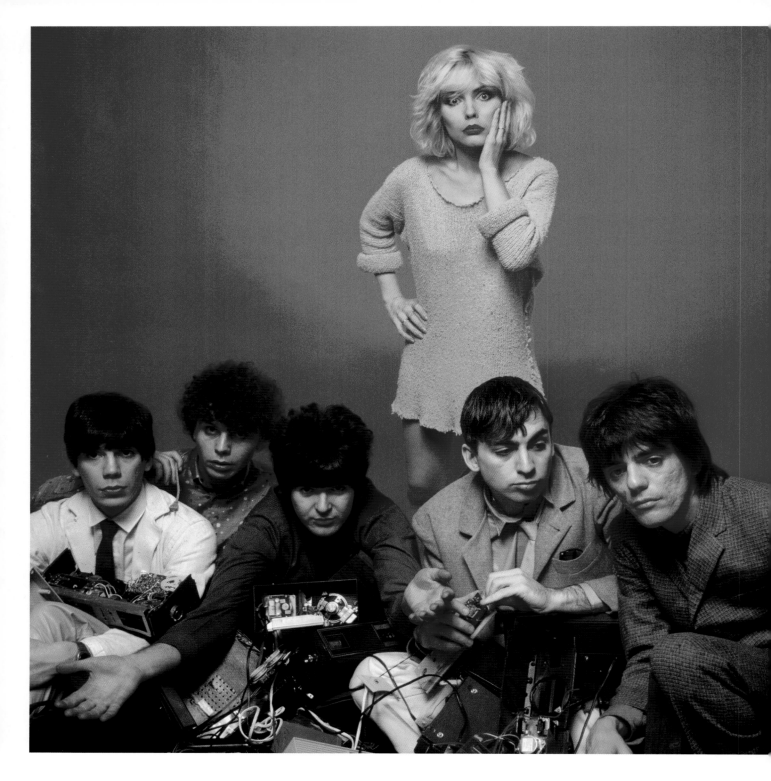

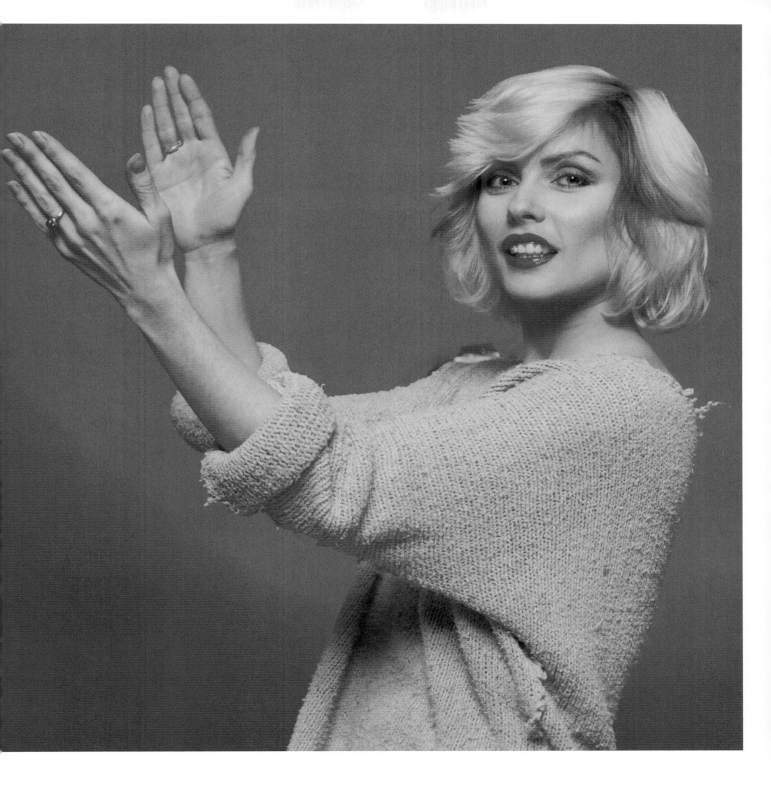

DEBBIE LOOKS TERRIFIC IN HER LITTLE FAWN CROCHETED DRESS, WHICH REVEALS HER SHOULDER AND THIGH VERY APPEALINGLY. I LOVE THE IMAGES WITH THE BAND ON THE GROUND, THE FLOOR LITTERED WITH BROKEN RADIOS AND DEBBIE DANCING AND PULLING FACES IN THE BACKGROUND. THEY WERE OBVIOUSLY TAKEN AT THE END OF THE SESSION AND THE CONTRAST BETWEEN THE POKER FACES OF THE BOYS AND DEBBIE'S LOONY EXPRESSIONS GIVE THE PHOTOS A UNIQUE SURREAL FLAVOUR. IT LOOKS LIKE THE END OF SOMETHING AND IT WAS. FOR VARIOUS REASONS, NO DOUBT DUE TO THE EXCESS AND PARANOIA OF THE TIMES WHICH BRED MANY AN IRRATIONAL MOMENT OF MISUNDERSTANDING, IT TURNED OUT TO BE MY LAST SESSION WITH BLONDIE.

"Wickedness is a myth invented by good people to account for the attractiveness of others." OSCAR WILDE

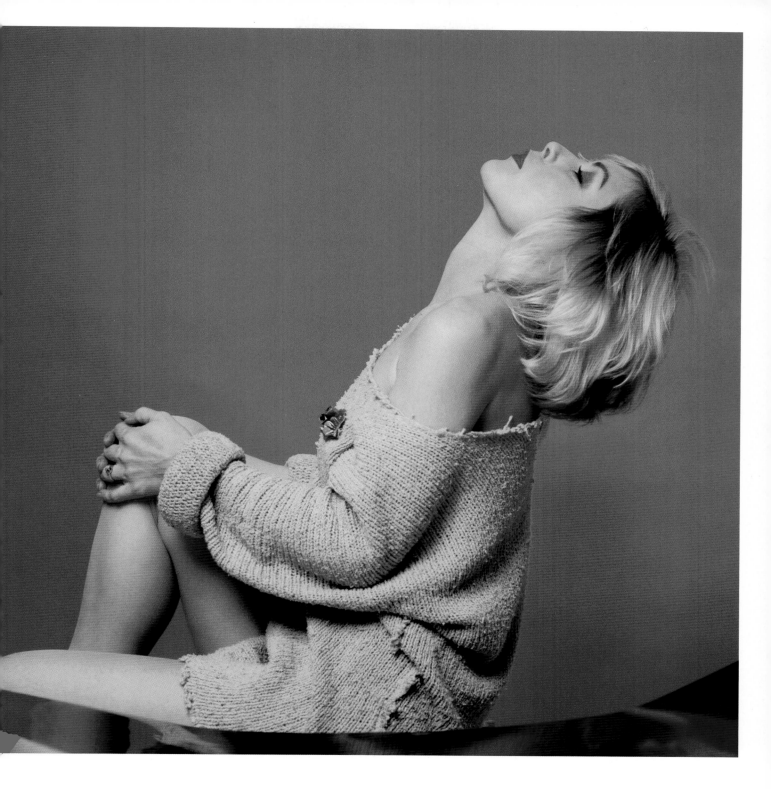

DEBBIE WOULDN'T GRACE MY LENS AGAIN
FOR OVER 20 YEARS…

Blondie as a band disintegrated after the release of their sixth album *The Hunter* in 1981.

The reasons for this are best left to the telling by the band members themselves, which they have freely related since their reunion in the late '90s. It is however clear that the eruptive insanity of New York's downtown culture of the '70s that bred and fostered them had a lot to do with it; coupled with the pressures of their overwhelming worldwide success in that period. Many of punk's offspring on both sides of the Atlantic fractured and withdrew in this period: Sex Pistols, Television, Richard Hell, Patti Smith, Johnny Thunders' Heartbreakers, and, soon after, The Clash and the Dead Boys. It was a time of extremes and over-imaginative indulgence. It was a lifestyle that I also immersed myself in up to my frontal lobes.

We all became delirious from teetering far too long at the cutting edge, peering wild-eyed and unrestrained into the brink and consuming the delicious, anarchic fumes it emitted. What drove us was not a longing for material recognition or wealth, but rather a lust to experience as many altered states as possible in as short a time as our overloaded nervous systems would allow. It was a period of high experiment and reckless foraging, fueled by a desire to rewrite all the rules of energy and obsession with no thought about the damage we inflicted on the bodies, psyches or emotions of others or ourselves. All that mattered was to live the anarchic bohemian life to the full and savour all the fruits of creative, sensual and chemical abandon and damn the torpedoes.

IT WAS AN EXTRAORDINARY AND EXHILARATING TIME AND WE WERE ALL INEVITABLY CHASTISED FOR THE FRENZY AND ARROGANCE OF OUR RELENTLESS BRINKSMANSHIP.

There are many tentacles to New York's rock 'n' roll saga of that period and not everyone has survived to tell the tale. There were compulsions born in that period that refused to cede to a more rational way of life.

That was certainly true of myself...

As the times changed and the exigencies of the material world bore down on me, as corporate mentality became the overriding force on the rock 'n' roll planet, I opened my creative antennae into broader fields – art direction, video directing, collage. I never ceased to work – after all rock photography had always yielded modest financial returns, and the escalating expenditures of the '80s and early '90s had to be paid...

I finally came face to face with my own personal Armageddon Thanksgiving of 1996 when I awoke in a hospital bed in New York, cut to the quick with my heart by-passed four times, totally looped on morphine and chemical withdrawal. The time had come to pay the piper and he wanted more than a pound of flesh. I still vividly remember that strange afternoon of my six hour blood transfusion; while on the other side of the partition lay an elderly gentleman who had been spawned in that part of Romania called Transylvania... It was a massive infusion and it cleansed my heart and soul of all its demons, and I was in a sense reborn.

THEY SAY WHAT DOESN'T KILL YOU MAKES YOU STRONGER; AND THE EXPERIENCE OF THOSE WEEKS ON MY BACK, AND THE AMOUNT OF PAIN AND BLOOD-LETTING I EXPERIENCED FLUSHED AWAY SO MANY IMBALANCES AND TREPIDATIONS.

Debbie of course had her own difficult times and that is her tale to tell.

THE MIRACLE MAY BE THAT UNLIKE HER ROLE MODEL MARILYN MONROE, SHE DIDN'T SELF-DESTRUCT.

In fact she continued to work and record albeit with a lower profile and much less commercial success throughout her non-Blondie years. And as has been well documented she nursed Chris Stein through his own mysterious life-threatening illness.

CERTAINLY SHE HAS PROVEN TO BE MUCH TOUGHER AND MORE DURABLE THAN ANYONE WOULD HAVE PREDICTED, GIVEN HOW SWEET AND VULNERABLE HER '70S PERSONA WAS. AND FOR SOMEONE SO IDENTIFIED WITH THE YEARS OF THEIR EARLY SUCCESS, THE REBIRTH OF BLONDIE HAS PROVEN HER TO BE A TRANSCENDENT CULTURAL FORCE FOR THE AGES.

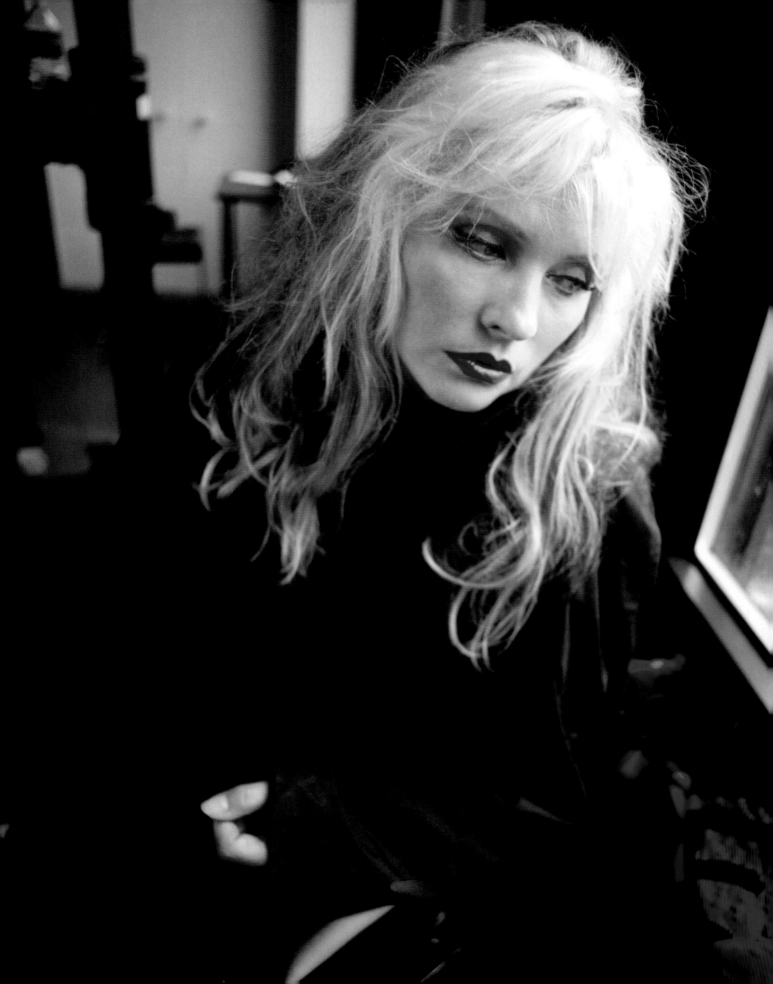

In the spring of 1998 with Blondie in the studio recording their first album since 1981, Debbie and Chris (unannounced, although the word had filtered on to the streets) performed a few songs for their first New York performance in years at Tramps.

Although a short set, it had a magical charm and made clear that the upcoming official Blondie reunion tour would not just be an exercise in tired nostalgia. The excitement in the club was electric and the empathy from the audience was palpable. The chemistry between them had not been diminished by their years in the wings.

And although I had rarely shot live performances since the early '80s, I couldn't resist tracking them again with my lens.

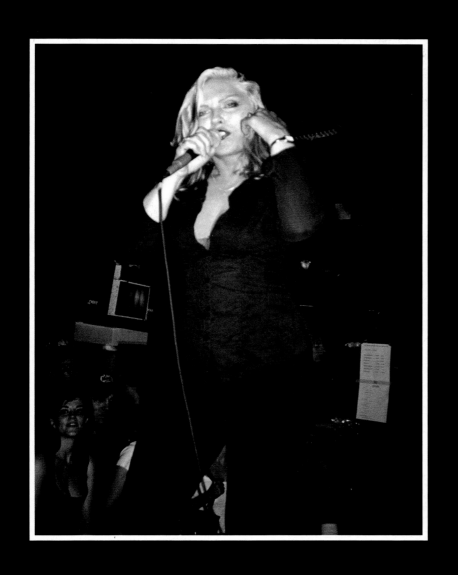
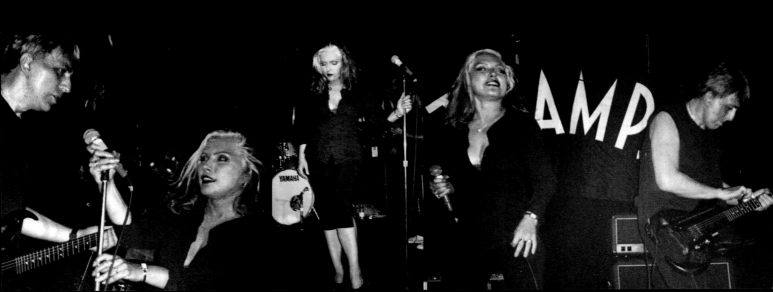

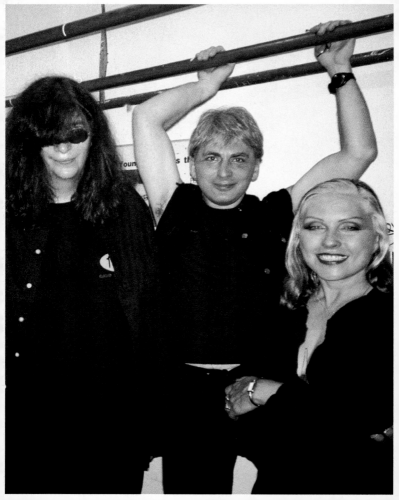

I WAS IMPRESSED BY HOW MUCH MORE RESONANCE AND RICHNESS THERE WAS TO DEBBIE'S VOICE: THE PASSAGE OF THE YEARS HAD SERVED HER SPECIAL TALENT WELL. THE BLONDE HAD RETURNED TO STAKE HER CLAIM TO HER PERSONAL CROWN, AND THE AUDIENCE SPARKLED WITH APPRECIATION, IT WAS, AS CLICHÉD AS THIS MAY SOUND, AS IF SHE'D NEVER BEEN GONE.

I HAD SEEN HER OCCASIONALLY IN SOCIAL CIRCUM-STANCES IN THE '90S BOTH BEFORE AND AFTER MY HEART OPERATION, AND EVEN GRABBED A FEW PARTY SNAPS BUT THIS WAS THE FIRST TIME I HAD SEEN HER PERFORM SINCE 1980 AND I WAS EXCITED. AFTER THE SHOW I WENT BACKSTAGE AND RAN OFF A FEW FRAMES OF CHRIS, DEBBIE, AND THE LATE AND BRILLIANT JOEY RAMONE. THIS WAS A SPECIAL OCCASION AND I FELT THE NEED TO HAVE A RECORD OF IT.

A few weeks later, we had dinner and talked of doing a new session, curious to see if we could recapture some of the special juice of those early sessions which over the years had come to be regarded as iconic. We had both weathered the years of confusion and realignment and rediscovered the energy and desire of yore, and in a way were both being rediscovered and appreciated by a new and enthusiastic generation of rock 'n' rollers.

Finally the stars found their alignment and Marlon Richards, Keith's son, asked me if I thought Debbie would be receptive to shooting a cover for the magazine he was art directing, *Cheap Date*, and the project would be gilded by Marlon's mom, the very fabulous Anita Pallenberg, who was conducting an interview for the same issue.

This was of course an offer neither Debbie nor I could refuse.

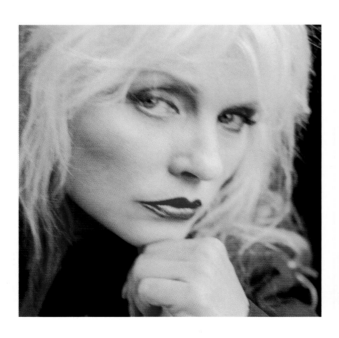
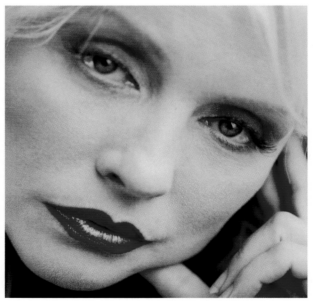

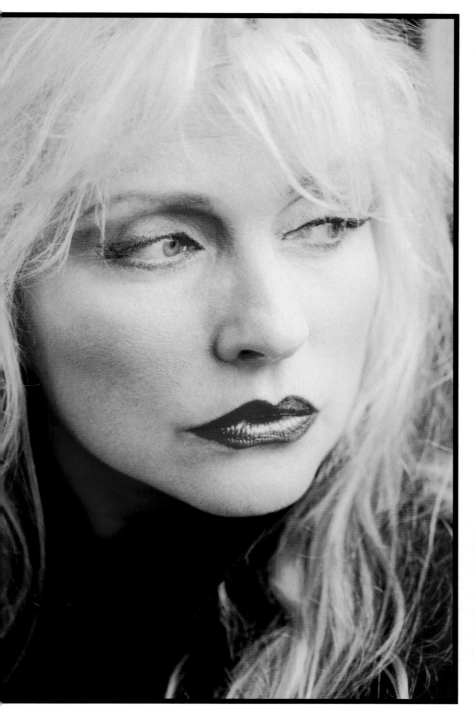
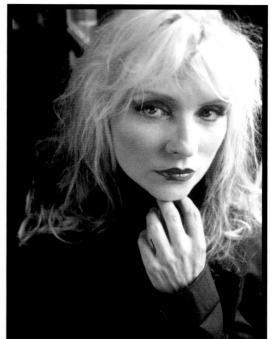
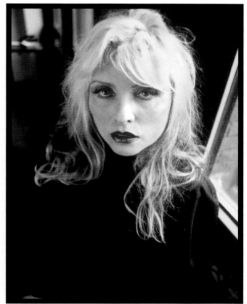

WE SHOT AT MILK STUDIOS ON WEST 15TH STREET IN MANHATTAN, ONE OF A ROSTER OF SPACIOUS AND WELL APPOINTED NEW STUDIOS THAT HAD SPRUNG UP TO SERVICE THE DYNAMIC MODERN PHOTO INDUSTRY.

IT WAS A FAR CRY FROM THE MODEST CIRCUMSTANCES OF THE '70S WHEN PHOTOGRAPHY WAS STILL REGARDED AS ONE OF THE LESSER ARTS, AND WHEN THERE WERE RELATIVELY FEW OUTLETS FOR OUR IMAGES.

I REMEMBER ARRIVING EARLY WITH A COUPLE OF ASSISTANTS AND MARLON TO SET UP THE LIGHTS AND THE MOOD OF THE SESSION. VICKIE BARTLETT, ONE OF THE BEST OF THE MODERN FASHION STYLISTS, HAD ASSEMBLED AN IMPRESSIVE ARRAY OF COUTURE AND STELLA ZOTIS, A PERSONAL FAVORITE OF MINE WITH A GREAT ROCK 'N' ROLL TOUCH, WAS TO DO THE HAIR AND MAKEUP.

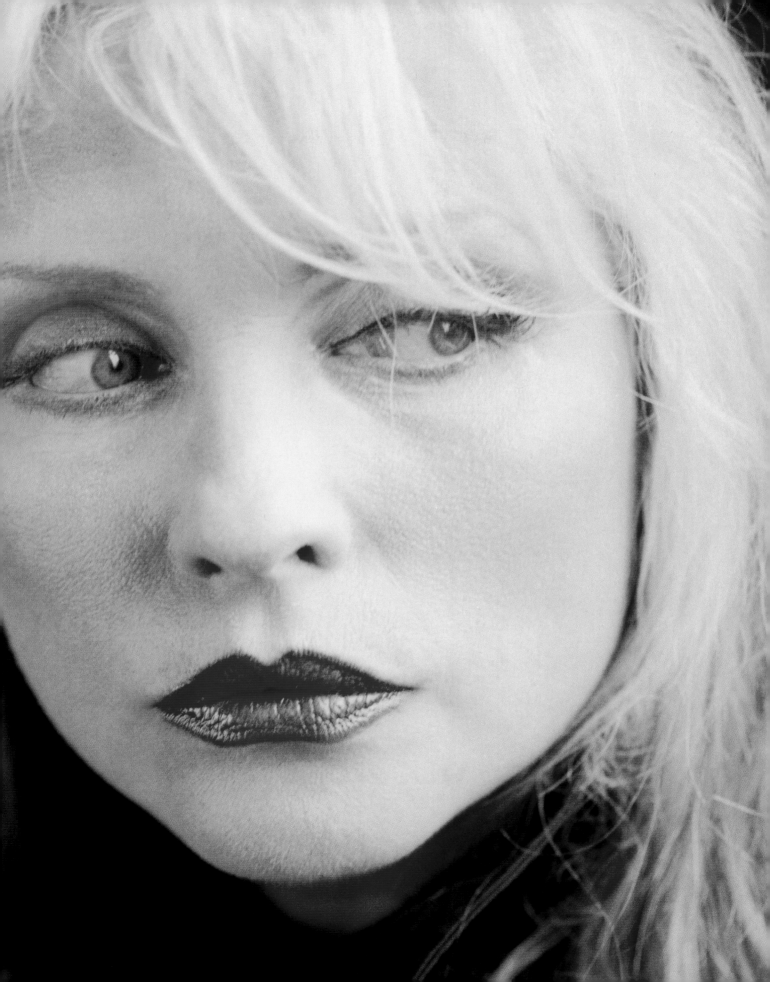

RIGHT ON SCHEDULE, WITH NO FANFARE OR RETINUE, DEBBIE SLIPPED QUIETLY INTO THE STUDIO. HER ALL-ENDEARING SMILE AND MODEST DEMEANOR CHARMED EVERYONE INTO ACTION. SHE FRETTED WITH HER SCHOOLGIRL GIGGLE THAT MAYBE SHE DIDN'T LOOK HER BEST. BUT OF COURSE SHE LOOKED DELIGHTFUL, AS THE RESULTANT PHOTOS BEAR WITNESS. WITH MY USUAL BRAVADO, I DECLARED THAT WE WERE GOING TO TURN BACK THE CLOCK AND EVOKE THE SPIRIT OF OUR FIRST GREAT STUDIO SESSION WHERE HER HAIR WAS VERY SIMILAR IN LENGTH AND STYLE.

We chose five different ensembles from the myriad provided by Vickie, but in some ways the images I like best are still the ones where she is clothed in black up to her neck.

We very consciously styled some of these frames with a scarf and emphasized the hands to directly evoke the feel of the cover of this book (and also of *Penthouse*, 1980).

I used a different lighting source (Tungsten as opposed to electronic flash) for this set-up in order not to simply copy those earlier images.

Evocation, not imitation, was the key word and the spirit of Marilyn Monroe worked the studio again that day.

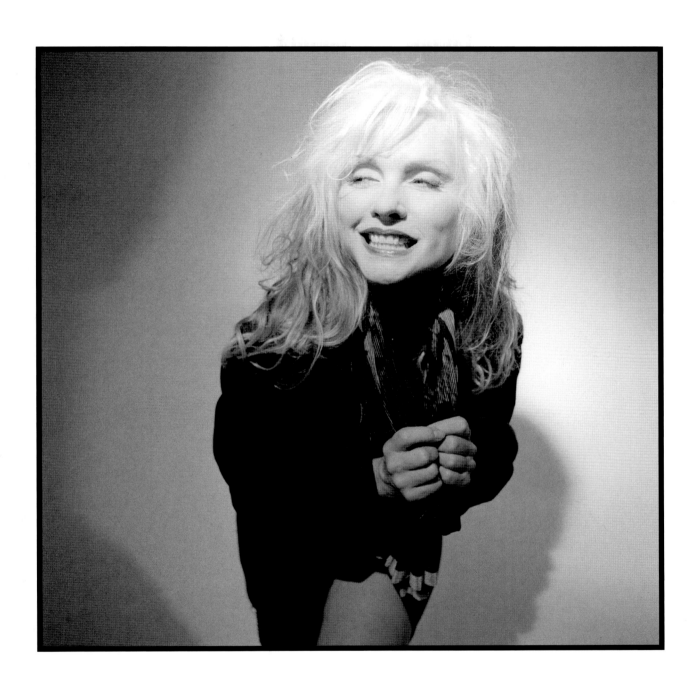

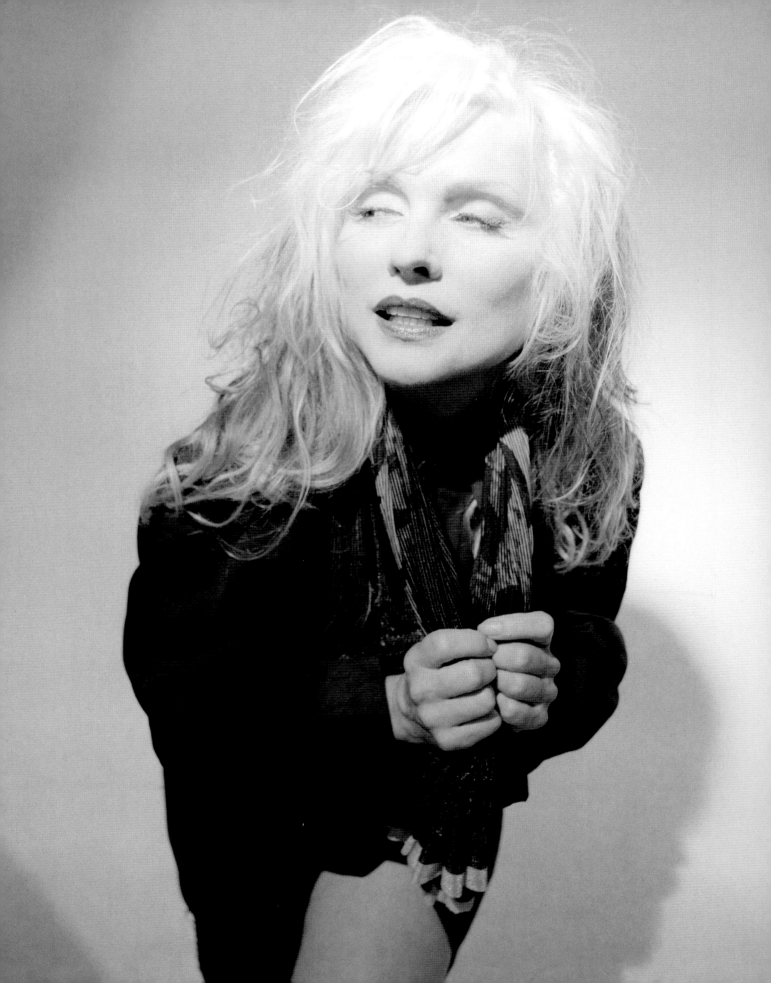

"Sexy was very faint praise for her."

RAYMOND CHANDLER
(The Little Sister)

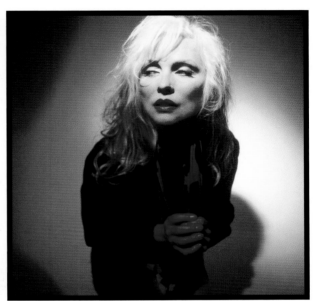
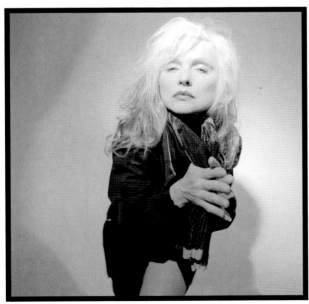
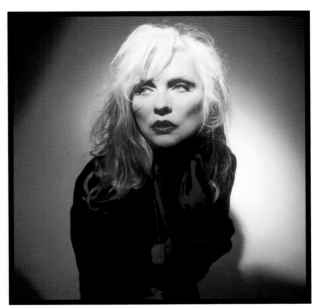

THE PHOTOS WITH THE WHITE LACE DRESS AND THE
PLUNGING NECKLINE EVOKE CLASSIC EARLY DEBBIE
'BABY DOLL' STYLE APPEAL.

CERTAINLY SHE SHOWS A LOT MORE SKIN THAN IN ANY
OF OUR OTHER IMAGES. THEY ALSO EVOKE AN ASPECT
OF DEBBIE'S '70S ALLURE, REPLETE WITH WIDE-EYED
INNOCENCE AND AN ECHO OF HER 'CHILD-COURTESAN'
SPIRIT — A REMARKABLE FEAT AND A TESTIMONY TO
HER CONTINUING ABILITY TO ACT UP TO THE IMAGE
HER PUBLIC ADORES.

IT FELT, INDEED, AS IF TIME HAD STOOD STILL, AND
WE PICKED UP EXACTLY WHERE WE HAD LEFT OFF.

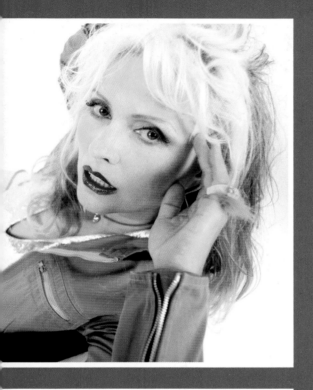

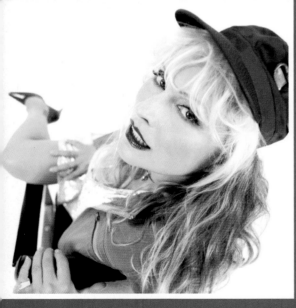

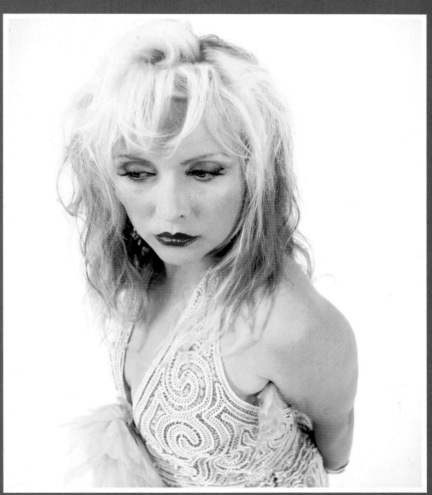

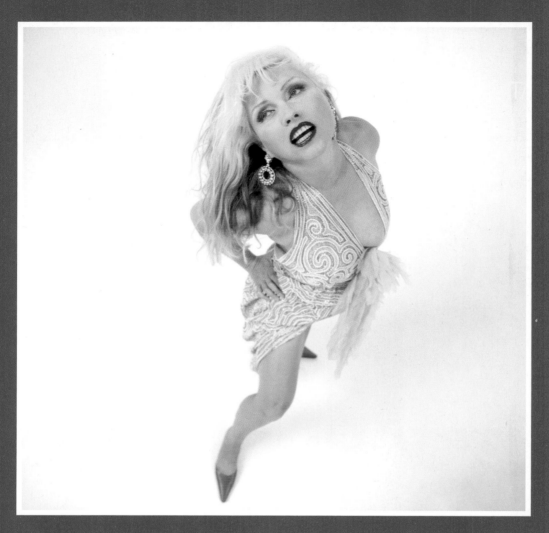

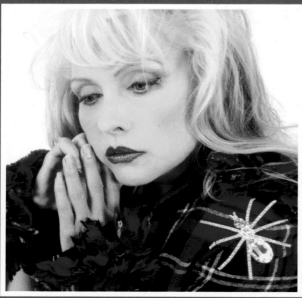

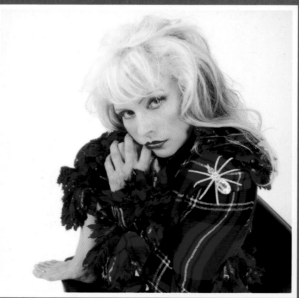

LOOKING AT THE RESULTS, IT WAS HARD TO BELIEVE THAT 20 YEARS HAD PASSED SINCE OUR LAST FULL-ON SESSION. SHE EXHIBITED THE SAME DELIGHT IN THE PROCESS, THE SAME SENSE OF HUMOUR AND CAMPNESS. SHE NEEDED LITTLE ENCOURAGEMENT AND GAVE ME A WHOLE SLEW OF MEMORABLE IMAGES.

THIS FACE FOR THE AGES SHOWED LITTLE SIGN OF HER LINEAR YEARS. THE EYES, THE LIPS, THE SMILE, THE HANDS: THIS SAVVY AND FABULOUS BLONDE COULD CLEARLY STILL OUT-BLONDE 'EM ALL...

THE RESULTS PROVED THAT WE BOTH STILL KNOW HOW TO DO IT REALLY GOOD...

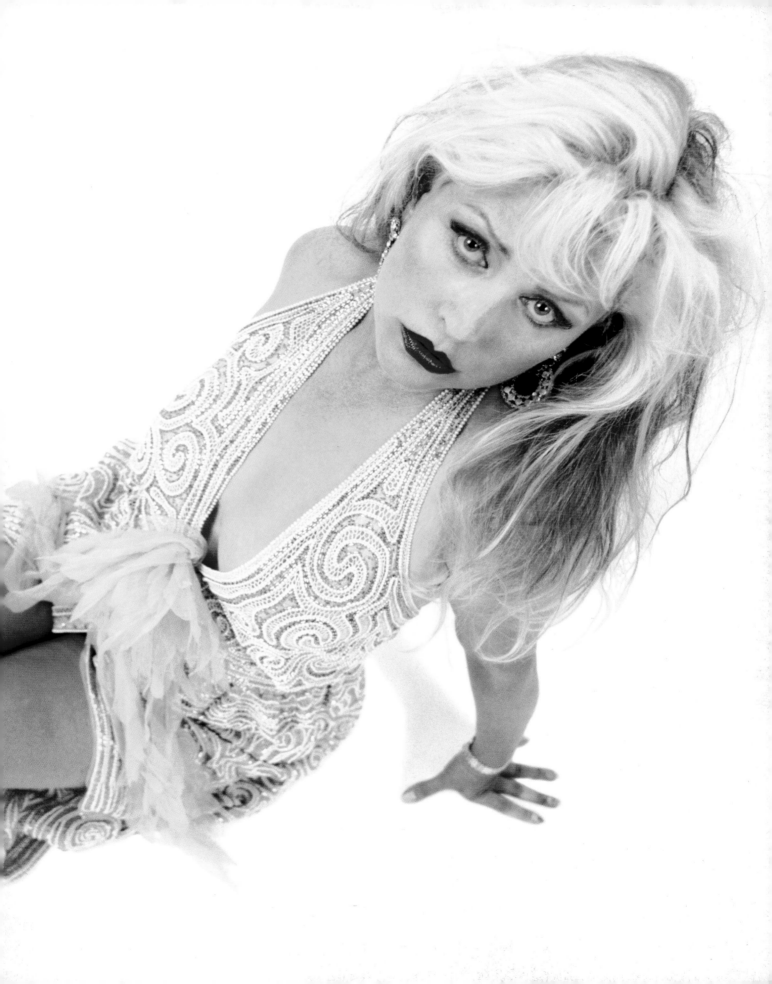

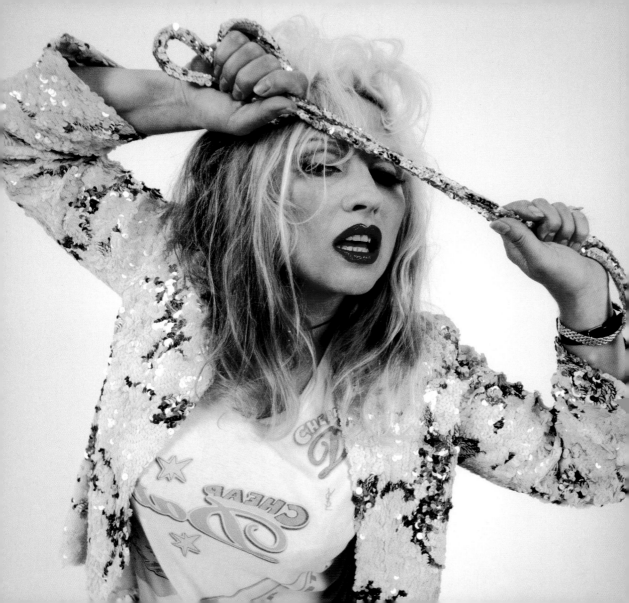

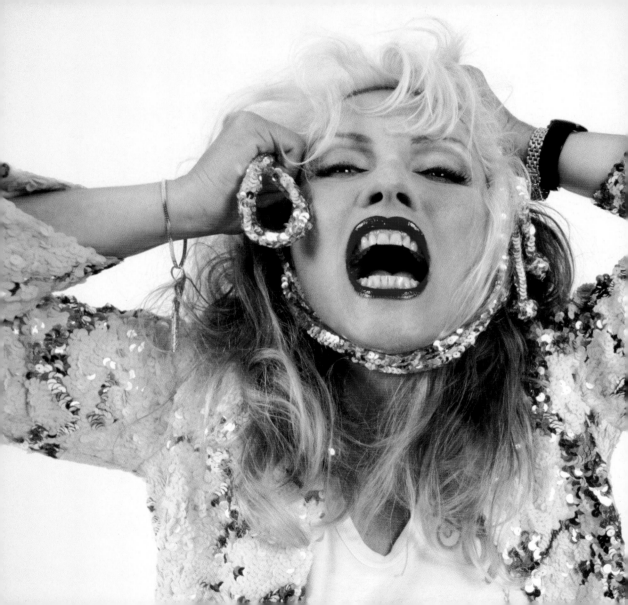

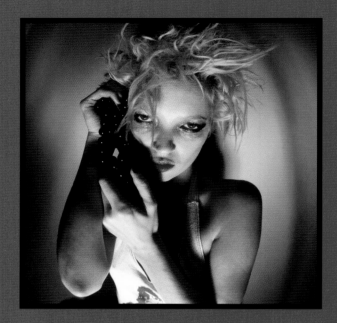

Kate Moss
New York City. 2002

In January 2003, the very hip French fashion magazine *Rebel* asked me to do a ten-page mixture of my collage work and fashion sported by New York rock 'n' roll musicians mostly they wanted hot young acts – the Rapture, Stellastarr*, Royston Langdon (husband of Liv Tyler, newly departed from his hit band Spacehog), WIT, and Cindy Greene from the Fischerspooner group. But they were also delighted when I suggested we anchor the layout with one of New York's legendary acts and we decided it should be Debbie. I had recently shot one of my new fave blondes, Kate Moss in such a way as to evoke the idea of Debbie's glam-punk aura. By now Debbie had reverted to her short punk hairstyle again, so I used the same hairstylist, Gerald Decock, who took inspiration from the look he had come up with for the Kate session and did a very similar wild, ragged style which brought a new flavor to my Debbie pix. Thus we evoked the idea of Debbie for Kate's rock 'n' roll image with a hairstyle Debbie had never really sported, but which had a great anarchic punk feel, and then transplanted it back onto Debbie – a fun and effective exercise in hirsute cross-fertilization!!!

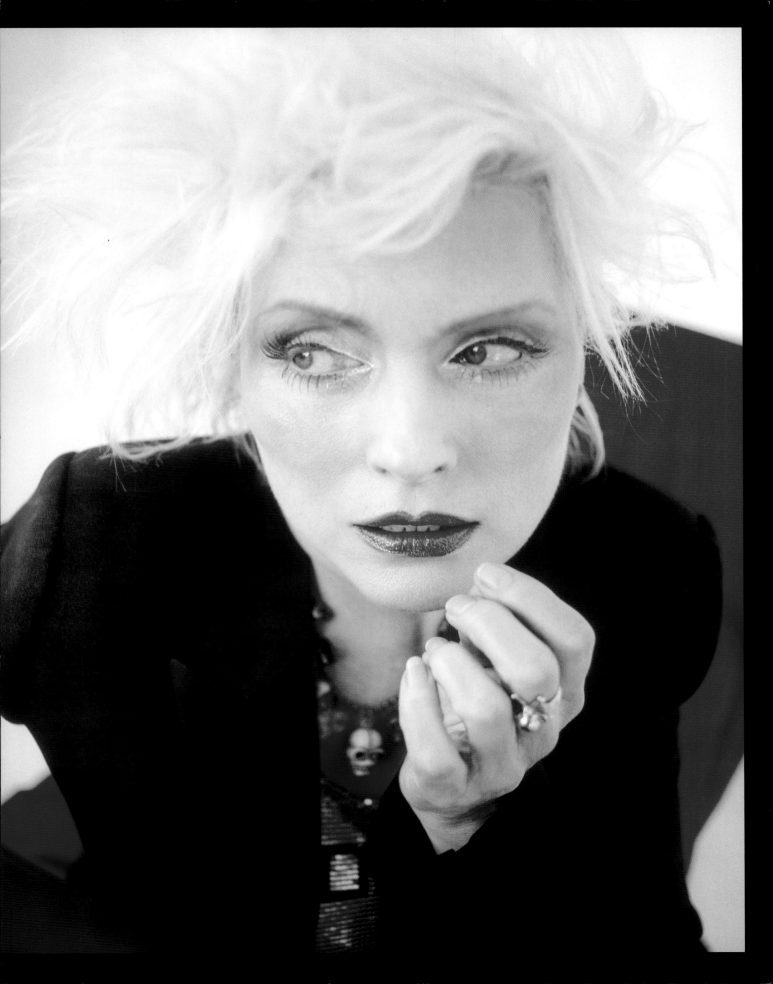

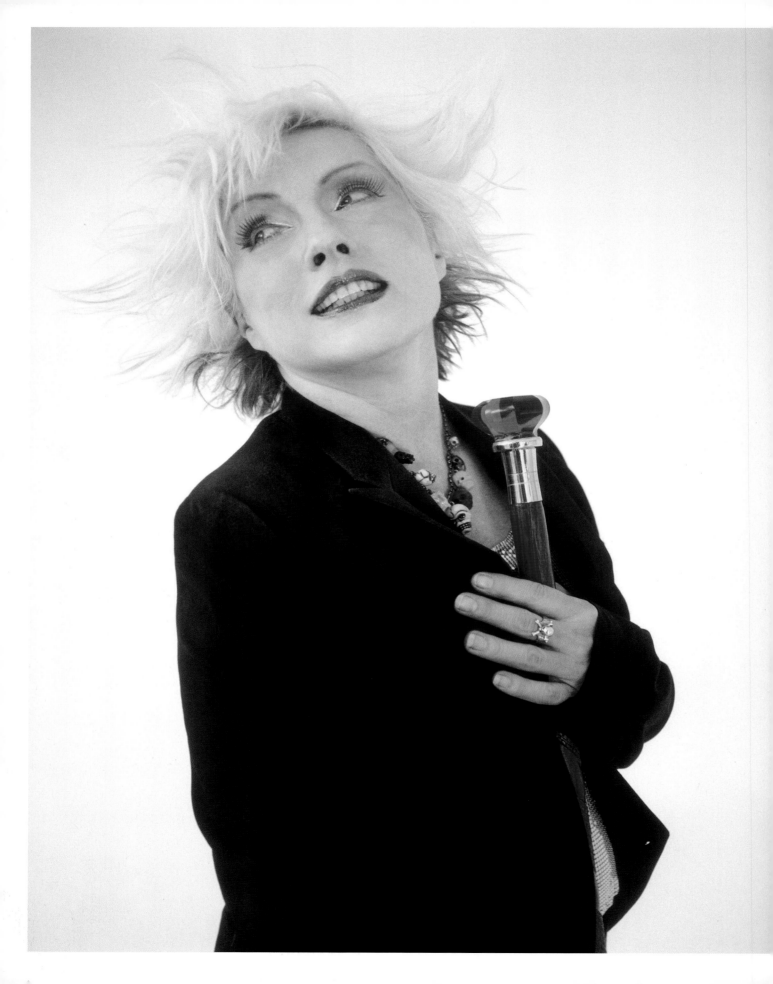

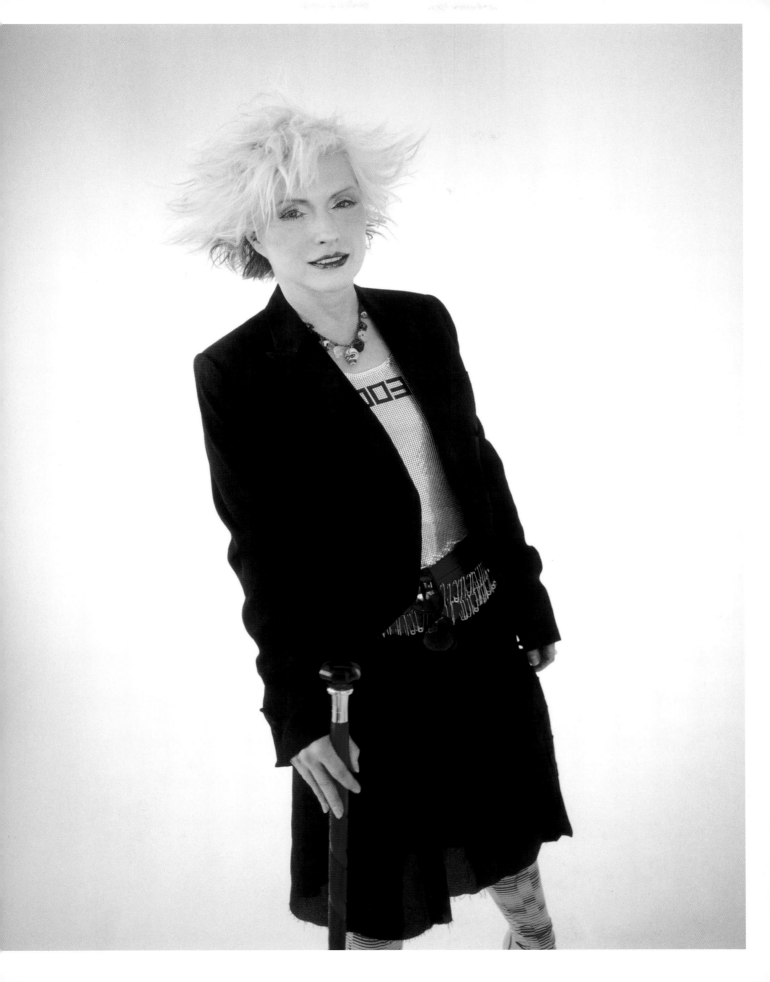

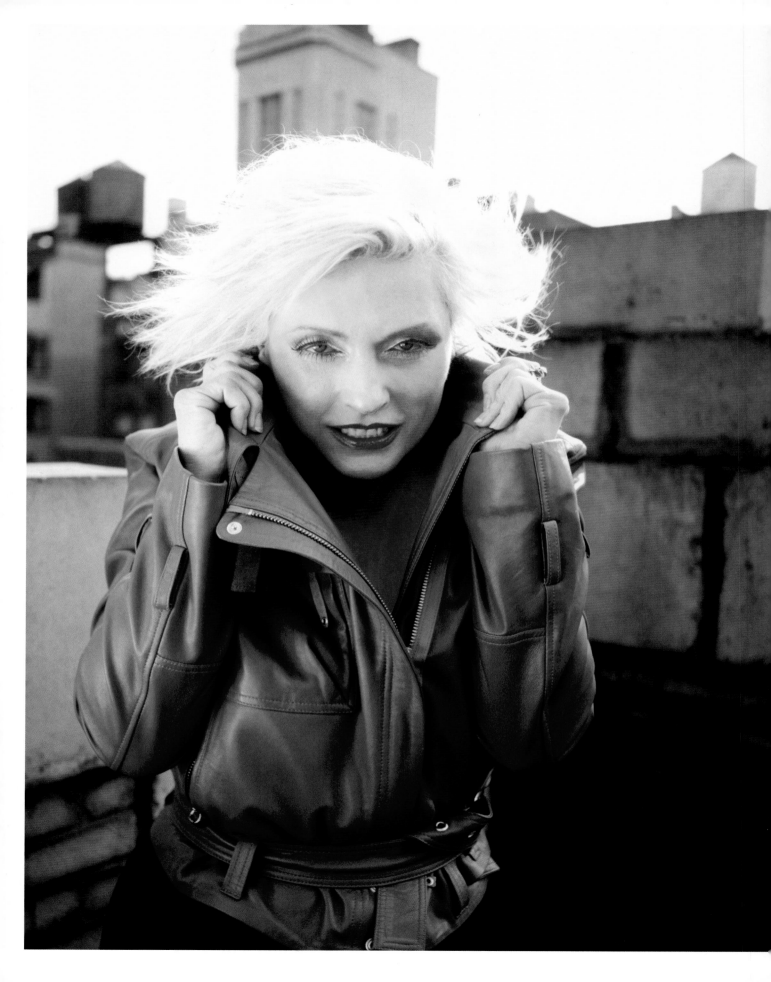

And so with the publisher breathing heavily down my collar, and the printer gesticulating frantically in the wings, I am reminded of a pearl from one of my favorite sources of wit and wisdom:

*"There are few great second acts,
but for those that can deliver in style,
the applause lingers long after the
curtain comes down and the critics
have been put to the sword...."*

OSCAR WILDE

To which I wish to humbly add: Hooray for cameras, blondes and rock 'n' roll and hooray for the divine Ms Deborah whose eternal charms can still put anyone to the sword...

Fin.

Bee Mine
1981

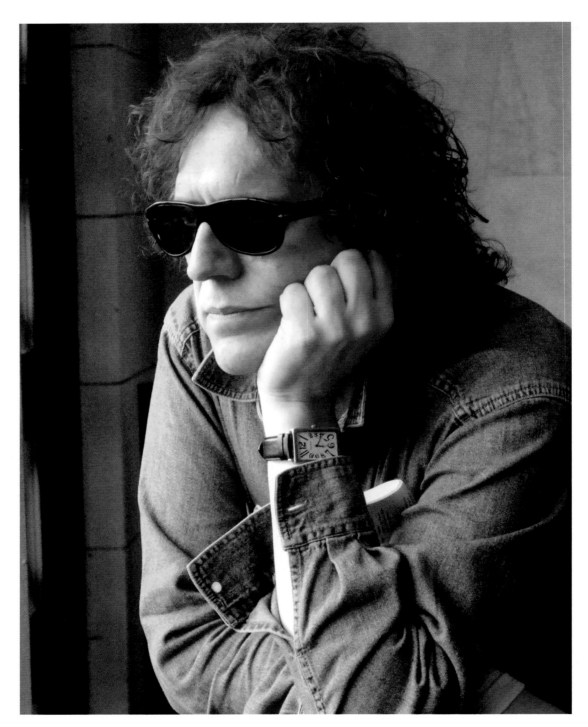

Mick Rock

Credits

The author wishes to thank the following without whom this project would have borne no fruit:

Debbie Harry – for being such an amazing photosubject!

Chris, Jimmy & Clem – for being so cool

Colin Webb of Palazzo Editions – for giving this book new life

Adrian Cross – for giving me such a great design

Liz Vap – for her continuing patience and support

Dean Holtermann – for keeping me up when things are down!

The author also extends his thanks to the following for their continued support and belief: Pati Rock, Nathalie Rock, Allen Klein, Iris Keitel, Andrew Loog Oldham, Joan Rock, Lisa Raden, Mazdack Rassi of Milk Studios, John Varvatos, Cody Smyth, Nestor Savas, Andrew Melchior, Howard Weintraub, Peter Blachley, Raj Prem, Jeffrey Gewirtz, Ramesh Gidumal, Pam Webb, Nur Khan, Anne Toglia, Catherine Alexander, Sat Jivan Kaur, Sat Jivan Singh, Richard Lasdon, Lucky Singh of Lucky Digital Inc, NYC.

Bibliography

Mick Rock: A Photographic Record 1969 - 1980, published 1995

Moonage Daydream: Ziggy Stardust (with David Bowie), published 2002

Killer Queen (foreword by Brian May), published 2003

Glam! An Eyewitness Account (foreword by David Bowie), published 2005

Rocky Horror (foreword by Richard O'Brien), published 2006

Psychedelic Renegades: Syd Barrett, published 2006

Tamashii: Mick Rock Meets Kanzaburo (Kabuki Theatre Photos), published 2007

Classic Queen, published 2007

Raw Power: Iggy & The Stooges (foreword by Iggy Pop), published 2010

Mick Rock: Exposed (foreword by Tom Stoppard), published 2010

www.mickrock.com

"A principle in life to remember is to travel light. You are traveling all the time. Travel light, live light, spread the light, be the light."

YOGI BHAJAN